Rhythms of the
KIMBERLEY
A Seasonal Journey Through
Australia's North

RUSSELL GUÉHO

FOREWORD BY
TIM WINTON

FREMANTLE PRESS
fine independent publishing

First published 2007 by FREMANTLE PRESS
25 Quarry Street, Fremantle WA 6160
(PO Box 158, North Fremantle WA 6159)
www.fremantlepress.com.au

Designer Tracey Gibbs
Map (overleaf) TM Typographics
Printed by Everbest Printing Company, China

Cataloguing-in-production data is available from the National Library of Australia

Disclaimer

The author and publisher accept no responsibility for any loss, injury or inconvenience sustained
by any person using the information contained within this book. Places and people change, as do
attitudes and accessibility. Issues associated with global climate change will have direct impacts on
the Kimberley region and could result in significant changes to seasonal events and indicators in the
future. Users of this book are encouraged to seek up-to-date information from relevant authorities
and organisations to ensure that a balanced decision is achievable.

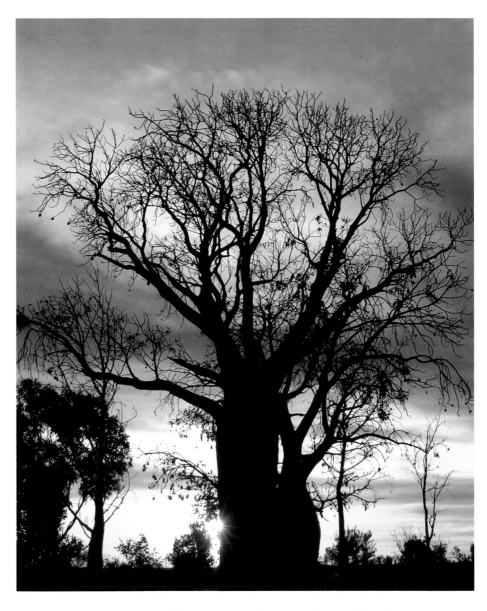

A craving for the impossible gratification of seeing, touching or hefting the innocent bulk of a dodo comes over me strongly in my more whimsied moments. I suspect that it must come over every man with any time to think. I believe our descendants will have more time of that kind. I know they will have a lot more dodos than we have, to yearn to have been allowed to see.

Archie F. Carr, Jr., *The Land and Wildlife of Africa*, 1964

The iconic boab tree of northern Australia

Map of the Kimberley Region

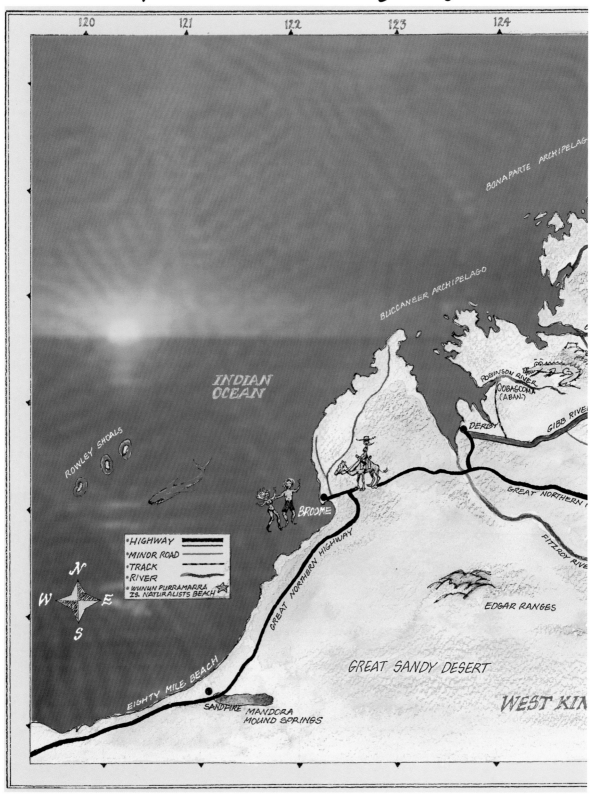

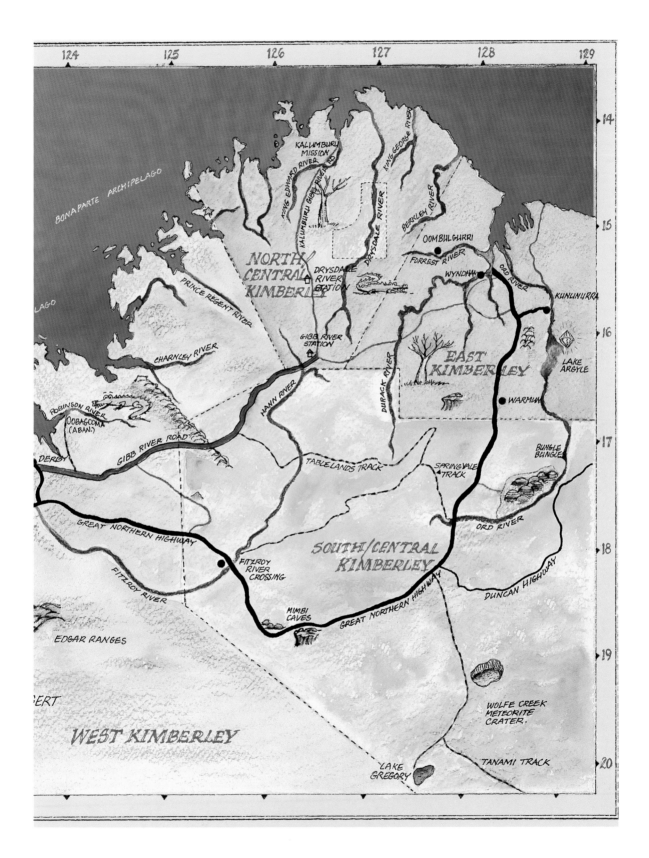

About the author

Rhythm is the second book that Russell Guého has written on the Kimberley and Northern Australia. *Icons of the Kimberley* gave a unique overview of 78 special places found in the Kimberley, and *Rhythm* leads us on a journey of rediscovery of the cyclical nature of this special part of Australia and reminds us to consider our actions on both a global and a local scale.

Russell has lived in the region for over 18 years and travelled over, under and around the Kimberley in a range of capacities. He has been a District Wildlife Officer with a focus on wildlife protection, law enforcement and crocodile management; he also started one of the first true nature-based tourism businesses in the region, focusing on accurate interpretation of natural systems. Russell has been a professional fishing guide and has worked with a number of Kimberley charter cruise operators to train personnel and improve and develop tourism product. He is also involved directly with the ongoing battle to keep cane toads from devastating the region. Russell lectures in Tourism (operations management and guiding) at Kimberley TAFE and still operates (with his lifelong partner, Vanessa Hayden) Northern Habitat, a sustainable tourism consultancy business.

He is passionate about this special part of Australia and has turned its protection from inappropriate and unsustainable development into a lifestyle choice.

Moonset and venus over Cape Bouganville

Foreword

The Kimberley region of north-western Australia is one of the world's last great wilderness areas. Its rugged and remote landscape is probably the most distinctive and iconic that we have and its riches are so complex and varied that they overwhelm the newcomer and the old hand alike.

In the first instance the Kimberley is the home of the world's oldest living culture. The people and traditions which sustain the ancient Wandjina and Gwion-Gwion rock art endure despite nearly two centuries of colonisation and although too many stories – and indeed languages – have been cruelly lost, there remain songs, dances and ways of being that make the post-modern mindset seem literal and simplistic by comparison.

Interleaved with these rich traditions, and vitally important to them, is the extraordinary diversity of landform, plant and animal species and habitat that distinguish the region. Even as this book was written and published, biologists were coming upon new species and coral reef systems previously unknown. Such is the size and remoteness and the natural wealth of the area.

Visiting or living in the Kimberley is not a mild experience. The area is marked by extremes of seasonal change, of tidal movement, of temperature, distance, colour and human personality. This vividness can lend the region a false air of invulnerability. Certainly the country and its people are robust but the Kimberley's riches are more fragile than they seem, and species disappear or become endangered as quietly and irrevocably as languages and folkways. The natural wonders of the far north – its river systems, mangrove communities, archipelagos, savannahs and remnant rainforest – are vulnerable to the pressures of mining, pastoralism, global warming, metropolitan anxieties about water, feral species and tourism, to name but a few.

The Kimberley has always had a special mystique, as if its very remoteness from southern and suburban Australia makes it impossibly exotic, and to some extent this frontier strangeness as presented by writers like Ion Idriess in the early twentieth century and a suite of colonial explorers before him endures in the public mind. But this one-dimensional view is rarely more than either nostalgic or journalistically shallow. What most of these influential accounts lack is a sense of long-standing immersion of the sort that brings genuine openness to the cultures and ecologies and geographies of this amazing region.

Russell Guého's book is neither a work of journalism nor travel writing, nor even pure science, but an attempt to write about the Kimberley from a more intimate perspective, from the air down and from the ground up. It's about patterns and movement, dance and cycle, with an understanding that all life and landforms and seasons in this special part of country are linked and interdependent. It's an act of homage by someone who has lived and worked for its survival, but also an attempt to reveal the underpinnings beneath the obvious and extend the non-specialist's knowledge of those species and landscapes we encounter as locals or visitors.

This book is an opportunity for tourists and armchair travellers alike to expand their perception of nature and thereby of life itself. In particular it offers a means of viewing seasons outside the European or Northern Hemispheric model that many of us have inherited. Within its ecological framework it endeavours to honour the wisdom of local Aboriginal peoples and tempts us to access, along with all the benefits of empirical inquiry, our own instinctive natures, encouraging us to imagine ourselves a part of the landscape we live and work and travel in. For it is only by seeing ourselves as interdependent, entwined and implicated in the processes and patterns of the natural world that we will have any hope of leaving enough of it to our grandchildren.

I welcome this book for its sense of intimacy and its gentle guidance, for helping us to see what it is that we're looking at when we encounter such a remarkable and complex region as the Kimberley.

Tim Winton, June 2007

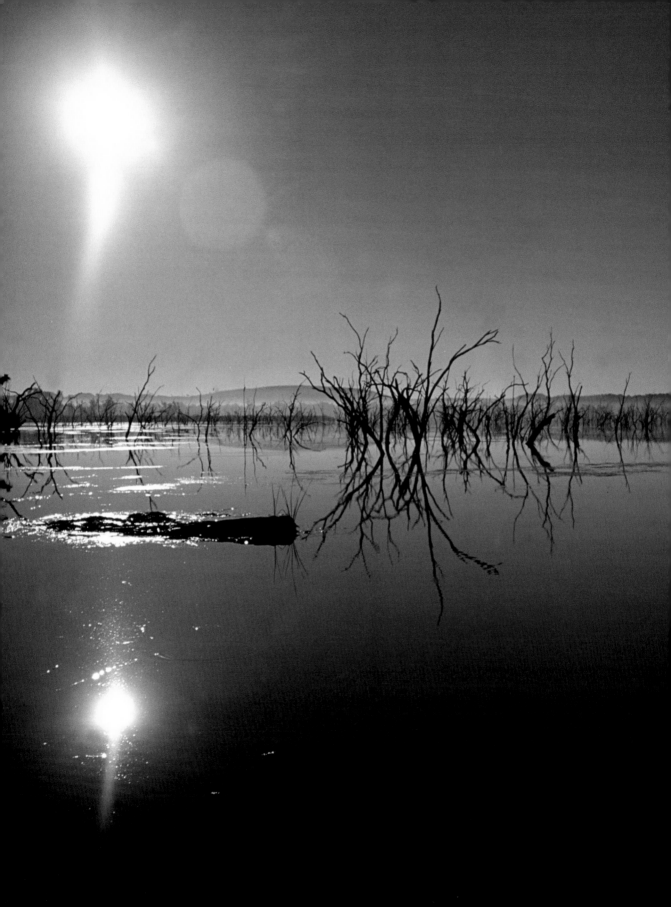

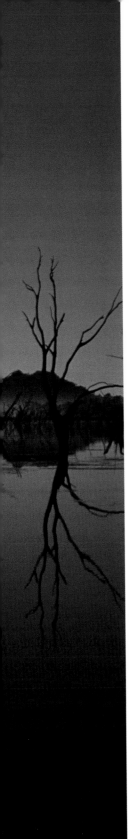

Contents

Spring sunrise, Lake Kununurra

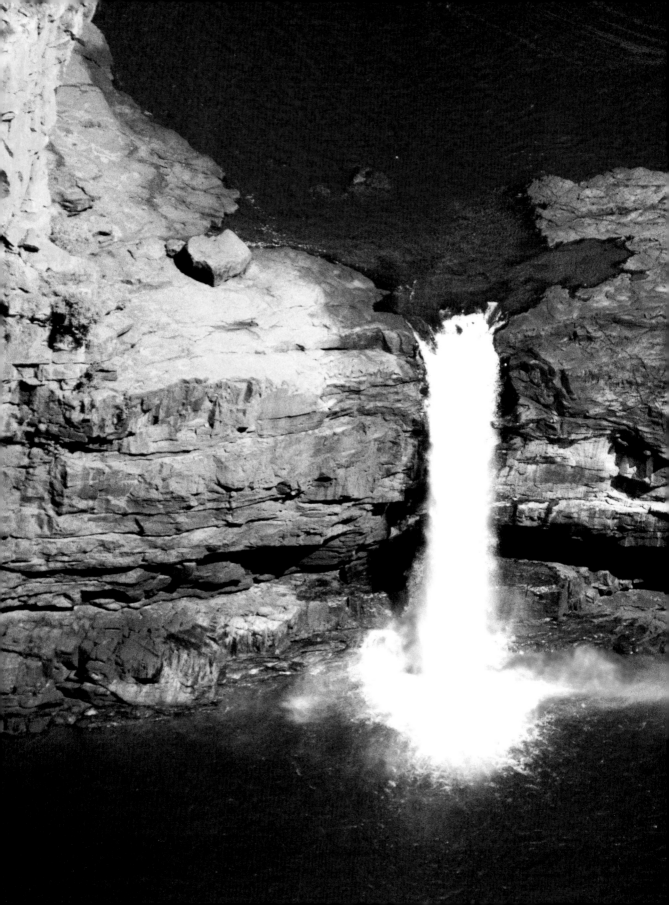

Introduction

We live in a universe of patterns. Every night the stars move in circles across the sky. The seasons cycle at yearly intervals ... Intricate trains of waves march across the oceans; very similar trains of sand dunes march across the deserts ... we have discovered a great secret: nature's patterns are not just there to be admired, they are vital clues to the rules that govern natural processes.

Ian Stewart, *Nature's Numbers*, 1995

Since the Industrial Revolution that changed the face of our world some 200 years ago, the emphasis on understanding our place within the natural order has ebbed and flowed with the development of technologies that have been designed to make our lives 'easier' and tame the environment to suit our needs.

But there is still a requirement to understand what our world is up to. It is imperative that we make the effort to observe what takes place around us and that we react as necessary. If we are serious about our intentions to survive as a species, we must regain an understanding of the rhythms of life in our world and how we are a part of the world.

The price of our couple of extra genes, our opposable thumb and our capacity to develop a brain large in comparison with our bodies is custodianship over millions of other creatures.

How we choose to display this power is what separates us from other life forms. A crocodile has simple needs: food to eat, others of its species to breed with and a small area in which to establish a territory.

Mitchell Falls

To fulfil its needs a crocodile uses observation skills – it watches if other animals establish patterns within its territory, it moves with the tide as fish are moved with the tide, it locates fresh water within its home range and seeks out suitable partners and nesting material when the instincts that drive it to reproduce are strongest.

We have the same basic needs as the crocodile but we are by nature a violent species, intolerant of others of our kind when they are different in some fashion, and possessed of a need to obtain and exploit territory.

We have developed credos to justify our impacts on each other and on the other creatures that share this world, and in the process we have set in place a chain of events that will be potentially devastating to future generations, and that even with our understanding of technology we have little hope of reversing.

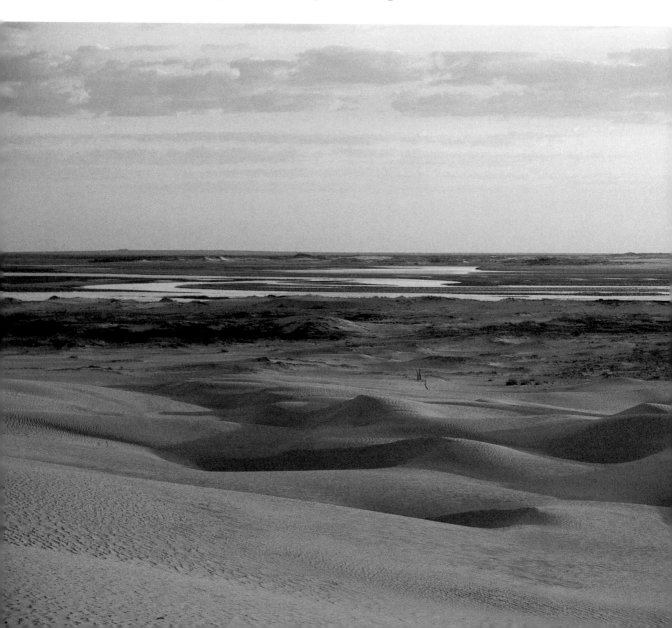

But we can regain our knowledge and treat the Earth as a home instead of a resource. The purpose of this book is to help identify what we have always known.

There is a cyclical rhythm to the Earth that is as inescapable as time itself, and the sooner we make the effort to remember this and understand our place in the cycle, the better off all creatures on the Earth will be.

The Kimberley has areas that are attractive in a variety of ways.

There are still opportunities for visitors to experience personal events – there are still undiscovered beauty spots and fishing holes, there are still plants and animals to be discovered, there are still adventures to be had. It's just important to appreciate that not everyone likes what goes on in the search for these adventures.

Many Kimberley communities are developing plans to deal with increased visitor numbers. They recognise the economic benefits associated with these increases; the trick is to manage it all in a sustainable fashion. Heard it all before? No doubt, but at the end of the day none of it will work without a recognition by the visitors, the managers and inhabitants of why these constraints are necessary.

The tourism industry and the rise of lifestyle television shows and adventure print magazines have contributed to these activities without an equivalent contribution in education about the fragility of Kimberley habitats.

There are also major new threats in the form of natural resource exploitation, with multinational companies targeting the gas, oil and other mineral reserves found along the Kimberley coast – in these times of rising greenhouse emissions it should be difficult to justify these forms of development, but such realities are frequently ignored when money is talking.

As economic, social and cultural influences increase and as travel into the Kimberley becomes more attractive – given the state of uncertainty throughout the world – the people pressures on our environment grow.

Already the iconic areas of the Kimberley, places like Purnululu National Park, the Mitchell Plateau, the Gibb River Road gorges and the fragile coastal habitats, are being tramped over by too many feet, burnt by careless communities and campers, and generally over advertised in inappropriate marketing campaigns about remote outback experiences.

Coastal icon areas including the tidal pinch waterfalls at Talbot Bay, the Mermaid Tree at Careening Bay, Kings Cascade at the Prince Regent River and the splendid waterfalls of the King George River are receiving frightening numbers of visitors, and are under continual threat from our thirst for greenhouse gas-producing energy supplies such as oil and gas.

Where will it end? We have a responsibility not only to ourselves but also to

Dunes near Beagle Bay

future generations to protect what we exploit – this is the basis for the argument of sustainability.

The question is, will we be able to manage our impacts in a sustainable fashion or will we allow the Kimberley to follow the path to overexploitation that has occurred in so many other remote and spectacular wildernesses regions worldwide?

To achieve a semblance of balance we all need to recognise the seasonality of our world and how its rhythms are inextricably linked to our own actions.

We must also acknowledge that an immense store of environmental knowledge has been passed down orally from generation to generation in all cultures.

Since the 1990s there has been a resurgence of Aboriginal culture and this has been expressed in a variety of ways. There is a revitalised interest in bush culture – in the development of a healthier lifestyle, the knowledge of bush tucker and other traditional resources.

Ongoing nature-based tourism developments that incorporate traditional knowledge indicate that there is a desire for a better understanding of traditional land-care practices.

European history and development has taken a different path from that of Aboriginal people. One major reason for this has been population growth – where European peoples had to develop resources to ensure supply for growing sedentary populations, the opposite was true for Aboriginals. The natural resources could not support substantial sedentary populations in Australia – they still do not.

What they do support is knowledge that all Australians will be poorer for not recognising. From an economic perspective, and from a traditional use perspective, the store of knowledge is immense.

Like all natural things, the concepts of sustainable resource use need to be practised. European agricultural styles, for instance, are not sustainable in Australia. Quite simply, we all use too many resources – particularly when it comes to land clearing, water use and energy use – to come close to sustainable use.

This has led our species to a crossroads. If we take – or allow our political representatives to lead us down – the wrong road, the legacy we will bequeath to our children will haunt future aeons. Perhaps an integrated system needs further research and development – we need something that incorporates the ideals that promote the ultimate aim of supporting large populations while still allowing cleaner, simpler, more traditional activities to flourish.

Reconciling these concepts and achieving consensus, while maintaining the earth's rhythms and retaining the vast potential of this country's natural resources, should be every Australian's desire.

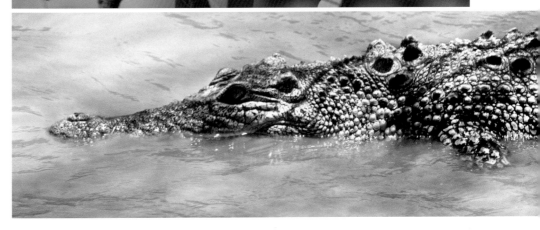

Top: Guhinge
fruit (Terminalia
ferdinandiana)
Bottom: Crocodiles
are masters of stealth
and observation

17

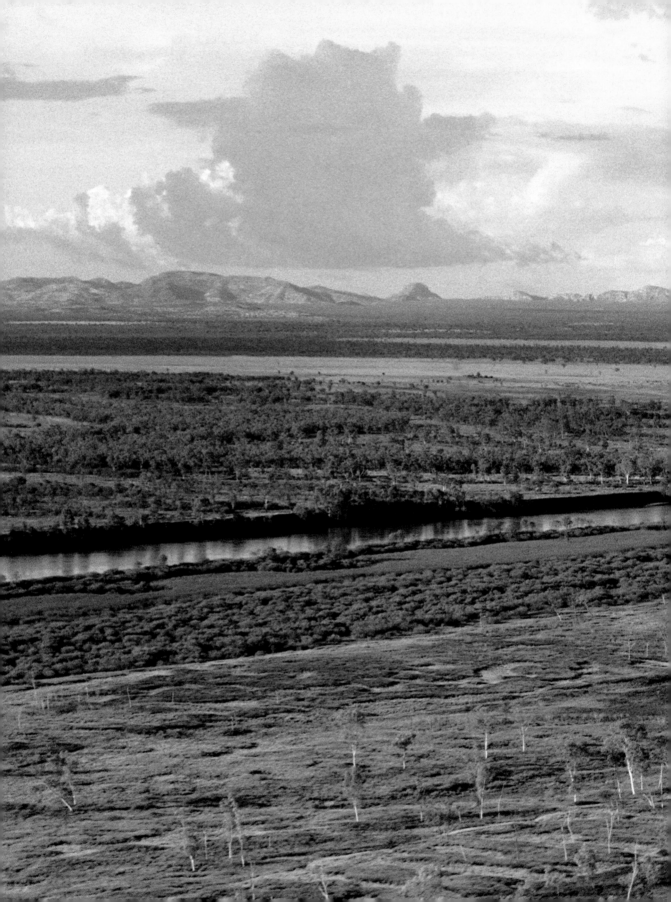

Rhythm

The rhythm of life is a powerful thing,
To feel that rhythm of life
To feel that powerful beat
To feel that tingle in your fingers
To feel that tingle in your toes
The rhythm of life is a powerful thing.

Sweet Charity

Ever since mankind evolved to walk upon this planet we have attempted to understand the significance of the plants, animals and seasonal changes around us, with the intention of ensuring our species' survival.

The survivors who have passed their genes to succeeding generations have been the most observant, the most adaptable and the most willing to learn more about the natural systems to which we are all inextricably linked.

The position of our Earth in the solar system imposes a number of cyclic rhythms on all life on the planet. Every 24 hours, as Earth rotates on its axis, there are periods of light (day) and darkness (night) that place temporal (transitory) restrictions on the time that an animal or plant can exploit the resources within its environment.

The Moon's rotation around the Earth produces a 28-day period of constant variation in tidal height – and of brightness of the Moon itself. This rhythm in itself restricts, for example, the times at which certain resources found in the inter-tidal

Ord River floodplain

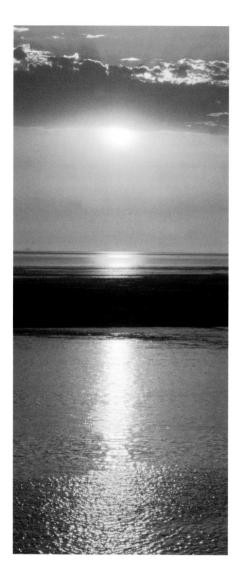

zone of the sea shore become available. On this localised scale these lunar and semi-lunar effects are reflected in the movement of various creatures through these habitats and by the reproductive activity that takes place.

Superimposed upon these daily and monthly rhythms of life is the annual cycle caused by the rotation of the Earth around the Sun.

In general terms, the seasonal changes that are a result of these cycles are most obvious in their environmental effects at the poles of the Earth.

In more temperate latitudes the seasonal effects are less strong and less obvious, and the closer to the equator we get the less real change there is in these environmental effects.

Many animals have adapted to these seasonal climate changes either by changing their behaviour as the seasons change or by moving from one environment to others as inhospitable effects, such as less reliable food resources, occur.

Seasonal indicators that have been recognised by all peoples are, in respect of animals, a form of migration. And in the minds of many people, the word 'migration' is closely associated with the seasonal movements of certain species of birds and insects.

Since even before biblical times it has been observed that 'the stork in the heaven knoweth her appointed times; and the turtle and the crane and the swallow observe the time of their coming' (Jeremiah 8:7).

In the northern hemisphere, many species of birds fly south for the winter – avoiding the extremes of climatic change that can occur in the polar regions.

These migrations involve regular journeys between summer breeding ranges and winter resting and feeding areas.

*Sunset over
Montgomery Reef*

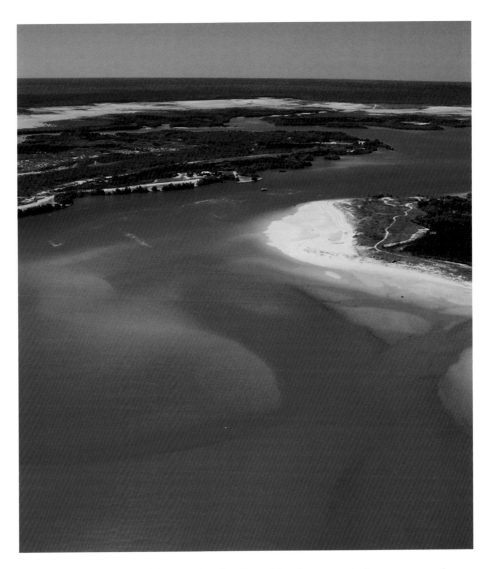

The authors of the Bible were also familiar with other natural phenomena, such as the plague of locusts in Egypt brought by 'an east wind upon the land all that day, and all that night' and which 'covered the face of the whole earth' (Exodus 10:13, 15).

Many insects can swarm and make long journeys during their lifecycle. But we are more easily able to identify that there are natural reasons for these actions. Locust swarms tend to migrate downwind into areas of low pressure, where they are most likely to encounter rain. Wet conditions stop the apparent migration and encourage breeding and egg laying.

Many animals use their senses to determine what movements are necessary. For example, on the plains of East Africa, migrating wildebeest use their eyes and their

Tidal waters of
Willie Creek
north of Broome
Overleaf: Migratory
wader birds at
Roebuck Bay

21

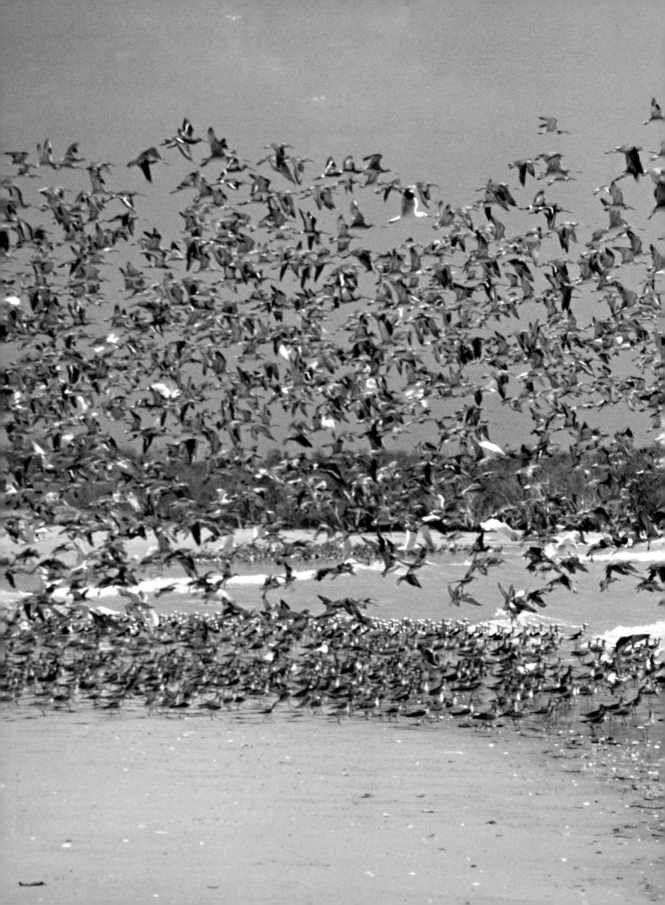

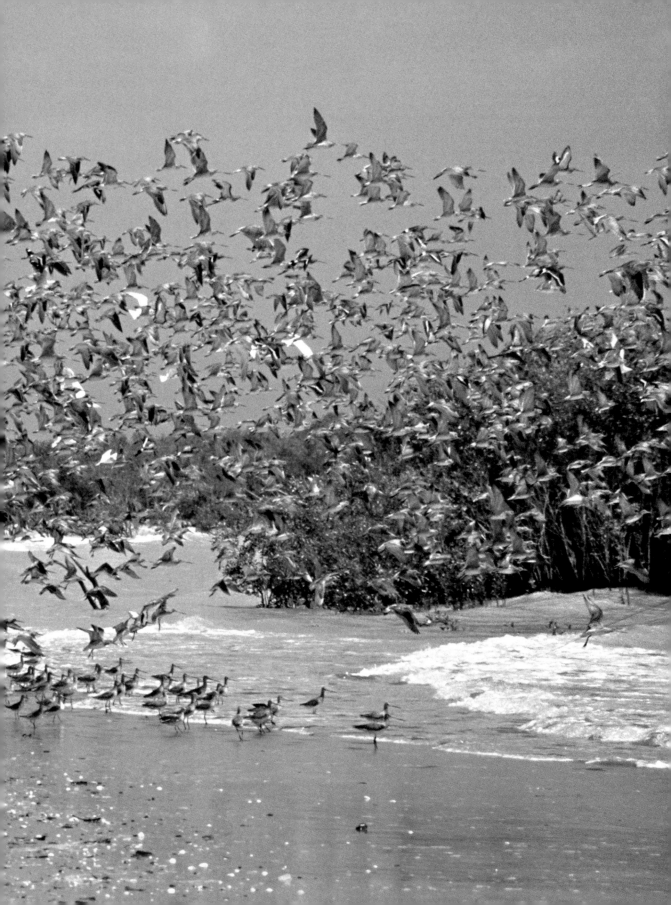

ears (and probably their noses!) to sense nearby areas where rainfall has produced, or will soon produce, fresh grass. The massive herds move towards the sight and sounds of the rainstorms.

There is a dearth of recorded knowledge in Australia about the similar events that occur here.

The knowledge exists, but the manner in which we react to an event often requires more thought than we are willing to engage in.

The construction of fences to try to thwart seasonal wildlife migration into agricultural areas, for instance, is often counterproductive.

Many people may recall how emu 'plagues' were 'managed' by shooting, poisoning and fencing off thousands of these magnificent birds as they followed the sight and sounds of storms, which indicated where the fresh growth would be.

When we look at the reactions of plants to various stimuli over a period of time it is possible to build a picture of what types of natural events cause these different reactions.

If you provide water and other nutrients to plants at a particular time of the year you will get a growth reaction. There may be new leaves, the stem or trunk may expand or heighten, flowers may form and fruits may be produced.

These reactions are also affected by other environmental considerations, including duration and intensity of light and predation.

In particular, the European concept of seasons is too constraining in a unique region such as the Kimberley (indeed, in all northern Australia) – and we can't just rely on classifying our weather patterns as the Wet or the Dry.

Throughout the year there are constant subtle changes that can be felt and seen if we only take the time to observe our surroundings.

Unfortunately, most of us have also been conditioned to suppress the instinctual skills that have stood our species in good stead for millennia.

More 'primitive' cultures have closer links to their environments and are consequently far more able to observe change, particularly when it is subtle, than the protective, managed western style of life.

But we can rediscover these skills and through them gain a better appreciation of how every living thing is linked in some fashion.

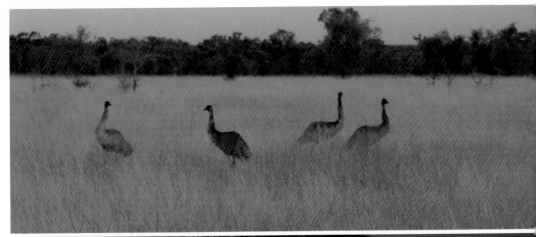

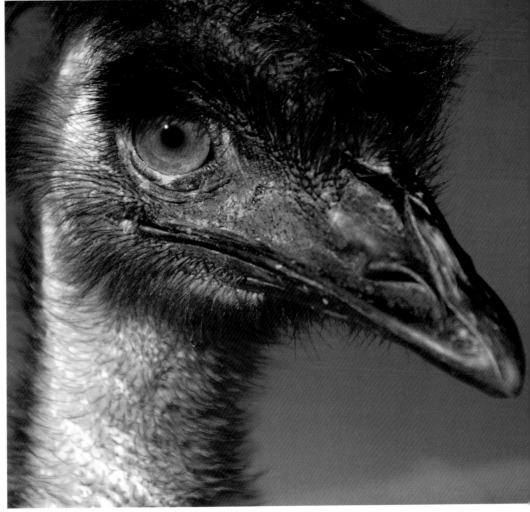

*Emus follow seasonal
rainstorms*

The start

The Kimberley seasons can be said to begin with the coming of the first cyclone. These events, although often very destructive, are also the harbingers of life.

The massive quantities of fresh water that are deposited, often far inland, soak a land that has been parched, baked and dried for six months or more.

But the stimuli that forecast the coming of these rains have already been working their special magic – the daytime temperatures have been rising and at night the humidity levels have also begun to increase.

This water vapour weighs heavy in the air and at times it can manifest as coastal and low country fogs. It is not much water, but it is enough to survive. It is enough for plants to push out new shoots.

Many plants have adapted to take advantage of this change in the atmosphere. Some have developed specialised leaves and fruits that concentrate airborne moisture, either directing it to the main stem or trunk, or ensuring that it drops directly onto shallow-running root systems.

The days become longer as the southern hemisphere of the Earth moves into its summer pattern. More sunlight equals more opportunities for photosynthesis, and as long as the other physical requirements are provided, growth will occur.

Ocean surface water temperatures begin to rise and climatic effects far from the Kimberley coast itself begin to exert an influence on what impacts will be felt in the region in the coming months.

The building of the monsoon to the north pushes equatorial low-pressure systems

Coastal fog

27

south into our hemisphere, forcing the southern ocean high-pressure systems to retreat off the Australian mainland.

With their retreat, the cooling easterly winds that have subjected much of the region to dry cool weather during the winter months are able to move further south and begin to collect heat from the deserts and the massively cleared agricultural regions. Summer is arriving in the southern hemisphere.

It is difficult to say what reacts first. Certainly the speed with which plants respond to the increase in water vapour and temperature is stunning, but then there are also the insect indicators that come in such a bewildering variety of species and make their presence known.

In the north and east of the region the giant water beetles (*Lethocerus* sp.), attracted by the lights, gather in our towns and communities. Often referred to as 'toe-biters' or 'fish-killers', these insects are specialised fish and aquatic animal feeders and have large raptorial forelegs for grasping their prey.

Termite mud tunnels appear, snaking across the ground as these cellulose feeders begin to take advantage of the first burst of new plant growth. Across the region the variety of cicadas announce themselves ready for breeding with mind-vibrating shrillness.

The first warm downpour on the pindan (iron-rich) and grey sands produces an overnight 'hatch' of winged termites that fill the air and provide a feast for the masses of insectivorous birds that have gathered in the woodland areas.

Almost as soon as they arrive, the neophytes find a suitable spot to found a new colony, drop their ephemeral lacy wings and use pheromones to 'call' for a partner.

Overnight the bare ground is littered with the cast-off remains of these virgin kings and queens and new colonies are commenced. In the morning, ants swarm to gather the bounty and store it for the coming rainy season.

Termites are an important food source for echidnas, many lizards and snakes and other invertebrates, and during their brief mating flights they are also targeted by many small bats and birds as a food source. Of the 350 termite species found in Australia only six cause us any grief.

Most biting and blood-sucking insects also take advantage of the increased humidity and temperatures and the resulting increase in activity from both warm and cool-blooded creatures.

Mosquitoes, biting midges and flies can all swarm at this stage of the yearly cycle, but it is only the females that require the high-nutrient blood meals.

The males play their role in helping many plants by actively pollinating and carrying the plant genetic material from place to place.

The variety of butterflies and moths and their offspring indicates a degree of specialisation that is often lacking in other animal families. There are literally thousands

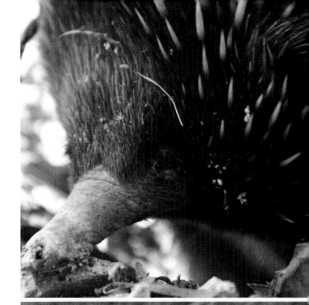

of species (over 20,000 Australia wide) that demonstrate the classic egg–larvae–pupa–adult lifecycle.

The colourful butterflies are simply day-flying moths, and their patterns have evolved to warn predators of their apparent unpalatability – in many species (especially migrating wanderer butterflies) this is a result of eating poisonous plants as larvae and concentrating the toxins.

With the rising temperatures, many butterflies seek a mate – this is the time when they are most vulnerable to predators.

Some species of tiger moth have developed the ability to warn bats that they are distasteful by producing an ultrasound that can be 'heard' by the echo-locating structures in bats' ears.

Birds are also a highly visible indicator that there are changes taking place across the region. The migratory wader birds that have spent the northern hemisphere summer breeding and raising young have started to fly south, away from the (northern) winter.

Over 30 species of these benthic (sea floor) feeders come to the Kimberley region after streaming across thousands of kilometres in their hundreds of thousands.

Each species has developed a beak that suits its depth range as the birds probe their way across the tidally exposed mud deposits seeking small crustaceans, worms and other creatures that burrow into the ocean floor as the tides ebb and flow on their diurnal cycle.

Top: Echidna
Bottom: Termite mud tunnel

The metallic 'tonking' call of the orioles and the 'gibbon'-like song of the pheasant coucals herald this time of change. Many species are making preparations for breeding or have already commenced; in some cases, if conditions have been suitable this will be the second opportunity they have taken to raise young.

Life is in the balance for many creatures at this time of year, yet unmanaged fire is still rampant throughout the region and the effects of this may be felt for generations.

The impacts that fire can have on their breeding and feeding cycle at this time of year may include loss of habitat, loss of breeding success and loss of food resources.

Fire use is an example of where one species (*Homo sapiens*) has decided that its needs outweigh the needs of the many.

Some species of reptile have adapted to a fire-prone environment by using refuge

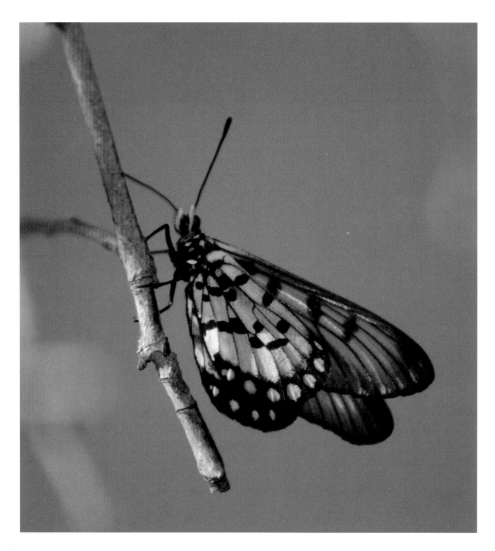

Left: Butterfly (Hesperiidae sp.) Right: Fire use has many issues and many impacts

areas within the landscape. Black-headed pythons and some skinks use the protection afforded by the termite mounds that dot the landscape to escape the effects of fire, but many reptiles do not have this option.

The Kimberley is home to at least 23 species of terrestrial snake, and to large monitor lizards, skinks from small to large, members of the dragon family, geckos and the legless lizard group known as the pygopods.

Snakes are rarely encountered during the day as the temperatures rise uncomfortably with the coming of summer. They are much more active at night – operating in the darkness allows them to use their special abilities more successfully and helps them avoid predators.

In the tidal rivers the largest land-based predators in Australia begin their territorial displays and the night reverberates with their posturing and jaw slapping.

The Indo-Pacific crocodile (saltie) responds to the stimuli of lightning, thunder and torrential downpours that become a feature of the time of year known as the 'build-up'.

Soon the monsoon will promote the growth of grasses along the rivers and the female salties will start their nest building and egg laying.

They will become more visible during the cooler months (May to September) as they spend more time basking in the sun, gathering ambient heat to aid the digestion of food.

In coastal areas the green turtles are preparing to lay their eggs. Their cousins, the flatbacks, have completed their laying tasks perhaps a month earlier, to avoid the competition that will soon come as thousands of marine turtles haul themselves up onto the nesting beaches.

The variety of mammals native to this region rivals other areas of Australia. They hop, run, waddle, glide and fly. Some, like the flying foxes, are recognised as linchpin animals in the broad scheme of things.

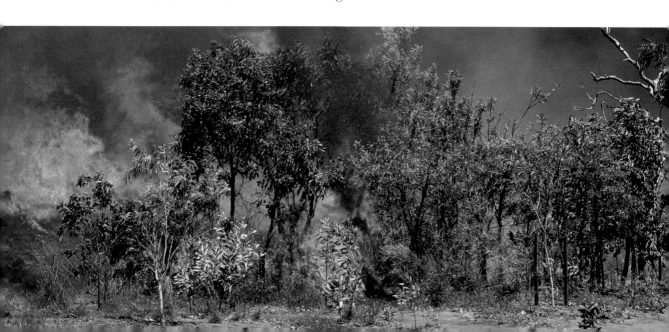

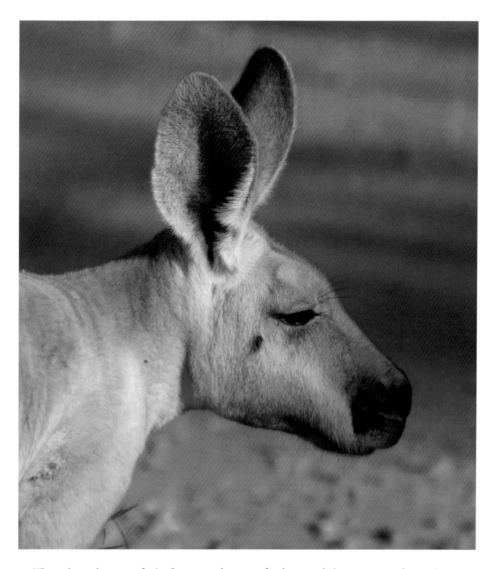

These large bats are fruit, flower and nectar feeders, and they can travel massive distances at night carrying plant material in the form of seed and pollen with them. There is also the specialist mouse-eared myotis, a microbat that trawls for its prey across wetland areas using echo location to find small fish and other creatures that live in water.

Larger mammals, including the wallabies, respond to seasonal changes that result in new growth (green pick) across dry and burnt country. They can take advantage of this food source as long as the seed store has not been destroyed by fire.

Amongst the coastal sandstone formations north of Derby the northern quolls (or native cats) flit and leap, investigating every crack and crevice for possible prey. These

Red Kangaroo

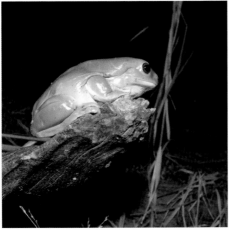 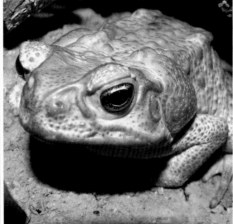

aggressive hunters will take large centipedes, scorpions, moths, small reptiles and amphibians.

Quolls are another feature of the Kimberley night that will be lost with the arrival of the toxic cane toads into this last frontier. Toads are effectively extinction in motion, and it is likely that many of us will witness extinction events in our lifetime as native predators are devastated and ecosystems irreparably damaged.

The daytime temperatures become oppressive and the nights are thick with moisture and sluggish flying insects. There is an air of anticipation and expectation that can only be resolved with the first serious downpour of the summer.

Soon the sky will roar and flash with thunder and lightning – the indicators that have been all around us will indeed have been correct.

But just as quickly the monsoon will retreat and the cycle will change again, moving to the next pattern and causing new reactions amongst the plants and animals of the Kimberley.

Left on this page:
Frogs are food for
northern quolls
Right: Cane toads
will devastate
Western Australia

Aboriginal food calendars

Across northern Australia a variety of events associated with seasonal change occur; plants and animals react in an almost predictable fashion to natural phenomena.

Since their arrival in Australia people have recognised that there are seasonal, climatic, wind and a variety of other signals that indicate that changes to their environment are occurring.

Aboriginal peoples and their European cousins have known this concept for millennia, and although the nomadic and sedentary lifestyles that characterise each group have changed in modern times, the instincts that drive animals and plants have remained the same.

From a European perspective, there are two main seasons in the Kimberley – the Wet and the Dry – and some transitional periods. This concept developed as a result of the types of agriculture Europeans introduced to this country after the arrival of the First Fleet in 1788.

Aboriginal concepts of seasonality are much more complex than the wet–dry pattern. The difference between the seasons is dramatic and the landscape goes through a remarkable transformation. Some groups identify more than six seasonal changes.

These are recognised by factors that include the direction and intensity of the wind and the rain, the different stages of ripening of particular fruits, and the presence, arrival or disappearance of particular animals.

Processionary caterpillars (a seasonal indictaor)

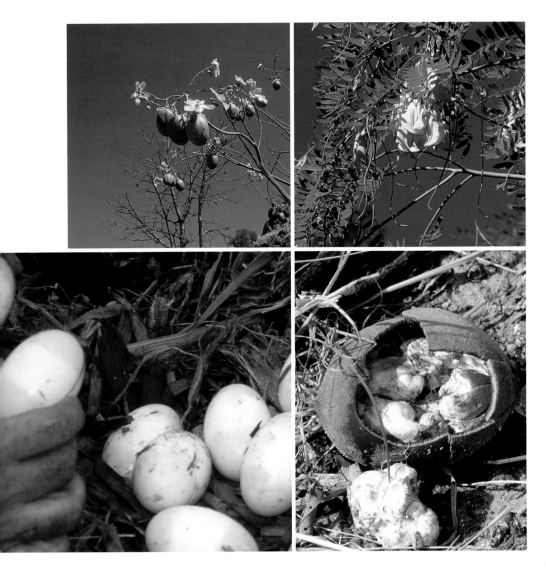

Many groups will also take note of the movements of constellations in the night sky to help with their prediction of resource availability.

These concepts should not surprise Europeans, as the same identifying factors were developed and successfully used for similar purposes, but on a much larger – and sedentary – scale in their homelands.

For the purposes of this book, the following describe a version of these seasonal changes that has been identified by some groups along the northwest Kimberley coast of Western Australia and into the Northern Territory.

Rather than being attributed to one particular group, this version incorporates concepts and events that are recognised by many groups. In some areas it is obvious

Top left: The cotton tree (Cochlospermum fraseri) is an indicator of seasonal change
Top right: Dragon tree flowers can be eaten
Bottom left: Saltwater crocodile eggs
Bottom right: Boab nuts are a takeaway meal

that indicator species may be substituted or changed due to climatic, geographic or environmental factors.

The wet or rainy season occurs between December and March. This time is characterised by strong winds and storms. It is hot and humid, and occasionally cyclones develop, but most wind comes from the northwest.

To avoid the hazards of cyclones people frequently used to move away from the coastal region at this time.

Food fruits can be difficult to locate but the white dragon tree provides sweet nectar and attracts native bees.

Many animals, such as flying foxes, are breeding and can be eaten.

In the south the green turtles are nesting and laying eggs, and along the tidal rivers the saltwater crocodile is nesting – these nests can be raided for the eggs.

After the Wet there is a hot transitional period between March and April. Winds are light, tending from the east. The cane grass dries rapidly and needs to be burnt so the people can move through the bush again. On the coast the white mangrove is in fruit and lizards are fat and tasty.

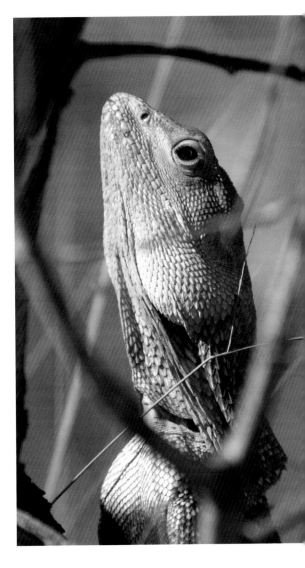

Frill neck lizards are a food source
Overleaf:
Thunderstorms herald a change of season

In May the winds back to the southwest. In waterholes, the lilies can be harvested for their roots and seeds, the jacanas are nesting and the nights begin to get cool. On the islands the seabirds are nesting and their eggs are fresh. The country is burnt by people to allow movement through the bush and aid hunting and the frill-necked dragons hide in the trees.

The dry season is between June and August. It gets cold at night and the wind can be strong from the east and southeast. Sometimes there is fog near the coast and the constellation of Scorpio is bright in the early evening, with the Pleiades dominating in the hour before dawn.

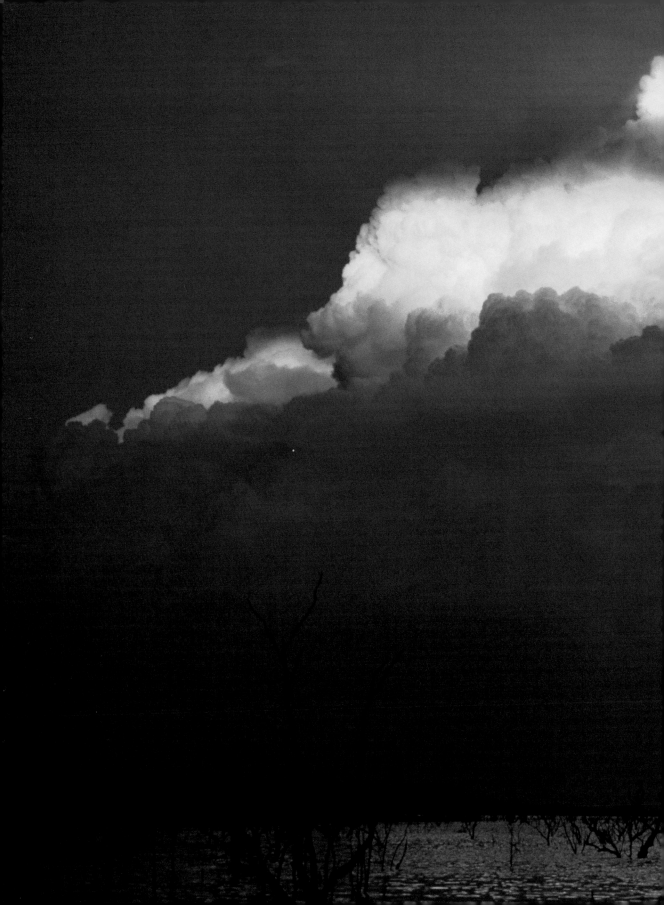

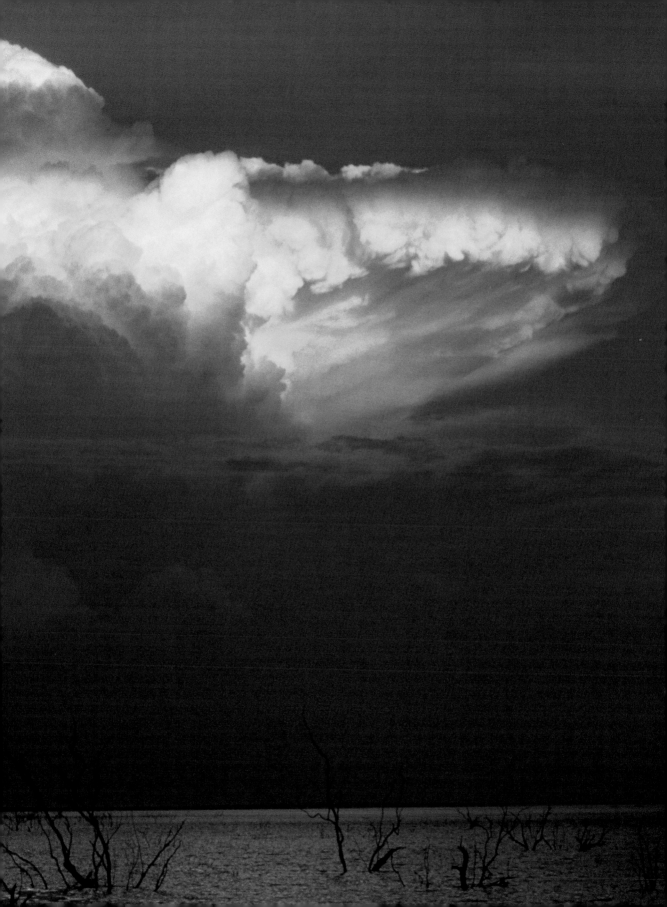

Fishing around the coast is good and the fish are fat. Wallabies have been feeding on the new growth following the fires of April and May, and during the day they rest in the sun. The cockatoos begin to nest, as do the freshwater crocodiles, whose eggs are rich and tasty. On the stony hills the cotton bush is flowering – these flowers can be eaten.

Another transition occurs in August and September, with the return of the west winds. The days and nights get warmer and more humid. The flying foxes concentrate around the waterholes and along tidal rivers where mangroves are flowering and the crocodiles try to catch them, launching themselves from the water as the bats leave their camp at dusk.

The cockatoos and the red-wing parrots are feeding on the seed of the acacias, the lizards are skinny after the cold of the winter months, and the flatback turtles finish nesting in the north. The range between the tides is very high.

October to November is the build-up to the Wet season. The winds begin to strengthen to the northwest and northeast. The boab trees grow leaves, and with the first rains come the flowers that are full of goodness.

The days grow hot and the green ants brace their nests. Powerful storms build over the water; in the desert the spinifex begins to seed and the bilby is breeding and hiding in the ground. Insects are plentiful and the young crocodiles are fat from eating them.

Mankal	Ngalandany	Iralboo	Bargana	Jalalay	Lalin
Monsoon/ Wet	No fruit	Big tides Much fruit	Cold time Winter/east winds	Big tides Good fishing	Hot/humid Green turtle mating
Mid-Dec– January	February	March– mid-May	Mid-May– July	August– September	October– mid- December

Summer		Autumn		Winter		Spring	

Calendar based on Bardi (west Kimberley) seasons *(adapted from Keneally, Edinger and Willing 1996)*

The concept of seasons as understood by Aboriginal people is based upon a knowledge of the natural systems around them. These systems have been observed

Green ants build nests to survive tropical storms

and understood, and that understanding has been passed on to succeeding generations through physical recordings such as rock art, petroglyphs (rock carvings), tree carvings and verbal storytelling.

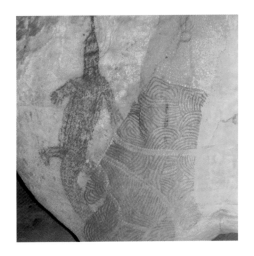

In some years these events do not occur as described, or if they do, it is only for a short period. Whether they do or not, for these relatively nomadic and mobile people it has always been important to understand the seasonality of their environment to help predict the sources of food and shelter.

Gudjewg	Bung-gereng	Yegge	Wurrgeng	Gurrung	Gunumeleng
Monsoon Profusion of growth/ good fishing	'Knock'em down' storms	Violent storms Cooler but still humid Fires begin	SE winds Fires Estuary fishing	Hot and dry Sharks and rays fished	Hot and humid pre-monsoon Winds swing wildly Thunder and lightning
Late December– end March	April	April– mid-June	Mid-June –August	September	October– late December

| Summer | Autumn | Winter | Spring |

Calendar based on Gagadju (Kakadu) seasons *(adapted from Johnson 1998)*

Because they were primarily nomadic, they could not afford to rely on one particular event to satisfy their requirements – it was imperative that they knew the location and uses of valuable items throughout their tribal lands.

The cyclical resource indicators that Aboriginal people understood through their close ties to their land show not only their understanding of the natural systems but also their desire to survive. Exploitation of these resources was a major component of achieving that.

Aboriginal rock art depicts food resources

41

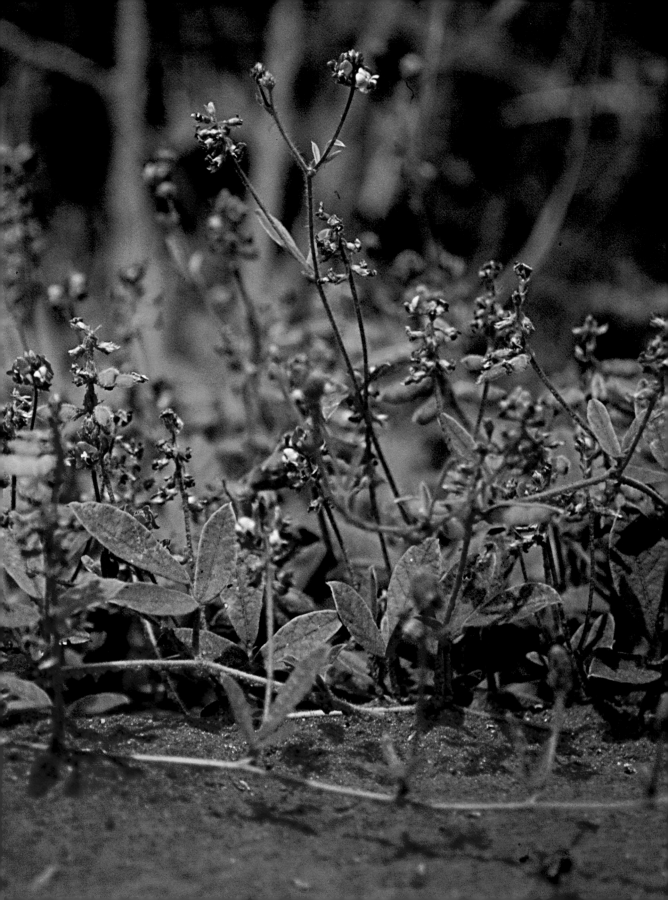

Summer (December–February)

From a European perspective, in the southern hemisphere the date of the start of the seasons is often chosen to start on the dates of the solstices (summer and winter) and equinoxes (autumn and spring). Alternatively, the start of a new season may be associated with the first day of the month (December, March, June and September) in which a solstice or equinox occurs.

cosmos.swin.edu.au

Solstice: From Latin *sol*, the Sun, and *stilium*, to stand still. The time when the Sun is at its greatest distance from the equator, and when its diurnal motion in declination ceases. In the southern hemisphere the summer solstice occurs on 22 December and the winter solstice on 21 June.

Equinox: From Latin *aequus*, equal, and *nox*, night. The precise time when the Sun crosses the equator making the day and night everywhere of equal length. The spring equinox occurs around 21 March and the autumn equinox around 22 September.

By December the rainy season can be well underway in the Kimberley. In the north and east, storms have dumped rainfall across a wide area of the region, particularly near Kalumburu and Kununurra. The response in the bush is instantaneous – areas

Woolly glycine (Glycine tomentella)

43

that were devastated by fires earlier in the year spring into growth.

With the loss of trees and understorey plants in fire-ravaged areas the grasses explode, carpeting large areas with lush growth. The conundrum here of course is that these areas will be the first to burn next year, continuing the cycle of devastation and increasing the area dominated by grass – this comes at the expense of many other unique species and results in habitat loss for many animals.

As rainfall increases the run-off begins. The major tidal rivers will swell with the input of fresh water from their catchments. Slowly the flow increases, carrying masses of nutrients and sediments that will provide food for creatures downstream and contribute to physical changes in the channel systems of the rivers.

The major rivers of the region show their capabilities. The falls on the Mitchell River, the King George and the Berkeley flow brown with 'caffe latte' foam, dumping millions of tonnes of fresh water into the tidal basins.

Mangrove communities can be devastated – they can be uprooted by the massive flow volumes. Experienced female salties anticipate this and build their nest mounds above the flood level; first-timers may lose all.

This is a time to view the Kimberley from the air, as roads are no longer accessible.

The visual contrasts that can be experienced from the air include the moisture-laden black algal growth over the creams and yellows of the underlying sandstone rocks, the intense greens of the resinous spinifex grasses and the multitude of hues of the thousands of plant species that have burst into life throughout the region.

An insect familiar to most Australians – the cicada – heralds the first rains of the tropical summer. In towns and communities throughout the Kimberley the strident call of these fascinating creatures resonates in the ghost gums and other trees and shrubs as they prepare for breeding.

In the heat of the day, at dusk and into the night, the singing males attract females. After a brief courtship, mating commences. Life is not long for these creatures – they survive for up to 6 weeks, but only if conditions are perfect. In their nymphal stages cicadas feed by piercing small roots and sucking up sap through their needle-like rostrum (feeding tube).

The Kimberley is home to several species with fascinating names: the green whizzer (*Macrotristria intersecta*), the northern double drummer (*Thopa sessiliba*) and the typewriter (*Pauropsalta extrema*), for example.

Male cicadas produce their unique song through an unusual structure called a tymbal – a ribbed membrane located on either side of the abdomen. Although the noise created by these creatures can often be deafening to the uninitiated, cicadas are an integral part of the habitats of the Kimberley and their sound is one that most Australians identify with the coming of summer.

Following tidal rivers by air will allow massive waterfalls to be seen, as the tonnes of

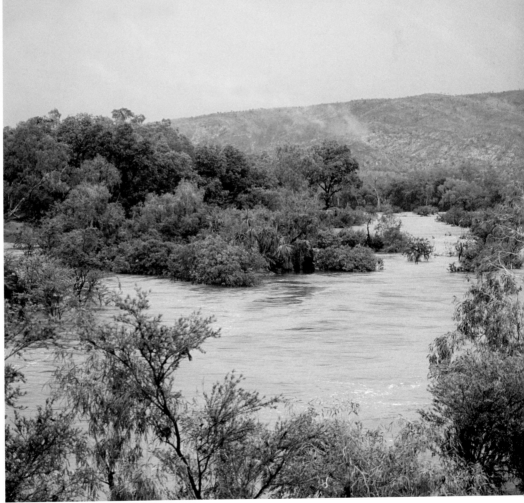

Top: Cloudburst over Carr Boyd Ranges (south of Kununurra) Bottom: Flooded rivers are full of sediment and nutrients

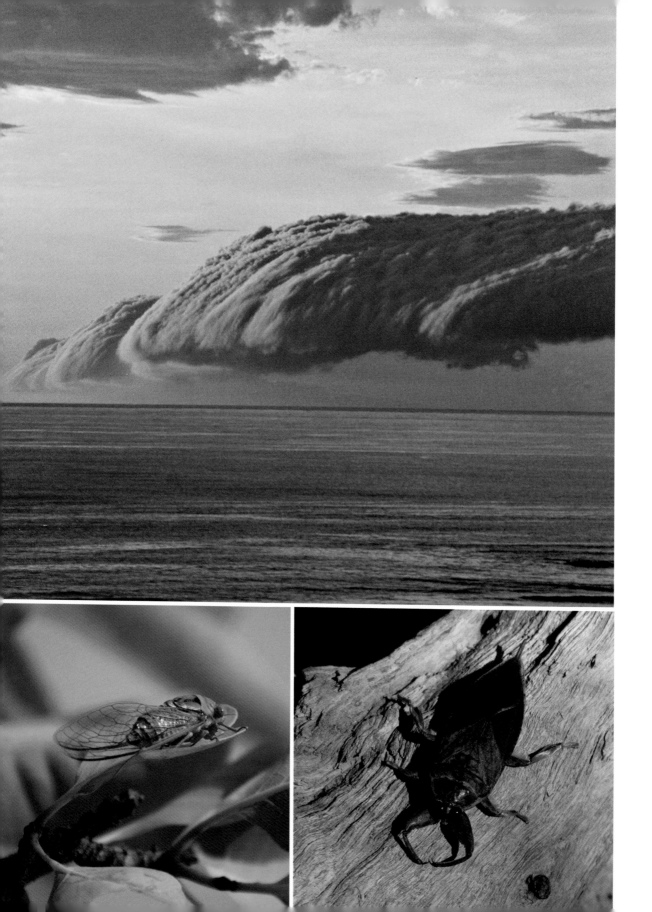

wet-season rain cascades down from the surrounding plateaus.

It will be several months before these rivers return to their gentle undulations; in the meantime they flush millions of tonnes of sediment into their basins, contributing to nutrient deposition and scouring new channels through last year's sediment.

Maturing male barramundi are migrating downstream on wet-season floods to meet with the females at the spawning grounds.

In between the tropical lows that can cover the sky with low cloud and drop daytime and nighttime temperatures dramatically are spectacular Kimberley sunsets.

Water vapour suspended in the air as clouds can form incredible patterns in the afternoon sky and the resulting sunsets are stunning. Liquid gold, volcanic red – the superlatives are endless.

In the Kimberley, as in most of northern Australia, January is the time when temperatures consistently hover around 38°C (the 'old' century mark). There can be a pause in the rain as the country is heated and humidity increases with the evaporation of moisture.

Travel at this time can take its toll on man and his machines. This break in the rainfall can also cause the concentration of cattle and wildlife along the road verges of the major roads. Between Broome, Derby and Fitzroy Crossing many animals take advantage of the new growth of grasses that results from the water-holding ability of these areas, and here they present a collision danger to travellers.

In the south, on the sandy beaches near 'Eco Beach' and Cape Villaret and on the offshore islands of the Lacepêde Islands, the nesting of green turtles is well underway. In common with other marine turtles, these animals return to the same nesting beach year after year to excavate their sand chamber nests, lay their egg clutches and run the gauntlet of predators and weather conditions.

Many tropical freshwater species, such as the Ord River turtle and the northern snake-necked turtle, are also breeding and nesting at this time of year – their strategies are similar, but the substrate they use is generally soil, not sand.

The irrigation channels and grassed parklands adjoining Lake Kununurra and the Ord River have become attractive nesting areas for these ancient reptiles.

The flying foxes have dispersed throughout the region. These animals follow the flowering cycles of many Kimberley plants, and the rainfall that has fallen means there are also plenty of freshwater pools available for them to drink from.

Insect life is prolific. The giant water beetles have reached their adult cycle and are hunting through the swamps and wetlands of the Kimberley. Attaining lengths in excess of 60mm, these spectacular and voracious predators hunt for small fish, tadpoles and insects. Grasping their prey with powerful holding arms, the beetles then spear their victims with a hardened proboscis and suck the moisture from their bodies. They are called 'toe-biters' by Kimberley locals, but they actually present no

Top: Line squall off Cable Beach
Bottom left: A cicada (the green whizzer)
Bottom right: The giant water beetle or 'toe-biter' Image by Eric Steffen
Overleaf: Sunset at Lake Kununurra

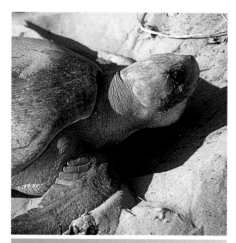

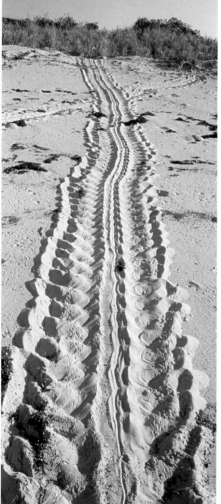

threat to humans at all – indeed they are considered a food delicacy in other parts of the world.

The north and east continue to receive regular rainfall in the form of occasional tropical lows and afternoon build-up storms.

Downstream from the Kununurra Diversion Dam the Ord River is bolstered by storm run-off from the Dunham River and the multitude of small feeder creeks that enter from the east and west across the floodplain of Parry Lagoons.

These creeks are full of life – they deposit nutrient and sediments to the main river and attract barramundi to feed on other creatures attracted to the run-off creeks.

The barramundi have recently spawned at the mouth of the Ord River where it enters the Cambridge Gulf, and the juvenile fish are congregating in preparation for their upstream migration. These juvenile fish are all males. When they are about five years old and about 60cm long they begin to change into females.

This protandrous lifecycle ensures that the millions of eggs produced by the larger females have every opportunity to receive sperm from one of the many male fish that are in constant attendance at spawning. The hermaphrodite approach occurs in many fish species; it may have developed to match the spawning cycle.

The timing of the run-off is rainfall dependent, and varies from year to year. The run-off ranks very highly among sportfishers, as many of the post-spawn

Top: Flatback turtle
Bottom: Turtles return to the same nesting beaches each year

adult fish will remain in tidal waters to feed at the run-off.

The lead-up to the run-off begins with the first rain-bearing tropical low-pressure system. That rain inundates the northern parts of the Kimberley plateau. The soil quickly becomes waterlogged, and as more rain falls the run-off begins. Across the top of the Kimberley, sub and surface water streams from high ground to low. As this water reaches drainage lines it forces masses of debris, sediment and nutrient before it. Tumbling and roiling, the water builds up speed as it approaches the coast, meeting other streams and eventually coalescing into the main river drainage lines.

The sheer volume and force of the water erodes river banks, undermines mangrove forests and realigns channels as it makes its way into the bays and estuaries around the Kimberley coast.

All across the region waterfalls have burst into life. A flight over the spectacular Carr Boyd ranges adjacent to Lake Argyle will show all sorts – from small zephyr-like falls through to raging, thundering torrents falling several hundred feet. The icon waterfalls of the Mitchell Plateau begin to build in intensity while further northeast the 80m twin falls of the King George River turn the river waters beneath them to a 'cappuccino' consistency.

Around the coast the ever-present sandflies are swarming in the mangroves. This burst of new life means increased activity among the many animals that provide blood meals for these almost invisible predators. These insects, like their mosquito cousins, do not discriminate – mammals, reptiles, birds and other insects are all fair game to them.

Statistically, February is the most common time of the year for cyclonic weather events to impact on the Kimberley coast. These events are the lifeblood of the region, because they bring massive amounts of rainfall to a part of Australia that is climatically classified as the dry tropics.

Intense localised thunderstorms are often encountered. These are characterised by their visually stunning line squalls and other cloud formations, and their strong, damaging winds.

During this short period of the year, perhaps up to three-quarters of the annual average rainfall will fall. In good rainfall years, many plants and animals take advantage of the widespread and consistent downpours.

Broome Airport	Derby Airport	Fitzroy Crossing	Halls Creek Airport	Kununurra Airport	Wyndham
599 mm	622mm	541mm	557mm	793mm	771mm

Kimberley major towns' mean rainfall averages to nearest millimetre *(Bureau of Meteorology 2004)*

Across the region many eucalyptus species burst into flower. Dampier's bloodwood produces masses of waxy shiny clusters of flower buds. As the flowers emerge, a vast array of insect and bird life arrives, attracted to the nectar produced. Flocks of red-collared lorikeets bring their specialised brush-like tongues into play, lapping nectar and transferring huge amounts of pollen between trees.

Honeyeaters flit and swoop through the flowers taking sweet sugary nectar and insect pollinators in equal abundance. At dusk the strong flying and robust hawk moths of the genus *Hippotion* hover and flutter around the same trees, feeding and transferring pollen while staying alert for predatory bats.

The floral diversity of the Kimberley is coming into its best at this time of year. On the pindan there are multitudes of ground-hugging creepers displaying flowers with colours including bright yellow, soft mauves and blues, white and dark crimson, all providing a contrast to their green carpet-like growth.

A secondary flowering event of some species occurs as the increased rainfall allows for an extra spurt of floral production. Native jasmine and gardenias fill some bush areas with their rich heavy perfumes and swamp paperbarks produce pendulous racemes of rich creamy flowers that attract birds, bats and insects.

Many biting insects frequent the Kimberley at this time. There are the sandflies that seem to proliferate during the humid weather and the mosquitoes

Red collared lorikeets are nectar feeders

that range in size from small annoying midge-sized creatures to the spear-shaped members of the malaria mosquito family and the great orange and brown-banded people movers of the lower Ord River – these can be over 10mm long!

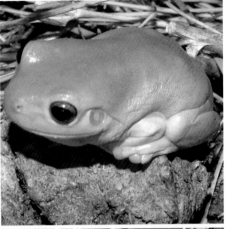

There are click beetles (*Elateridae*) that produce evil-smelling deterrents when disturbed, and multitudes of moths and beautifully patterned butterflies, all of which emerge at this time of the Kimberley year to take advantage of the profusion of plant displays.

With so much water about, the green tree frogs that have inhabited the human homes during the 'build-up' (October–November) have gone back to their preferred environments – low-lying areas and the moist humid leaf litter of the remnant bush that still surrounds many Kimberley communities.

There is movement in the reptile world as well. Saltwater crocodiles are still breeding if the season is warm and wet enough; some females may even be producing their second clutch of eggs if conditions have been suitable.

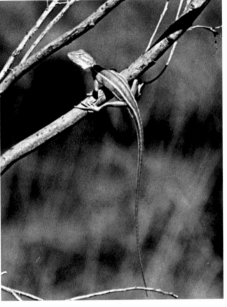

The monitor lizards (*Varanidae*) are stalking the bush lands, watercourses and spinifex plains searching for other hatching family members, such as the 'TaTa' or Gilberts dragon, or birds' eggs, or the carrion of creatures that have succumbed to the conditions.

Road travel is difficult, with the black soil impassable and the pindan turning to the consistency of slurry. This is a time to stay on the bitumen or seek other methods of transport.

*Top: Green
tree frog
Bottom: Gilberts
dragon*

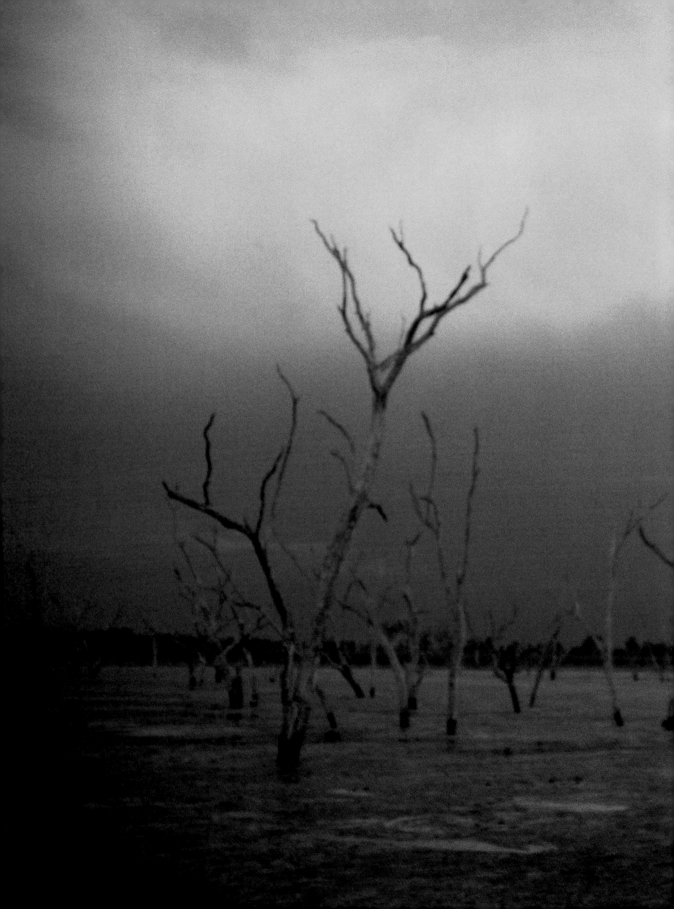

Tropical revolving storms (cyclones)

Cyclones are a fact of life in northern Australia. But what causes them, and are there warning signs that one may be developing?

One indicator that can be useful when predicting the likelihood of cyclonic activity is the presence of water vapour in the air. We recognise this vapour as humidity, and over a period of several days during the tropical summer it is possible to appreciate just how much vapour can be held in the air around us. The air basically acts somewhat like a sponge, and the warmer the air is, the more vapour it can hold.

As the ground loses some of its heat during the night this suspended water vapour condenses – it can often be seen as dew in the morning.

Water vapour is possibly a mainspring for the development of cyclones. There are also other indicators, of course, including sea surface temperatures. Basically, the higher these are over an extended period of time, the greater the likelihood of a cyclone developing. And high sea surface temperatures, of course, contribute to the creation of water vapour.

Cyclones 'breed' in equatorial regions where there are a number of comparatively small mountainous islands (such as the Indonesian Archipelago). It is suspected that these island areas are much hotter during the summer day than the surrounding areas, and so help create imbalances in very humid atmospheres.

Soon after tropical low systems develop in these areas, they begin to move westward, revolving in a clockwise direction. This movement brings them under the influence of the Earth's rotation, which has a recurving effect, which means the developing cyclone tends towards the southwest.

Lurid sky is an indictaor of tropical low systems

55

The recurving effect may not be particularly strong in the initial stages, and the cyclone may move parallel to the northern Australian coast for a 1000 kilometres or more before it turns towards the coast.

In February of the year 2000, tropical cyclone Steve formed off the north coast of Queensland. Over the next 14 days it travelled across northern Australia, degrading and reforming. Steve travelled southwest along the Western Australian coastline, eventually crossing just south of the Gascoyne town of Carnarvon.

The degraded rain-bearing depression that resulted continued on a southeastern path through the goldfields and eastern wheatbelt and eventually departed Australia east of Esperance into the Great Australian Bight.

Other cyclones develop east of the continent among the islands of the South Pacific; these ones recurve clear of the Queensland coast or crossing it, bringing floods and wind damage.

Occasionally a north Australian tropical low may be forced into the Gulf of Carpentaria and there develop into a cyclone.

Cyclonic weather systems require massive amounts of water vapour to maintain their intensity and this can only be gathered from the sea (although there is an opinion that moisture dropped by the tropical lows over land is often evaporated back into the mix).

At the centre of these storms is the 'eye', where there is little or no wind; what can be found here, though, are huge seas, created by the powerful swirling winds of the outer reaches of the storm.

Large numbers of seabirds can also be found here – they take the line of least resistance and the winds spiral them into the centre. Land birds and insects usually associated with drier areas can also be carried vast distances offshore during these events, as they go with the wind.

After a cyclone crosses the coast it begins to 'dry up', because it is then denied access to the masses of water vapour required to maintain its existence. As it continues to move into the dry interior it spreads out and dissipates, dropping masses of accumulated water vapour as monsoonal rain over hundreds of square kilometres.

To get an idea of the weight of water a cyclonic system can support, we need only remember that 25 millimetres (1 inch) of rainfall over 0.4 hectare (1 acre) is equal to 101 metric tonnes.

There are a number of other natural indicators that can also suggest that a significant weather change is imminent.

Buy's Ballots Law can be used to determine (approximately) the direction of the centre of low pressure commonly referred to as the eye of a cyclone. In the southern hemisphere an observer with his face to the wind will find lower air pressure on the left hand side and higher pressure on the right hand side of his body (opposite in

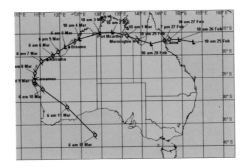

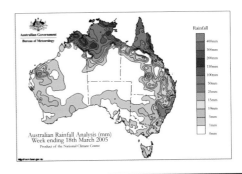

Australian Rainfall Analysis (mm)
Week ending 18th March 2005
Product of the National Climate Centre

Rainfall
400mm
300mm
200mm
150mm
100mm
50mm
25mm
15mm
10mm
5mm
1mm
0mm

wind direction

rising barometer
(high pressure)

90°

110°

falling barometer
(low pressure)

Buy Ballots Law

1. Face into the 'true' wind direction

2. Place left arm perpendicular to your body (90°)

3. The approximate location of the cyclone eye is between 110° and 90°

Top left: Track of tropical cyclone 'Steve'
Top right: Rainfall chart for tropical cyclone 'Ingrid'
Bottom: 'mackerel clouds' (scary sky!)

57

northern latitudes). If you stand and face the wind with your left arm extended at 90 degrees perpendicular (at a right angle) to your body, the approximate location of the cyclonic eye is within an arc extending from your arm to 110 degrees ahead. This technique can indicate whether the cyclone is still offshore or is tending towards or crossing the coast.

Changes to the size and direction of sea swell on the Kimberley coast can be used to forecast weather changes. If a cyclonic system is developing, increased swell rolling in from the northwest and surface 'glass off' conditions (where the sea assumes an almost oily appearance) can quite often be experienced up to several days before the system is fully developed.

Birds become less active and many coastal species tend to move inland some distance. Unusual insect and bird species (for the area) can be forced ahead of the system by extreme high-altitude winds, so their presence can indicate the imminent arrival of unusual weather activity. Vessels operating far offshore often receive a warning of unusual activity when insects, particularly moths, suddenly begin to fall from the sky. They have been carried into these offshore areas by the high-altitude winds associated with a developing storm.

Cirrus clouds generally precede these tropical storms. They are sometimes referred to as 'scary sky' in the Kimberley. If these clouds stretch in converging streaks or bands and the formation remains visible from a fixed direction, it is a fairly good warning that there is a storm approaching, and that its centre lies in the original direction of the convergence. Often there are also lurid or coppery sunsets and sunrises.

The weather can become very oppressive, with sultry humid conditions. Even our blunted instincts can detect that all is not well.

The reduced air pressures associated with cyclones can cause one of the most dangerous of the events associated with them – storm surges. The main cause of storm surge is wind stress on the sea surface. This, when combined with the lower pressure, allows the sea to rise by about 10mm for each hectopascal of falling pressure.

A number of factors, including underwater topography, the shape of bays and estuaries, the state of the tide, currents and the angle of approach of the cyclone to the coast can affect the height of water impacting on the coast.

In a Kimberley scenario where an area is subject to an 8 metre high tide, a cyclonic storm surge could increase the height of tidal influence by 50 per cent – the height of the surge could then be up to 12 metres.

Although there is some debate about this, the phases of the moon may also have some bearing on the intensity of cyclonic systems. After all, both the Sun and the Moon have a gravitational effect on the Earth's atmosphere.

At full and new moon this effect is at its greatest. There is some evidence that

Lightning is often associated with tropical low storm systems

points towards cyclone systems wandering somewhat and tending to remain at sea between the full and new moon.

Though a study of records (from 1907 onwards) shows that some cyclones in northern Australia have occurred as late as May and as early as August, most occur between December and March.

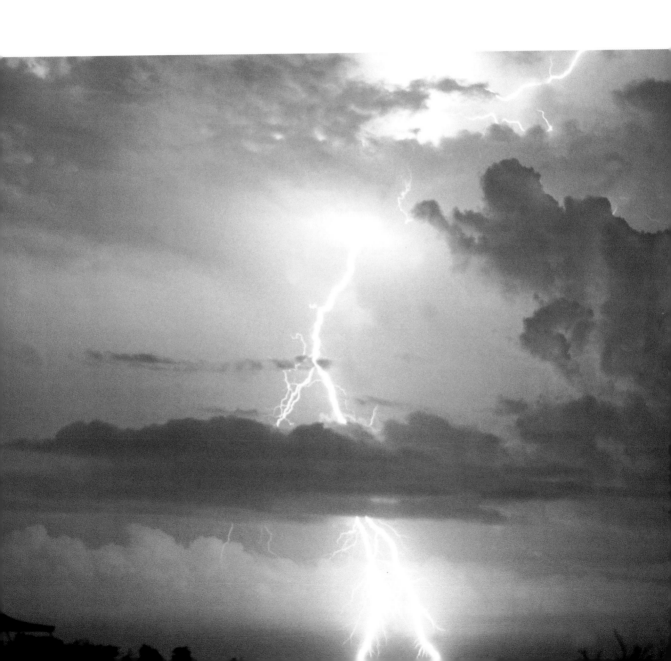

Autumn (March–May)

The masses of rainfall that have fallen on the Kimberley during February and March have inundated the catchments. Rivers are flowing fit to burst their banks and there is a massive replenishment of nutrients going on across floodplains in the lower reaches.

With this amount of rain having fallen, temperatures begin a subtle change. The heat and humidity experienced only several weeks before are reduced, and this general cooling of the land begins to affect the weather patterns.

Periods of rainfall are less common now, and although there are still frequent electrical storms, they are becoming more isolated.

The weather patterns in southern Australia begin to have more of an impact on the Kimberley, with high-pressure systems pushing northwards onto the landmass and bringing drying winds to the region.

These first easterly winds are associated with a number of localised events.

Dragonflies, particularly the all-red males (*Diplacodes haematodes*), arrive in large numbers several days after these wind events begin. These insects epitomise the changing of the seasons. Thousands of them hunt for small insect prey and a mate to breed with in the temporary wetlands created by the rains of the wet season.

But this is not the end of the rainy season. In most years the arrival of the dragonflies indicates that there will be at least one more major rain event.

In the bays around the coast the giant threadfin salmon and blue nose salmon are beginning to mass in large numbers and it is a time of plenty if a fisherman can reach them with carefully cast lures or presented baits.

A gomphrena flower

The run-off from the surrounding land is beginning to diminish, and the damage to the mangrove forests and the changes to the tidal channels become more obvious.

In the north, jelly prawns begin to mass in the tidal bays and estuaries and schools of juvenile giant trevally, queenfish and the salmon erupt in feeding frenzies when they encounter the prawns.

The saltwater temperatures are still high enough to encourage the movement of the dangerous Cnidarians – the chironex box jellyfish and its smaller, less visible, yet equally potent cousin, the irukandji.

It is a dangerous time to swim or wade in the ocean, as these creatures, being translucent, are almost impossible to see. Jellyfish have been implicated in a number of human deaths across northern Australia and every year an unwary pearl diver or surfer or an unprotected swimmer at Cable Beach, near Broome, suffers the excruciating pain caused by the venom delivered by the nematocysts (stinging cells) in the jellies' tentacles.

In the west the scent of jasmine is thick in the coastal vine thickets and the unusual aromas of the mustard bush and hyptis waft through the air. The plume sorghum has grown to more than two metres in height and is now topped with masses of russet brown seed heads.

This species is often found in association with vehicle tracks, as it is transported around the Kimberley in car radiators and the screens placed across them.

Grass growth across the region is phenomenal, with several native standouts and several unwelcome exotics competing for the same resources.

The many species of spinifex grasses are heavy with seed on the pindan and sandstone formations around the coast, and south and west into the more arid zone of the desert margins.

Exotic species such as the aptly named spiny burred Gallands curse and the sole-piercing caltrop have run rampant. Many exotic grasses were introduced into the Kimberley by the cattle industry.

The most common method involved aerial seeding – flying light aircraft over the region and dumping masses of viable seed to provide food options for cattle.

This approach, with industry and government support, was still occurring as recently as the mid 1990s. Combined with man-influenced changes to traditional and natural fire regimes, it has ensured that exotic grasses will be a part of the Kimberley forever.

The horticulture trade, government departments and uncaring individuals have also introduced many other exotic plants.

As cloud-filled heavens become less common, during April, in the northwest evening sky it is possible to make out the pointer stars to the North Star and the long curving spine of the constellation of the Great Bear (Ursa Major). The constellation

Left: Sorghum grasslands are widespread in the Kimberley
Right: Dragonflies (Odonata sp.) are indictaors of seasonal change

of Scorpio is high in the west near sunrise. Nighttime temperatures are becoming milder, but there can still be high humidity during the day.

There are usually only light winds, and usually they are in the form of sea breezes that come in with the tides in the afternoon. As the month progresses, easterly breezes become more common, but there is still a good chance of late season thunderstorms that can bring localised heavy rain and squally winds.

The dragonfly species that first appeared several weeks ago have increased to even greater numbers. Using their legs to form catching baskets, they hover and swoop to collect moths, mosquitoes and a range of other flying insects; in return, they are a food resource for spiders, geckos, skinks, birds and bats.

Boobook owls move back onto the unmade roads to hunt insects over open ground in the evening. During the day blue-winged kookaburras hunt snakes and lizards over these same clear areas and birds of prey such as the brown falcon and black kite stoop and dive, catching insects, small reptiles and fledgling birds.

There are many juvenile birds of different species learning their craft at this time of the year and there is an ample food available to them – the seed-eating hardbill birds, including the various finches, are well catered for by this seasonal cycle of grass growth.

Many adult birds in the wader group are moving north along the coast. These birds are departing the southern hemisphere to return to their breeding areas for the northern hemisphere summer. Not all will fly north, though. Many juvenile birds will remain in the region for a year or more before following the adult rhythms.

On many offshore islands large concentrations of boobies, terns, cormorants, egrets and herons are beginning to pair and mate.

On Aunt and Uncle Islands near the Berkeley River, lesser-crested terns perform pairing displays; at the same time, in the waters around Montgomery Reef the spotted eagle rays are also showing interest in breeding.

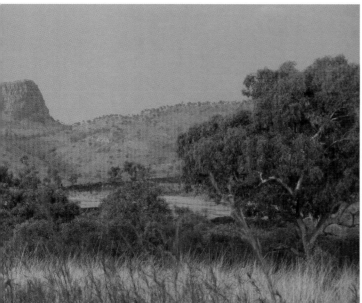
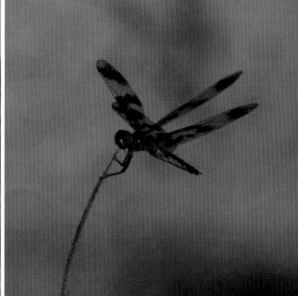

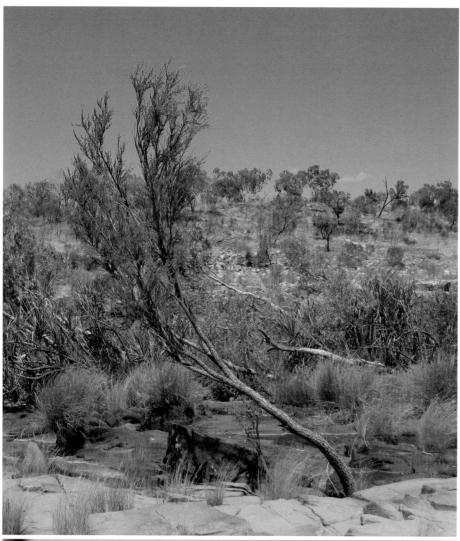

*Top: The aptly
named bendee
(Terminalia
bursarina) reflects
the power of floods
Bottom: The rainbow
bee-eater is another
indicator of change*

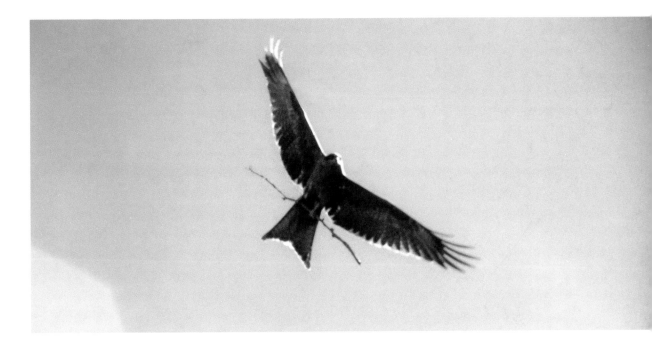

The geckos are fat from the wealth of insect food available during the warmer months and as water recedes from the flooding rains the bendee tree, which almost always grows in the beds of rivers and creeks – especially where there are rock and sandy areas – begins to reappear. The trees get their name from the habit of 'bending' downstream due to the action of floodwater.

The temperature and moisture convection effects begin to produce fog and mist, particularly near the coast and in the southwest of the region. Because there is now a lack of rain, these fogs and mists become very important for a range of animals and plants.

Dingoes will lick the dew resulting from fog from young grevillea trees, and the small poverty bush, an acacia species, is heavily in flower on the sand country which has been protected from regular fires.

The Kimberley Christmas tree (silky grevillea) has spectacular golden inflorescences high in nectar, and is popular with insects and birds. Following good rainy seasons it flowers early in April through to July, particularly in the medium and higher rainfall areas of the region.

Black kites arrive in large numbers for the burning season

Rainbow bee-eaters gather in large aggregations. These gloriously coloured members of the bird family produce a concerted trilling call as they hunt in flocks across the towns of the region or in pairs for insects. As their name implies, they do impact on bees, both native and introduced, but they also control masses of other insect species, a benefit which is often not understood.

The bush is green and lush, with large concentrations of pink bachelors buttons heavily in flower over stony and well-drained country and strongly aromatic herbs profuse around watercourses.

Following good seasonal rain the long-fruited bloodwoods begin to produce masses of creamy white flowers that are attractive to a range of birds and insects. Large flocks of red-collared lorikeets, honeyeaters and insectivorous birds descend on this food resource and help spread its genetic material (pollen) among the trees.

As the trees begin to produce fruit, following this wave of bird activity, the next wave of birds arrives. These include corellas and red-tailed black cockatoos, which have followed seasonal prompts and migrated within the region to reach the Dampier Peninsula in time to exploit this food resource.

In the summer of 2004, there was good rain across the Kimberley, which led to an extended flowering of the bloodwoods. However, nature has a way of throwing the odd spanner in the works, and a late season cyclone (Steve) blasted the flowering eucalypts with winds in excess of 140 kilometres an hour – these stripped the vast majority of the trees of their flowers before the pollen set and they could begin fruit production.

The result, during 2004, was that many species that typically concentrated on this resource were forced to disperse across a much larger area, and viewing these magnificent birds became difficult.

Around the coast was further evidence of the power of the winds associated with this event, with many trees also being stripped of their bark.

Low-lying areas inundated with water during the Wet are where the plants that eat flesh live. There are carnivorous sundews, with their sticky trapping liquid-covered foliage, and bladderworts, which have vacuum-like traps that operate below the surface and suck small earth-swimming creatures into their digestive chambers. These plants have intricate and beautiful flowers in pinks, mauves and yellows and they are often home to insects of the *Setacoris* family, which appear impervious to the sticky liquids that so often trap their cousins.

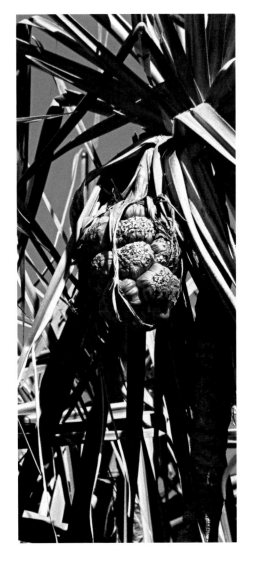

Left: A sundew (Drosera broomensis) *Right: The fruit of the screwpalm* (Pandanus aquaticus) *changes to red at the end of the Wet*

May is a transitional month – early in the month the planet Venus can easily be seen in the west just after sunset, with the outline of the Southern Cross in the southeast. The weather is becoming balmy and there is generally little wind. It is a great time to view the Kimberley, as there are still raging waterfalls about; there may also be the occasional thunderstorm, particularly in the north and east. The country is green and the fishing can be sensational.

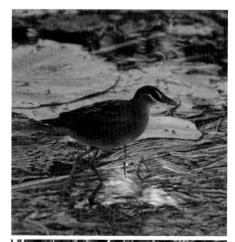

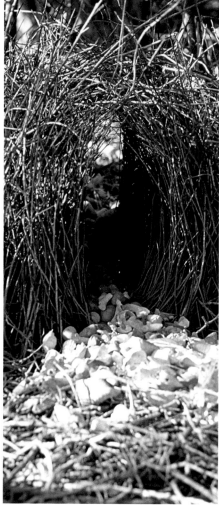

Many plants are still flowering and fruiting, particularly the long-fruited bloodwoods in the west. Around the coast the pandanus fruits are beginning to change colour. These plants are a good seasonal indicator – Aboriginal people use them to identify the onset of the cooler weather. The seeds change from a dark green to an almost scarlet red when the drying easterly winds that are common across the region arrive.

Cattle egrets migrate to the freshwater wetlands in the east and breeding and nesting has been recorded at Lake Kununurra, one of the few areas in Australia that caters for these birds.

Other juvenile birds associated with wetlands can also be seen more regularly – rufous night herons, comb-crested jacanas, Baillons crakes and white-browed crakes. Around the coast and next to suitably sized bodies of water the ospreys or fish hawks are building new nests or adding to existing ones.

Usually placed on a headland or high vantage point, these nests can be many years old and present a formidable tower from which the osprey can observe the happenings within its territory. This species nests extensively in the Kimberley, and by late June the osprey chicks will be hatched. They then work through the processes of sibling rivalry ... until eventually only one chick per nest remains.

Young birds of all species are active in May. The melodious calls of the pied butcher birds resonate through the woodlands, and early in the month the

Top: White-browed crakes feed across mats of floating vegetation Image by V Hayden
Bottom: The 'bower' or display stage of the great bowerbird

great bowerbirds are actively hunting insects and drinking the early morning dew from the coastal vegetation.

Their bowers will have required some repairs following the late season storms of April. They also need display items, and the males are meticulous with the placement of these items – this is a labour that is aimed to attract females.

There is still a chance of hot, humid days but the nights are pleasant. Green tree frogs move back to the houses they vacated when the rains were constant – as do the insects that are the frogs' primary attractant.

The house geckos are active, and all over the Kimberley their strident barking calls warning off territorial thieves pierce the night between the subtle calls of the tiger crickets (*Endacusta* sp).

Well-fed dingoes are frequently seen during this month and they vary in size and colour from the west to the east. Soon their pups will be moving from the den-holes – in more traditional times, the Southern Cross rising in the east was an indicator that it was time to search out the dens and collect young pups for food and training.

The vegetation that thrived during the rainy season is beginning to dry and sour and fire is used by traditional people to knock this dying growth down and allow walking access. The fires at this time trickle and burn cool, allowing the native trees and understorey a chance to re-establish themselves before the parching dry season winds arrive from the east.

The new growth or 'green pick' that appears after the burns is popular with wallabies and wild turkeys, and the insects that are a valuable food source for many creatures.

Trickle and burn fires ('cool fire') are easily managed

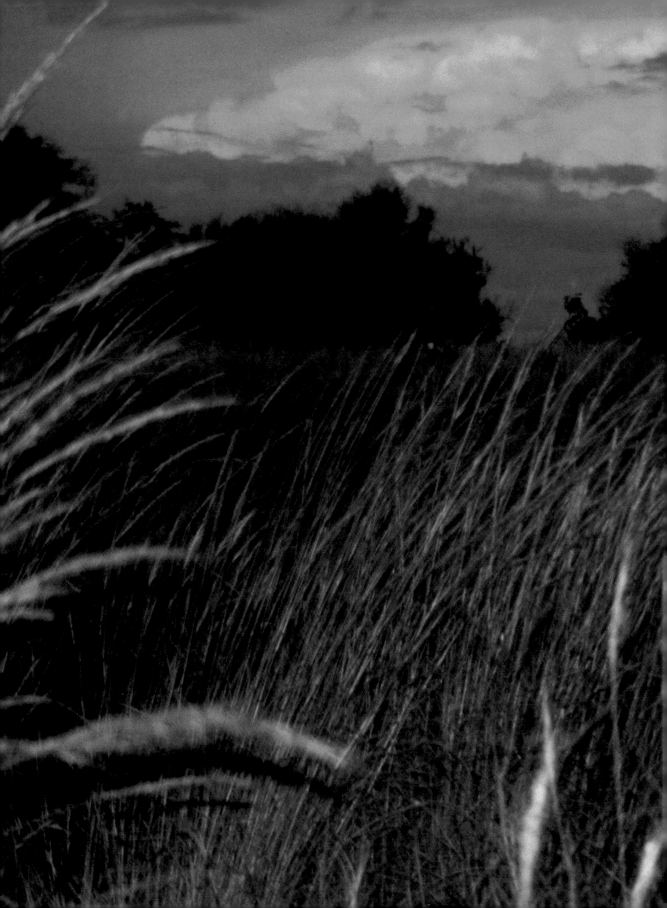

Kimberley flora – an introduction

Where should we start on a subject as diverse as the plants of the Kimberley? How much background knowledge – or, in fact, expertise – would be necessary to truly appreciate the floral wealth of this region?

If we were to approach this as a dissertation, it would probably be helpful to have some formal training in botany. But that is not the intention of this book, and there are in fact many texts that deal specifically with the Kimberley flora. The approach here has been to review the knowledge of what can be seen in various areas at different times of the year (hopefully in flower!) and there are some suggestions on what characteristics to look for so that you can eventually satisfy yourself that you have a pretty good idea of what you are looking at.

Most major reference books still speculate on the actual number of plant species that can be found in the Kimberley, but in general there is consensus on a figure in excess of 2140. Of these there are representatives of most of the major family groups, with the grasses (*Poaceae*) in particular being dominant, followed by members of the pea family (*Papilionaceae*), then the wattles (*Mimosaceae*), eucalypts and myrtles (*Myrtaceae*), and then the little 'belly botany' plants in the sedge and herb families (*Cyperaceae*).

There are few individuals who can lay claim to know them all by sight and habit but there are those who can look at an area and, through a simple assessment of habitat types, soil composition plus some knowledge of form and characteristics, have a good idea about what might be growing in front of them.

Spinifex grasses are well represented in the Kimberley

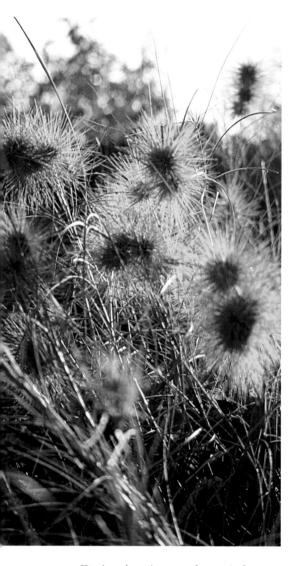

Much of the Kimberley is classified as woodland. In these areas there are trees and shrubs and a prominent ground layer of grasses. There are also plains and grasslands where trees are absent, and watercourses, rivers and billabongs that are fringed by trees, shrubs, grasses, palms and sedges. Living within the water is a suite of aquatic plants, including water lilies, carnivorous plants and aquatic grasses.

Coastal areas are particularly fascinating, with scree slopes and rocky gullies that often support small pockets of vine-thicket rainforest. In the tidal estuaries, the distinctive saline-loving plants that make up the communities of mangroves are demarcated along the upper limit of the king or spring tides.

Rainfall can vary significantly across the region, with averages from 350mm on the desert fringe in the south and east to 1500mm on the Mitchell Plateau in the northwest.

Most rain is received during the southern summer, when the region comes under the influence of the monsoon. As a consequence, the main flowering and new growth period occurs during and immediately following this period.

During the winter or dry period many species become dormant and may even shed their leaves, but it is still possible to find flowering species where there is remnant moisture and where the plants have adapted their blooms to target dry season pollinators.

Everyone who travels the Kimberley will encounter grasses. There are the spinifexes or hummock grasses that are common in a variety of habitats – on rocky sandstone and basaltic hills, on coastal sand dunes and on the drier southern plains that fringe the desert areas.

These plants are commonly of the genus *Triodia*. In the Kimberley, spinifex sets flowers for a short period towards the end of the wet season, so for the rest of the

Beach spinifex (Spinifex longifolius)

year many species are very difficult to tell apart.

Spinifexes are perennials that last for several years (some species are estimated to have been growing for several hundred years). They form large tussock rings that collapse and then regenerate. The rock spinifex is commonly found on sandstone faces and between rocks. It can form quite massive tussocks when unaffected by fire or grazing.

During and following the wet season, annual sorghum is very common over the sand and sandstone hills. It grows very rapidly up to four metres in height then produces large 'ears' of brown flowers and seeds. Following fire events, the sorghum grasses are an increaser species – they replace other plants that cannot tolerate regular or annual burning.

Mangrove communities consist of some 17 different species (not including other plants that have adapted to living in association with true mangroves) around the Kimberley coast. They are very well represented in the large estuaries of the Ord and Cambridge Gulf, the Hunter River and Prince Frederick Harbour, the Prince Regent and St George Basin and

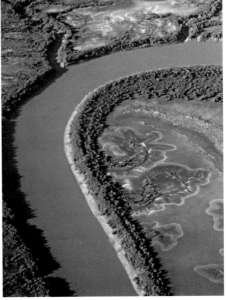

further south in the Walcott Inlet along the Glenelg River and in the upper reaches of Talbot Bay, where the salinity levels probably favour them by excluding competitors.

The most common are the white mangrove and the prop root or stilted mangrove. The methods mangroves use to remove salt and live successfully in the tidal zone include using buttressed roots for support in mud-filled tidal areas, using prop roots that help support and trap mud and silt, and using pneumatophores (aerial roots) to breathe above the mud deposits.

Some species also excrete excess salt through their leaves or their bark. Mistletoe is often seen growing on the white mangrove – it relies on the activity of the mistletoe bird to distribute its sticky seeds.

Top: the flower of the iconic Kimberley boab tree (Adensonia gregorii) Bottom: Mangrove communities dominate tidal rivers

73

Visually at least, plants of the family *Myrtaceae* appear to be very dominant in the Kimberley. If you are travelling around the coast or inland along defined roads, it will seem that eucalypts are the principal trees.

In 1995, however, this taxon was split to create a new genus called *Corymbia*. Many of the 'old' bloodwoods have now been reclassified into this genus. Bloodwoods, such as the variable-barked bloodwood, tend to have large branching arrangements of creamy white flowers. This species is a host tree for an insect that produces galls, sometimes known as bloodwood galls. These contain an edible fleshy layer that thas the texture of coconut flesh … and the small crunchy edible insect larvae.

A prominent tree found throughout the region is the northern woolybutt; on coastal

Mistletoe bird

travels it is probably the eucalypt most commonly encountered. It is characterised as a large tree – up to about 15 metres in height. The bark of the upper branches is a smooth creamy white and the bark of the lower trunk is rough brown and somewhat stringy; this species produces magnificent clusters of bright orange flowers between June and August. These provide masses of nectar to native bees and a variety of birds, such as honeyeaters, cockatoos and lorikeets.

There are about 50 species of eucalypt in the Kimberley. Traditionally these plants have been identified as groups such as the bloodwoods (now *Corymbia*), so called because they sometimes exude 'blood' or kino from lesions in the bark, the woolybutts, which are known for their obvious dark and stringy bark on the lower trunk, and the boxes, which tend to have grey bark that is finely 'scaled' and persistent over much of the tree. The most reliable method for identifying them is to check the size and shape of their fruit – and use a good reference book!

Paperbarks, so named because of the texture of their layered bark, are often found along watercourses. They are in the genus *Melaleuca*. The one most likely to be encountered is the river paperbark, which has long, narrow silvery grey leaves that flash in the sunlight and can grow to more than 20 metres in height. It is common on sandy riverbanks, particularly around Camp Creek (Prince Regent River), and along the Ord River.

In coastal and freshwater swamps, the white paperbark grows up to more than 25 metres in height. The bark has been used to make waterproof shelters and as a wrapping for food and implements. All the paperbarks are believed to have medicinal properties, and often the leaves are crushed and soaked and the resulting decoction drunk or inhaled as a remedy for coughs and colds.

Top: A paperbark (Melaleuca leucodendron) Bottom: Kino (gum) exudes from wounded trees

The broad-leafed paperbark is a small shrub when growing in open forest such as around the DC3 crash site at

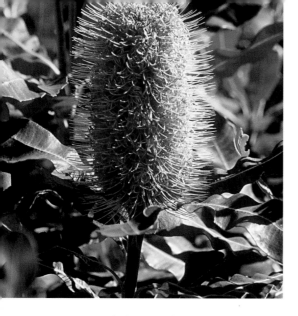

Vansittart Bay, but it can grow into a significant tree along watercourses and around billabongs.

The one tropical banksia, a member of the *Proteaceae* family, is often found in association with this species where the soil types suit. There are some fine examples at Atlantis Creek on the north Kimberley coast and near the remote fishing camp at Freshwater Cove in the west Kimberley.

Other members of this family include *Grevillea dryandri*, which has a prostrate growing habit. It is found on rocky hillsides and sandstone areas from the Mitchell Plateau to the Bow River, south of Kununurra, and the wild pear, found from the Deception Range to the Bonaparte Archipelago and south to Anna Plains Station.

The caustic bush is found in a variety of habitats from the pindan plains of the west Kimberley across to the stony hills of the east Kimberley. This plant produces spectacular floral displays and seed pods coated in a caustic material that has been used to produce semi-permanent ceremonial scarring by Aboriginal people.

There are also several species of hakea recorded from the region.

In the same family group as the eucalypts and melaleucas are the fringe myrtles in the genus *Calytrix*, commonly called turkey bush, which are found throughout the Kimberley. On coastal sandstone cliffs and watercourses and billabongs, the masses of mauve pink flowers growing on straggly shrubs up to some 2.5 metres in height help identify this winter-flowering plant. The leaves can be crushed in your hands to release fragrant oils that are believed useful as a liniment for aches and pains.

Another myrtle, *Xanthostemon paradoxus*, grows in most of the rocky sandstone habitats from Talbot Bay through Deception Bay and on into the Prince Regent River area. The flowers of this bushy tree, which grows to about seven metres in height, grow in a centrifugal arrangement, with the oldest flower central and lowest on the branch. The flowers range in colour from an orange yellow to a green yellow and they are quite distinctive during the cooler months of the dry season. Other good examples can be seen in Cyclone Mooring Creek in the upper reaches of Talbot Bay.

The white dragon tree is probably the most spectacular representative of the pea family in the Kimberley. It is a prominent tree in near-water vegetation but other members of this family are quite inconspicuous; some have an ephemeral (short-lived) form, lasting perhaps only one season. The dragon tree is a fast growing tree and its ash can be used as a topical dressing on small wounds. Its showy white flowers

The tropical banksia (Banksia dentata)

76

are edible, and are often used in Asian cooking.

Other members of the family include the rattlepods, which can be either perennial or annual plants. They have clusters of bright yellow flowers and small sausage-like seedpods. Another member of the pea family, *Paratephrosia lanata*, is a spectacular purple to mauve-flowered, silver–grey shrub found throughout the spinifex country to Wolfe Creek Crater.

Members of the *Senna* family are frequently encountered – *S. venusta* is often seen along roadsides, as it loves sandy and somewhat disturbed areas. The bright yellow flowers occur between June and September.

One of the most easily identified and most well-known relative of this group is the bauhinia, or mother-in-law tree. It is found on a range of soil types from the near coastal pindan around Broome to the heavy black soils associated with the Ord River floodplain. It is a good indicator of fresh water. This common name originates in the west Kimberley and refers to the arrangement of the leaves, which are butterfly-like, two-lobed, and back to back – reflecting the back-to-back non-speaking association mothers-in-law and sons-in-law have in some Aboriginal cultures.

With over 80 species, the acacias (wattles) are well represented. Most have the identifying structure known as phyllodes – essentially enlarged, flattened leaf stalks that resemble and perform the functions of leaves.

Top: Kimberley heather (Calytrix exstipulata)
Middle: Paratephrosia lanata
*Bottom: Flowers of the mother-in-law tree (*Bauhinia cunninghamii*)*

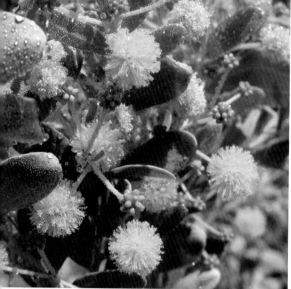

Acacias occur over a range of habitats. Some of the most obvious are in the pindan country near Broome and north and east to Derby, Kalumburu, Fitzroy Crossing and beyond. Typical species are the pindan wattle, the poverty bush, the turpentine wattle and the unique elephant ear wattle, with its massive phyllodes (upwards of 35cm in length). It is found from the quartz sandstone hills around Cape Levêque through to the basaltic ranges near Wyndham.

Some herbs, shrubs and trees are members of the *Rubiaceae* family. One such is the magnificent Leichhardt tree, whose common name 'rewards' the privations experienced by the explorer Ludwig Leichhardt. Found along drainage lines and seepage areas, it grows in excess of 25 metres in height. Its shape is somewhat pyramidal, its fruit is dry but edible – and its shade is always welcome.

Members of this family can be recognised by the opposite pair arrangement of their leaves, which are are joined around the stem by a narrow or broad sheath. Their flowers are usually small. Other members include *gardenias, aidias* and the herb *Spermacoce*.

With fruits that are variously winged, pear-shaped and usually edible, *Terminalia* species, sometimes called ironwoods, can occur as trees or shrubs; the wild plum grows upwards of 20 metres in height. They are usually found growing along rivers and drainage lines as well as in the heavy soils and even in coastal areas.

They are often quite similar to eucalypts, but are partially or completely

Top: Acacias are well represented across the Kimberley (Acacia bivenosa, dune wattle)
Bottom: Rock fig (Ficus platypoda)

deciduous, shedding their leaves at the end of the growing period.

A related species is the green plum, which has a number of medicinal properties, including an ability to effectively deal with toothache. Its fruits are also very sweet and tasty.

The Kimberley walnut is also common across a variety of habitats, but is usually found on the upper slopes and tops of sandstone and rocky hills. Its poisonous fruits start off red, and fade to brown as they ripen. Aboriginal people have allegedly used them to catch animals, because animals become sluggish after eating them.

A closely related species found through the Oscar and Napier ranges is the white cedar. It is similar in shape and form to the invasive Cape Lilac of home gardens and suburban streets.

In the *Bombacaceae* family, the boab tree would be the most distinctive and well-known tree in Australia. It gets its name from a close African relative, the baobab. Spectacular white flowers and the girth of the fibrous trunk are the standout features of this species. Growth rates are determined by referring to measurements of a boab at Careening Bay, north of the Prince Regent River, that were taken by the botanist Alan Cunningham in 1820. It is a particularly important tree to Aboriginal people, as it provides food, shelter and water.

There are several species of wild fig; they are members of the *Ficus* family. They are often seen growing horizontally on sandstone walls and along watercourses, and are easily identified when fruiting, although the fruit is often dry and somewhat tasteless.

When travelling through the sandstone country and sandy soils associated with the Drysdale River through to Wyndham, along the Diamond Highway at Argyle Diamond Mine and south as far as the Wolfe Creek Crater, look for the unusual *Triumfetta plumigera*. A member of the *Tiliaceae* family, it flowers between February and August, and the soft pale green flower clusters certainly catch the eye.

Aquatic zones have a flora that is also interesting – and occasionally unique. Following the damming of the Ord River at Kununurra in 1962 and the subsequent creation of Lake Argyle in 1963, vast wetlands were created, which have developed freshwater vegetation in line with other northern areas.

Brought in by birds, on winds and most likely by man on his boats, water thyme, the marshworts and the waterlilies have all established themselves there. Several of these

Triumfetta
plumigera

can also be found in other freshwater systems throughout the Kimberley.

On Myctis Island in the Talbot Bay area there is an extensive population of the native cypress. A highly fragrant timber, the cypress grows in excess of 15 metres in height, but it is under threat throughout the Kimberley due to frequent and inappropriate fires.

The distinctive screwpalms (*Pandanus* species) are found along watercourses, on beaches and in swampy areas, often in close association with other members of their species. They can form impenetrable barriers along drainage lines.

The plants are dioecious: separately male and female. The female plants produce fruit, which is the easiest way to know which plants are which gender. The fruit is often quite massive, and can resemble a soccer ball in size, shape and pattern – but not colour!

P. aquaticus is commonly found in freshwater habitats; the screwpalm is more often seen in coastal environments. The leaves of both are immense, sometimes more than 2 metres long, and edged with a multitude of small-recurved spines.

The cabbage palm grows along the Mitchell River and the associated bauxitic plateau. Further north, on the smaller sandstone gorges of the Drysdale River, a close yet distinct relative, *Livistonia lorophylla*, is found. Usually seen as scattered plants, these have finer leaves and are smaller in height than their Mitchell Plateau cousins.

Both species have been used as a food

Screwpalms (Pandanus aquaticus) can form inpenetrable thickets

resource by Aboriginal people – the leaves and the lower part of the growing bud are chewed for their sweet flavours. Given the length of time these people have been living in the Kimberley, we may wonder how many plants may have died as a result of this action, but there were, until recently, still many thousands of hectares of palms. Regular fire has unwanted effects on these species.

There are many different types of creepers and vines in the region. Most occur in the vine-thicket pockets, which are restricted to the higher rainfall areas, but the snakevine is widespread in a variety of habitats. It twists around trunks and strangles trees and shrubs; its triangular leaves with rounded corners are also distinctive.

Cycads are gymnosperms: they produce naked seeds, just as conifers (pine trees) do. So even though they look like palms, they are actually more closely related to the pines.

There are four dioecious species in the Kimberley, and all are relatively easily seen. You will find *Cycas basaltica* from the southern end of the beach at Careening Bay and on the quartzitic sandstone hills of the entrance to Sampson Inlet south of Kuri Bay. The aptly named Cycad Hill near Fairfield Station, northwest of Fitzroy Crossing, supports a good population of *C. furfuracea*.

The Kimberley flora is spectacular and interesting. Not only is there a diversity that far exceeds the scope of this publication, but there is also a usage history that requires further investigation. These plants can be introduced into the nursery trade, and investigated for pharmaceutical use – and there is already an extensive knowledge of their use as food plants.

Ongoing bioprospecting investigation will increase our knowledge of the species range and will without doubt turn up new and undescribed species that may have a characteristic that makes them economically, culturally and environmentally invaluable.

Cycads are dioecius – there are male and female plants – this is a male plant

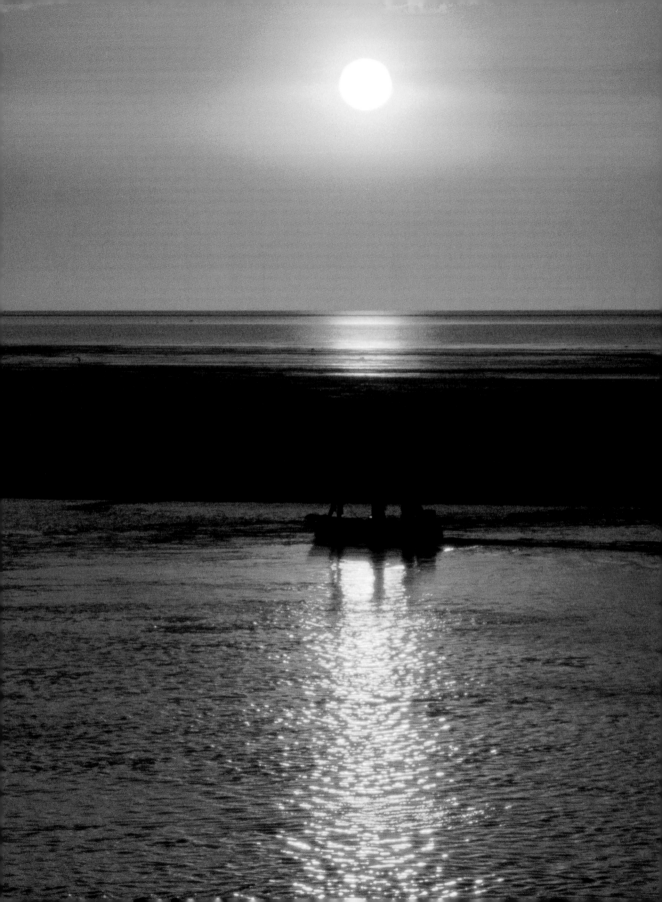

Stargazing in the Kimberley

I stood upon that silent hill and stared into the sky until my eyes were blind with stars and still I stared into the sky.

Ralph Hodgson (1871–1962), *The Song of Honour*

The clear unpolluted skies of the Kimberley are renowned worldwide in stargazing circles and any discussion of seasonal indicators would be incomplete without a reference to the apparent (westerly) movement of the major constellations.

This movement is, of course, tempered by our present knowledge that it is in fact the Earth that is doing the major moving, and its revolution in a west to east direction that brings the constellations into our view.

Since the dawn of civilisation the night sky has fascinated people. Many cultures have developed stories and legends about the movement of heavenly bodies, the relationships between them, when dominant star systems can be seen and the changes related to the natural environment that their appearance heralds.

Indeed it is possible that Cro-Magnon people notched bones to mark the changing seasons at least 50,000 years ago.

The first recorded writings in the Middle East, some 5000 years ago, bear witness to an emerging knowledge and understanding of the stars and constellations.

The priest-astronomers of the first great civilisations used their observations

Sunset at Montgomery Reef

of the rhythms of the night sky to create calendars that helped bring a semblance of order to expanding human populations.

They also looked to the heavens for signs that indicated the will of the gods, whom they believed ruled their day-to-day lives.

The patterns of the stars we see in the sky today have scarcely changed in over 5000 years, and the records kept by the ancients show graphically that the constellations they were familiar with are virtually identical to those we see today.

Across Australia, Aboriginal Dreamtime stories abound with legends that not only account for the presence of the various constellations but link them to cultural and kinship practices. Aboriginal belief, rituals and stories all revolve around Dreamtime events, and the land and the creatures that have inhabited it are seen as physical manifestations of this Dreaming.

Australian Aboriginal myths that deal with the creation of the universe and that establish the rules of human and social behaviour are the foundation of social, secular and ceremonial activities.

The links that dominate much of traditional Aboriginal life in respect of country allow them to look upon themselves as the direct descendants of mythological beings of the past. Each person lives in the country created by these beings, and as a consequence is linked intimately, by both myth and lineage, to everything in their environment.

Top: The moon is a man constantly chasing the Sun
Bottom: The Eta Carina region presents some of the richest deep space vistas in the whole sky

These beliefs, to a certain extent, allow many traditional Aboriginal people to exist in the understanding that there never have been, and never will be, changes in their lives. The myths that support this presumption provide a reasonable explanation for the world in which they live: the stars above, the plants and animals that provide food and healing, and the natural forces of cyclones, wind, rain and thunder.

In traditional Aboriginal Australia there are stories that relate to the events that occur in the night and daytime skies.

The Sun is often viewed as a woman who provides light and heat. Every morning she rises and provides these necessities, and at the end of each day she travels through a long underground tunnel to reach her camp for the night before she begins another journey on the next day.

This rising and setting is viewed as a constant – the process has not changed for millennia, and neither has life. The Moon is seen as a man, who makes the same journey, but at different times from the woman.

There are myths associated with several constellations, other heavenly bodies and the Milky Way; they vary considerably across northern Australia.

The constellations that Europeans call Orion and the Seven Sisters (Pleiades) have remarkably similar belief outcomes to those in Greek mythology. In some areas the Pleiades are wives or daughters of Orion; other groups have the constellations in conflict, with the Sisters constantly fleeing the unwanted approaches of Orion.

The Milky Way is frequently viewed as myriad campfires of the sky people. The system is sometimes looked upon as a 'River in the Sky' that is inhabited by all the creatures, such as fish, turtles and stingrays, that these sky people need to survive.

In parts of northern Australia the Magellanic Clouds are seen as the

Comet Hyakutake
Image by Greg
Quicke www.
astrotours.net

campsite of an old man and woman who are looked after by the other sky people. Some desert people believe the people who inhabit this area of the night sky can be unfriendly to Earth dwellers.

Aboriginal people's knowledge of the constellations and interpretations of astronomy have helped them develop well-defined food and seasonal cycles upon which they have based rituals, seasonal journeys and trade routes.

The constellations and their mythical representations do not match European constellations, but they seem to translate cultural heroes and heroines from an earthly context into the skies in much the same way as the early inhabitants of Asia and Europe did.

The origin of fire

There is considerable diversity in the Aboriginal myths dealing with the origin of fire. Some tribes believe that it originated in a lightning flash, others that it came from a burning mountain, or that it was accidentally discovered by man. A myth of the Aboriginal people of the northwestern coasts of Australia tells how their fire came from the sky:

Two brothers named Kanbi and Jitabidi lived in the heavens. Their camp was near the Southern Cross, and their fires were the Pointers, Alpha and Beta Centaurus. At that time there was no other fire in the universe.

Food was getting scarce in the sky-world, so Kanbi and Jitabidi came to Earth, bringing their fire-sticks with them. They established their camp and laid their fire sticks on the ground while they went out to hunt opossums.

The two hunters were away so long that the fire sticks, becoming bored, began to chase each other about in the grass and among the branches of the trees. This game started a bushfire that burnt out much of the surrounding country. Seeing the smoke and the flames, the brothers returned at once to their earthly camp, recaptured the playful fire sticks and restored them to their place in the sky.

It happened that a group of Aboriginal hunters saw the fire and felt its warmth. Realising the value of this strange new element, they took a blazing log back to their own camp, from which many other fires were lit. Now all Aborigines have the fire that once belonged only to the men of the Southern Cross.

CP Mountford, 1974

Across the world, indigenous peoples have linked their lives and timed the activities of the natural systems around them to heavenly events.

It could be argued that the success of early harvesting and agricultural activities and the subsequent ascent of mankind were determined by an understanding of the relationships between seasonal events and the arrival of particular dominant constellations during each month.

There are a multitude of constellations, star systems, clusters, nebulas and other galaxies to be seen in the night sky, but we can identify the main constellations that can be seen on a seasonal basis.

It is also possible to observe other closer celestial bodies, the planets, as they wander across the night sky. Their paths are determined by the massive gravitational control exerted by the nearest star to Earth – the Sun.

The Earth is one of the larger bodies in our solar system, which we call planets. There are at least seven more planets, four smaller than the Earth and four very much larger. Venus, Mars and the immense Jupiter outshine the brightest stars – and they are quite easy to observe as they move through the constellations month by month.

As well as the planets, there are more than 60 moons, thousands of asteroids (mini planets) and an unknown number of icy lumps that we can see as comets when they approach the Sun.

And in the crisp clear Kimberley winter nights there are specks of interplanetary dust that provide spectacular light shows when they burn up in our atmosphere, creating meteors or shooting stars.

The following outline of the Greek alphabet will help readers identify many of the as yet unnamed stars within the main constellations that can be seen on a Kimberley expedition. Many celestial charts use the symbols below:

Alpha	Beta	Gamma	Delta	Epsilon	Zeta
α	β	γ	δ	ε	ζ
Eta	Theta	Iota	Kappa	Lambda	Mu
η	Θ	ι	κ	λ	μ
Nu	Xi	Omicron	Pi	Rho	Sigma
ν	ξ	ο	π	ρ	σ
Tau	Upsilon	Phi	Chi	Psi	Omega
τ	υ	φ	χ	ψ	ω

Key constellations

The constellations are like signposts in the night sky. There are 88 recognised constellations, many of which are known from records dating back to the stargazers in Babylon and Egypt. The names we use for them today may have originated with the ancient Greeks, but generally we use the Latin form to identify them for the sake of consistency.

Often the name is also translated into English – Sagittarius the Archer, Leo the Lion, Taurus the Bull and Scorpio the Scorpion, for instance.

The Greeks named the constellations after their gods and heroes and the creatures and objects that featured in their mythology.

It can be difficult for us to relate what we see in the night sky to the figures the Greeks have described. However, with time, some imagination, and perhaps a penchant for consuming mulled wine in the boab tree groves of a Kimberley habitat, the figures do begin to take on the shape of the mythological figures.

One of the easiest is the magnificent constellation of Scorpio, which really does look like a scorpion with its wickedly curved tail and the bright star Antares at its heart.

Signposts in the night sky

Orion

The constellation of Orion is also unmistakable. Its shape is distinctive and its stars are bright.

Orion begins to appear on the eastern horizon during October, and by November the supergiant stars of Alderbaran in Taurus and Rigel and Betelgeuse in Orion form an almost perfect triangle low in the eastern evening sky. By 8.00 pm during December at Broome this system is well above the eastern horizon.

Orion spans the celestial equator and is a useful constellation for observers in both hemispheres. The first magnitude stars of Betelgeuse and Rigel are striking, and the three stars that make up Orion's Belt are pointers to the brightest star in the sky – Sirius, in Canis Major – and to Alderbaran in Taurus, which is the fiery eye of the Bull.

The group of stars found in Taurus is known as the Hyades. In Greek mythology these were the daughters of Atlas, who had been placed in the sky by Zeus – many ancient cultures believed that when this group rose with the Sun, rainy weather was approaching.

A diagonal through Rigel and Betelgeuse leads to the twins of Gemini, the bright stars of Castor and Pollux. In mythology Castor and Pollux are the sons of Leda, the Queen of Sparta. One was fathered by her husband, King Tyndareus, and the other by Zeus, while he was in the form of a swan (represented by the constellation Cygnus in the northern hemisphere). The twins served aboard the *Argo*, the ship used in Jason's quest for the Golden Fleece in the legendary voyage of the Argonauts.

Bellatrix is the other major star in the Orion group, and due east from it is the bright Procyon, in Canis Minor (the Little Dog), that trots at his master, Orion's, heels. Capella, in the Auriga (Charioteer) constellation, is found on a line running north through the middle of the main star pattern.

In mythology, Orion was a mighty hunter. Son of Poseidon, the god of the sea, he was given the power to walk on the ocean. Orion features in many tales from many cultures. In one, he fell in love with seven sisters, the Pleiades, and pursued them across the heavens, followed by his favourite hunting dog (Canis Minor). Orion's heart is set on possessing Merope, one of the Pleiades, and making her his wife. Between the seven sisters and the hunter is the constellation of Taurus, the Bull, who has placed himself in a position to protect the sisters from the advances of Orion (while harbouring his own plans!).

Sagittarius

Between Capricorn and Scorpio is one of the richest constellations in the heavens, Sagittarius. Spanning the Galactic Equator of the Milky Way, the half-man, half-horse centaur is the Archer of mythology.

With his bow drawn and pointing at Antares, the heart of the Scorpion, the constellation is studded with star clusters, nebulae and dense star clouds.

The densest of these point the way to the heart of our Milky Way galaxy, some 30,000 light years away. Northern hemisphere starwatchers in higher latitudes are denied our magnificent views of this constellation – they must surely envy the opportunities 'down under'.

The chief attractions to be found in this constellation are deep-space objects such as the Lagoon Nebula and the Trifid Nebula. Both can be viewed using binoculars or a small telescope.

These nebulae are located just in front of the upper part of the bow of the Archer. The Lagoon is named after the dark lane running through it; the three dark, dust lanes are the Trifid.

Sagittarius presents itself late in the evening during June. From July through August

the constellation rises earlier in the evenings as the Earth moves into its southern spring orbit. By late September the Archer is disappearing into daylight.

Scorpio

To the west of Sagittarius is perhaps one of the most stunning and easily identifiable constellations to be observed in the night sky, the Scorpion.

Best viewing times range from midnight to pre-dawn in December and January; there are less tiring opportunities in the mid-evenings of late April and May. From then through to August this system can be seen overhead quite early after sunset.

According to one legend the hunter Orion was resting in an olive grove (no doubt recovering from his pursuit of the seven sisters!) when a scorpion crawled inside his ear and stung him on the eardrum.

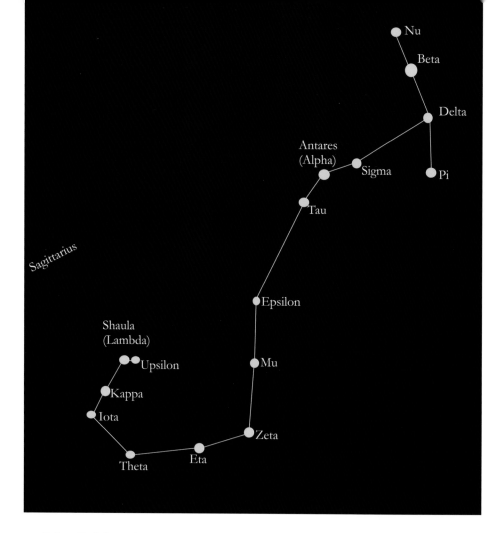

Orion died from the sting and both he and the scorpion were turned into constellations – on opposite sides of the heavens. The myth says that Orion must continue to flee the scorpion for eternity, for should the scorpion catch up with him again the Earth will be destroyed, so as Scorpio rises in the east, Orion sets in the west.

The constellation is best viewed when it is high in the southern sky – during May, June, July and August. It is one constellation whose name is definitely appropriate. Very little imagination is required to recognise the typical shape of a scorpion poised to strike with its poisonous sting curled back under its tail.

The brightest star in Scorpio is the red supergiant, Antares. Its name means 'rival to Mars', and it does superficially resemble the planet Mars. It is, however, probably over 300 times the size of our own Sun.

Every few years during August the path of Mars passes quite close to Antares – the two golden bodies are great when viewed through binoculars, and spectacular through a telescope.

The head of the scorpion is made up of four main stars – Nu, Beta, Delta and Pi

Above: Scorpio
Opposite: Taurus

– and in front of these stars, where the scorpion's claws would normally be, is the start of the neighbouring constellation of Libra.

Along the backbone of Scorpio is a series of bright stars. The first is Sigma (σ), which is followed by the star pairs of Mu (μ) Scorpii and Zeta (ζ) Scorpii. The sting in the tail is Lambda (λ) Scorpii.

Taurus

The supreme deity of the ancient Greeks, son of Cronus and Rhea and husband of Hera, was the ever-amorous Zeus. Zeus assumed the form of a magnificent white bull with shining horns when he set out to woo a Phoenician princess called Europa. Encouraging her to climb on his back, he carried her off to Crete, where he revealed his true self.

One of their offspring was King Minos, who went on to build the Palace of Knossos, which housed the legendary man-eating Minotaur in its basement maze.

This constellation is found to the west of and adjoining Orion, and to the east of the Pleiades or Seven Sisters.

Although the majority of Taurus is quite faint, it does have an outstanding leading star that marks the 'eye' of the Bull, two bright open star clusters, and the best-known

remnants of a supernova or starburst.

The brightest star in the group is Alderbaran. The name is derived from the Arabic 'Al Dabaran', meaning 'the follower', more than likely recognising that this star follows the Pleiades through the night sky.

Close to Alderbaran lies the distinctively V-shaped group of stars called the Hyades. In mythology these were the daughters of Atlas and Aethra – half-sisters to the Pleiades. Under good conditions as many as 20 stars in this group can be seen with the naked eye.

At the tip of the southern horn of Taurus, directly in line with Alderbaran, is the spectacular Crab Nebula. This system is the remnant of a supernova that was observed by Chinese astronomers in 1054 – they recorded that it was so bright it could be observed during daylight for several weeks.

To the northwest of Taurus, but still under its influence, is the cluster of stars called the Pleiades or Seven Sisters. Under good conditions at least seven of its brightest stars can be seen with the naked eye; there are probably at least 300 in the system.

The seven bright sisters in this group have been ranked in order of illumination: Alcyone, Atlas, Electra, Maia, Merope, Taygete and Pleione (descending order).

This constellation leads Orion across the night sky and is best observed from January to March (cyclones permitting), then in April and May and just after sunset in June.

Centaurus

This constellation dominates the southern skies, particularly as it associates with one of the smallest constellations found in the heavens, the Crux or Southern Cross.

Centaurus can boast many 'firsts' in the stargazing stakes. It has the closest star to Earth (Alpha Centauri), a wealth of star clusters and galaxies, it is the source of some of the strongest radio signals to reach Earth from deep space, and to top it off, Alpha (Rigel) Centauri is also the third brightest star in the night sky, outshone only by Sirius and Canopus.

In mythology, Chiron was the half-man, half-horse centaur who differed from his wild kin by being wise and learned. He became a great teacher, with special skills in medicine, hunting and healing. Unfortunately for Chiron, his great skills could not save him after he was accidentally hit by one of Hercules' poisoned arrows.

The brightest star is Rigel Kentaurus or Alpha Centauri, just 4.3 light years away. Its relatively close partner is Hadar (Beta Centauri). These two are often referred to as the Pointers because they point to the Southern Cross, which is perhaps the most well-

known constellation to many in Australia.

The star at the foot of the Cross is Acrux (or Alpha Cruces) and it, plus the Pointer stars, can be used as a reference point for working out 'rough' south. To find approximate south, first draw an imaginary line directly through the long axis of the Southern Cross down towards the horizon. Second, bisect the Pointers with another imaginary line and extend it to meet the line from the Cross. Third, from where these two lines meet, draw a line to the Earth's horizon. Where it touches is roughly south. Otherwise, carry a compass!

Just near the southeastern corner of the Cross it is possible to see a dark area amongst the bright stars of the Milky Way. This is a nebula area known as the Coal Sack. Made up of clouds of gas and dust that obscure the stars behind, the Coal Sack is best viewed from the Kimberley and remote desert areas well away from light pollution.

Midway between Gamma and Zeta Centauri is the most spectacular globular

Centaurus

cluster of stars in the entire sky. Called Omega Centauri, this cluster contains about one million stars that are packed tightly together (in astronomical distances, that is!). Astronomers have found evidence that suggests the stars in this system are of differing ages – why this might be so remains unclear.

These two spectacular constellations are at their peak during May, June, July, and August early in the mornings of September.

The Milky Way

When you look up into the sky on dark, haze-free nights when there is no Moon visible, the first image that your eyes will see is the blurred white band of light spanning the dome of the heavens. This is the Milky Way, a cross-section of the great galaxy to which our Sun and all the other stars, planets and other interstellar material belong.

Our Milky Way galaxy takes the form of a spiralling disc with a prominent bulge transfixing the centre. From this nucleus a number of arms spin outwards, carrying masses of stars and other stellar material.

Our Sun is located in one of these arms, at a distance of approximately 30,000 light years from the galactic centre. As we on Earth rotate around the Sun, the Sun rotates around this central point, completing one complete orbit in a cosmic year (every 225 million of our years).

The Milky Way transfixes many special constellations in the southern hemisphere. In particular, it crosses Puppis (the Stern), Pyxis (the Compass), Vela (the Sails) and Carina (the Keel), which join together to make the great constellation of Argo, commemorating the legend of Jason and his Argonauts and their search for the Golden Fleece.

Straddling Carina and Vela is the standout False Cross, located southwest of the true Southern Cross.

The Milky Way is visible all year from the Kimberley. The only thing that really changes is the aspect of the constellations and the best viewing times. The great constellation of Argo 'moves' to the west and south of the Southern Cross, and its closeness to this system allows stargazing at both at the same time of year.

There are many other great constellations associated with the Milky Way that can be viewed. It is at its brightest in Sagittarius and Scorpio in the south. Aboriginal people from the central desert regions use the dark nebulae in the Milky Way as an indicator of seasonal change.

Late in August the dark areas appear to have coalesced into the shape of a long-

necked bird indigenous to Australia, the emu. It does not take much imagination to see the spectral outline of this iconic bird, with its head and beak formed in the Coal Sack near the Southern Cross and its long neck passing through Centaurus and Lupus (the Wolf) then into Scorpio, where it begins to form a narrow body reminiscent of the fleet-footed emu.

Aboriginal people have used this cosmic sign as an indicator that eggs and young emu chicks will soon be available for harvest. In a European perspective, this correlates to the time of year we call late winter/early spring.

There are many constellations and stars in the southern hemisphere and there are many specialised books on this fascinating subject and guides and organisations dedicated to imparting their knowledge. Most visitors to the Kimberley can expect to see the systems discussed above during their stay in the area (excellent local guides can be contacted through Tourist Visitor Centres). Often the best time of night for viewing particular constellations is between 7.00 pm and 10.00 pm local time.

Another feature of the Kimberley night is the occurrence of meteor events. On any moonless night it should be possible to see four to five meteors per hour. The rate increases between midnight and dawn – as the observer's view is carried towards the Earth's leading orbital edge, more interplanetary material can be viewed.

Meteor showers occur in particular quadrants of the night sky and are often named after the constellation they seem to be emanating from.

In the Kimberley, some good observations are likely to be made looking towards Orion and Taurus between early September and mid to late November, and looking into the northern sky towards the constellation of Leo in mid-November. In May and July it is possible to see some good meteor events in the watery constellations of Aquarius (the Water Bearer) and Capricorn (the Sea Goat).

Bolide events can occur low on the horizon just after sunset or just before sunrise. Bolides are bright, shooting meteors, often with long trailing fiery tails that are somewhat reminiscent of the magnesium strips that students have been known to smuggle from science class and ignite and drop from some high building at night. They frequently explode into a cascade of smaller burning fragments, and occasionally there is even an audible explosion. They are a spectacular sight, and are quite often seen in the Kimberley.

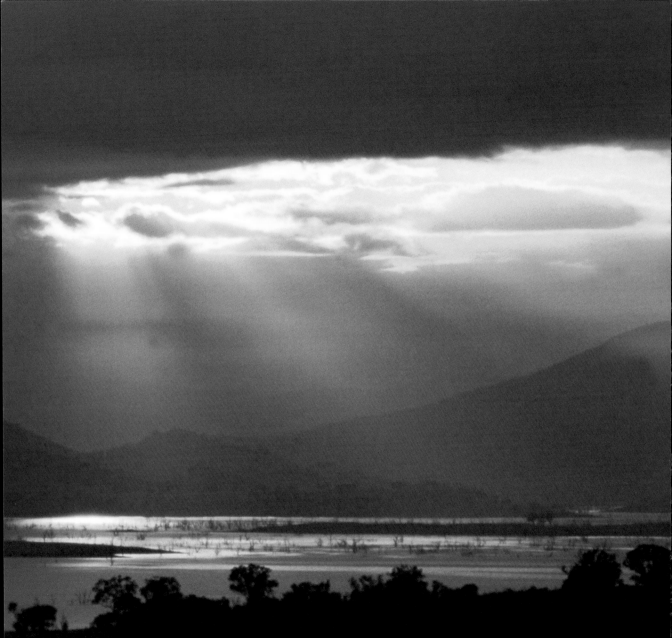

Other atmospheric indicators

Crepuscular rays

It is often possible to see this atmospheric phenomenon as sunlight passes through clouds at sunset and sunrise. 'Crepuscular' comes from a Latin word *crepusculum*, meaning 'twilight' (probably because the effect is most often observed in the early evening).

Caused by clouds just below the horizon partially blocking the Sun, the shafts of light that do get past the cloud illuminate dust and moisture particles in the air above the horizon. As the clouds move and the Sun's angle changes it is possible to watch the movement of the shafts across the sky.

As an indicator of seasonal change, the effect is pretty well confined to two periods: between October and January and between late March and the end of May. Occasionally the effect will occur in July or August, if a low pressure frontal system reaches the southern Kimberley from southern cold weather systems that are particularly powerful.

From Lake Kununurra in the east Kimberley, fantastic shafts of sunlight rising up from the western horizon are a feature just after sunset. There are also great viewing opportunities from Cable Beach at Broome and all along the Kimberley coast. If you're up early enough, the same effect can be seen in the pre-dawn to the east.

Crepuscular rays are created by light reflecting off dust and water vapour

Moon halos

As light passes through the water vapour suspended in the atmosphere it creates a variety of arcs, rings, halos and other light events. Of course predicting these events is fraught with danger, but some are more likely to be seen at particular times because of the conditions that are typical for that time of year.

Moon halos are spectacular, and although they are not restricted to the Kimberley, for some reason (probably lack of pollution) they are relatively common here.

They often occur during the build-up time, from October through to January, when the air is heavy with moisture. They are an indication that the heavy seasonal downpours that often occur before the monsoon establishes across northern Australia, and then the wet season, are on their way. After this time there is generally too much continuous cloud to allow good halo viewings.

High atmospheric water vapour and a full moon occurring at the same time can be interpreted as a precursor to rainfall. In most cases, the larger and more intense and defined the halo is, the more likely significant rainfall is. Predicting where it will fall is the problem!

During July, a blurred halo effect can often be observed near coastal areas as the moon reaches its apex in the night sky. This indicates the likelihood of heavy sea mist. The more intense the effect, the more intense the fog.

This is also the time that many Aboriginal law events begin throughout the region.

These moon halos indicate that there is an increased chance of surface water being available for men to make long journeys across the Kimberley, which they need to do to be involved in these ceremonies.

Water vapour helps create moon halos

Green flashes

One of the rarest atmospheric events is a sudden flash of green light at sunrise or sunset.

How do these happen? The Earth's atmosphere bends different coloured light by various amounts, especially at our range of vision, towards the horizon. The light that travels through the atmosphere in effect reflects the colours of the spectrum, with red, green and blue being dominant.

Taking this a step further, imagine that there are actually tiny delays in the light reaching us from the Sun, so there are red, green and blue suns that are setting at slightly different times. Blue light usually reaches us last but it is often distorted by the atmosphere, which means that green tends to dominate.

Searching for the green flash event also requires a physiological change to take place in our eyes. If we look at bright light for a short period we 'burn' out the red light-gathering structures in our eyes, the red cones. As our ability to see red is diminished, it becomes more likely that we will experience a green flash.

To see the green flash you need a clear horizon, and no cloud or haze. It is best experienced when viewing a sunset across the ocean, and there are many great beaches and sandstone formations to do this from in the Kimberley. The effect can be seen all year, but during the winter months, from June to September, when wildfires burn uncontrollably through the region and the easterly winds prevail, the atmosphere above the ocean is often polluted with smoke haze.

Even when the Sun is setting, looking at it can cause serious damage to your eyesight, so do it only for a few seconds. The green flash event only ever lasts for a few seconds anyway, and is very difficult to observe. But once experienced it can become an obsession!

Tides and the Equinoxes

Solar and lunar gravity act like a powerful magnets on our oceans although the Sun, despite its immensity, only exerts 46 per cent the force of the Moon due to its vast distance from Earth. Their forces produce a result that varies with the constantly changing positions of the Sun and Moon relative to Earth. We can observe the effects of this distant tug-o-war in the form of the daily rise and fall of sea level, the tides.

As the Moon orbits around us every 29½ days, the tidal cycle fluctuates in response. Tidal influence is greatest each month when the Moon is between the Sun and Earth (in conjunction) when we face the new Moon.

This is the time the Moon is said to be at perigee (the point of its elliptical orbit closest to Earth). Similar, but slightly smaller forces act when the Moon is aligned with the Sun on Earth's far side (in opposition), illuminating the disk of the full Moon. At these times, the Moon is said to be in syzygy and we experience the larger spring (the source of a stream) tides.

At the two points of the Moon's orbit when the Sun and Moon are at right angles to us (in quadrature), the resultant force is least. These are the quarters, which produce the smaller neap (Anglo-Saxon: nep, scanty, lacking, as in nepflod: low tide) tides that occur about a week after each spring tide.

Around 21 March the Sun crosses the equator during its apparent annual journey north to the Tropic of Cancer, and it passes back again around 23 September on its way south to the Tropic of Capricorn.

These are the equinoxes, the times when the Sun's declination (angle above or below the equator) is zero and the length of day and night all over the world are equal. The tide-generating force of a body is greater when its declination is smallest, as it is more closely aligned with the Earth's centre.

When the Moon is at perigee (closest point of orbit to Earth) and with little declination around the time of either equinoctial full or new Moon, the magnitude of the celestial forces peaks to produce the largest spring tides of the year. These are known as the 'king' or 'equinoctial' tides, when the exceptionally higher high and lower low tides are observed.

Captain Bruce Palmer

Phases of the moon

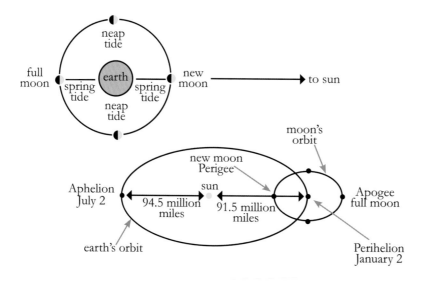

Tidal ebb at
Montgomery Reef
Overleaf: standing
waves created by
tidal flow

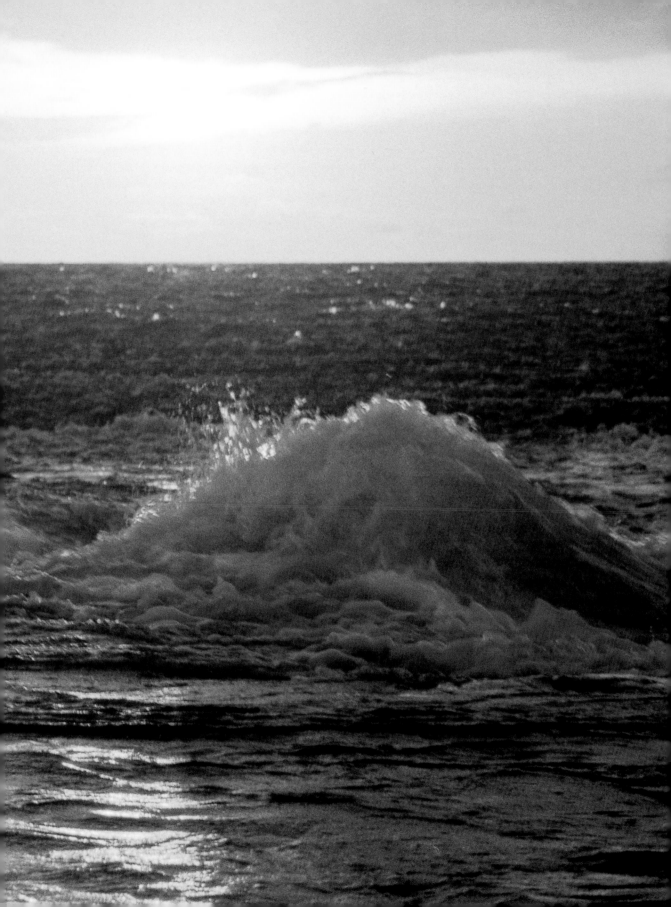

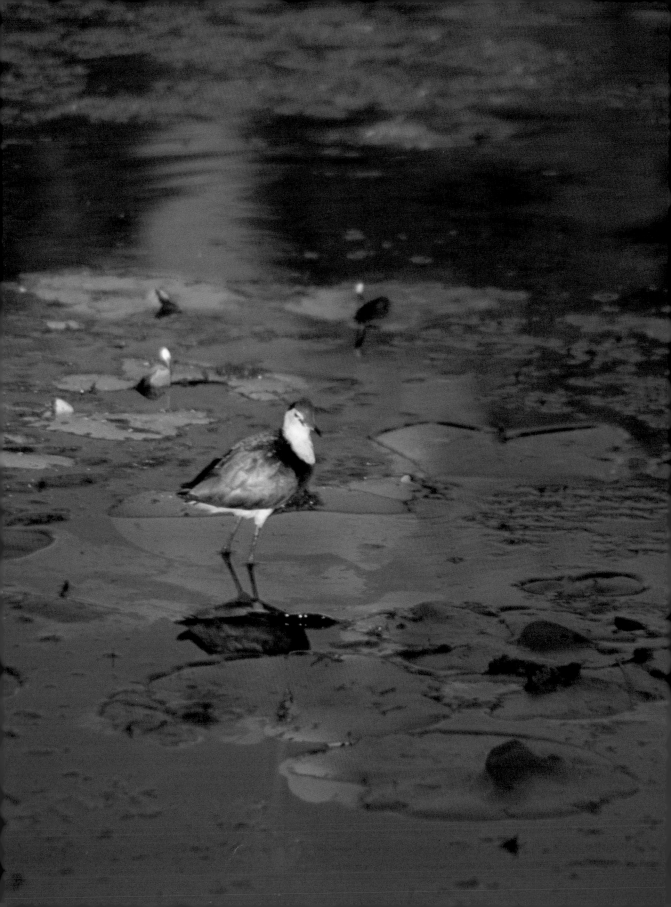

Kimberley bird watching

How many birds can you identify – birds that you see frequently enough to have a long-standing knowledge of them? Magpies, parrots, finches, honeyeaters – what about the emu? There are many common birds that fit into one of these groups, or perhaps another, that you are familiar with.

With a little bit of thought it's easy to see that perhaps your knowledge is greater than you first realised!

What is an Australian bird? Should we have a list that includes every species identified in mainland Australia and the territories? Do we include vagrants and migrants – those that visit for a little or a long period? How about residents? How about only those species that are known to occur nowhere else but here?

To understand birds and why they do that individual bird thing requires a broader understanding of Australian wildlife habitats. It is important to recognise that there is variety, and also that it is the vastness of the Australian continent that allows for this variety.

Many Australian birds take advantage of this vastness, migrating from north to south and back again, following seasonal events or taking advantage of unique situations.

When you consider the thousands of kilometres of beaches and coastline, the diversity of forest types, the treeless plains and vegetation-filled deserts, not to mention the agricultural and urban environments and the mountains and escarpments, it becomes easier to accept that there is a multitude of bird species that have adapted

Comb-crested jacana

to specialise in particular areas, and that there are many species that raid and run following the seasons.

There are so many factors that contribute to this diversity – the climatic conditions alone are unique. There are places where rainfall is measured in metres and places where it has been decades since the last rain was felt. There are hot tropical environments in the north, then various other zones through to the cooler to cold wet south, with its snow-covered mountains and bitterly cold oceans.

The survival of any species, not only birds, depends on a continuing supply of suitable living conditions – these must have the ability to access food, shelter, protection and other specialist needs.

Think of all the special adaptations birds have – long, slender bills for probing at various depths for benthic invertebrates that live in coastal mudflats, wings shaped especially for gliding, hovering, soaring, flitting or stooping, waterproof feathers, brightly coloured feathers or drab and plain colouring, webbed feet or strongly curved talons, to name a few. How many walk, or hop or waddle?

All of the things that help describe a species are also characteristics that allow those species to exist in particular locations under certain conditions. These characteristics also determine their movement and limit their capacity to survive in areas that are unsuitable.

Red-tailed black cockatoos, for instance, have particular wants and needs: they are social birds for only part of the

Top: Female darter (snakebird)
Bottom: Azure kingfisher

year, they require particular types of trees to feed and nest in and they have distinctive flight styles and calls.

Habitats are under threat across Australia, which will impact on many species.

Undoubtedly the most significant threat comes from clearing vegetation for agriculture – it is disturbing to still see broad-scale chaining of land occurring, particulary when inefficient agricultural practices are going to be used on that land.

Across the Kimberley, habitats are many and varied. We have sandy beaches, mangrove-lined tidal rivers, sandstone escarpments, ocean and offshore islands, and eucalypt woodlands and grasslands. There are vine-thicket rainforests, saltbush areas, savannah woodlands and arid spinifex zones as well as riverine habitats and billabong wetlands. All in all, there is a diversity of habitats that allows for specialisation and generality – a crossover of usage.

The overriding issue is the value we place on protecting these habitats. The Kimberley and its coast are unique and we are in a position to promote its conservation and long-term sustainability by recognising this and explaining these issues to visitors.

Vine-thicket rainforest

In this type of 'forest', found mainly between Prince Regent River and Darwin, growth is luxuriant. It has its own distinctive bird life. The closeness of the canopy and the masses of ground cover (decaying leaves and other debris) restrict some larger species.

In these areas it is possible to encounter the rainbow pitta, which is endemic to northwestern Australia. Sometimes called 'jewel thrushes', these birds forage through the leaf litter searching for land snails, worms and ground-living insects.

Pittas are generally unobtrusive, but can become very noisy in their breeding period, which is during the monsoon period. These birds can occasionally be sighted in the vine-thicket behind Naturalist Beach in Prince Frederick Harbour.

Vine-thicket habitats are found behind beaches

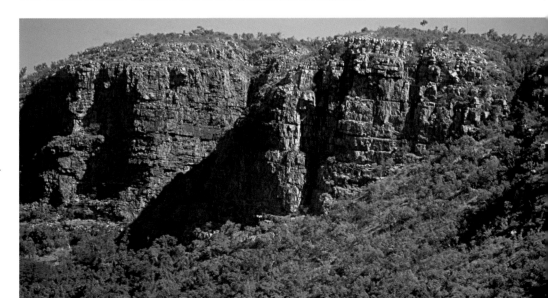

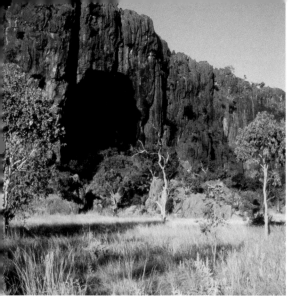

Tall tropical woodland forest

Consisting mainly of eucalypts in high-rainfall areas, particularly around Mt Elizabeth, Mitchell Plateau, Careening Bay and north to Cape Bougainville, these types of habitats recognise the dependency that many Australian birds have on the gum tree and the resources it provides.

The canopies here differ from the rainforest, though the understorey and groundcovers are still sparse. Red-tailed black cockatoos and Torresian imperial pigeons are frequently seen in these habitats as they follow the fruit and flower set during the seasons.

Semi-arid woodland

This country occurs widely in the Kimberley – it is dominated by acacia and eucalypt and is particularly attractive to bird lovers, as it is home to a significant variety of birds and other wildlife. Also, the breakaways, dry river beds and stark white eucalypts are always a welcome sight.

Birds of prey, including kites, eagles, falcons and kestrels, are frequently encountered here, along with finches, songlarks, grass wrens, tree-creepers and babblers.

They like these habitats because the country is open and can be food rich following the rains.

Top: Semi-arid woodland at Windjana
Bottom: Grey-crowned babblers are woodland birds

Mangroves

The estuarine habitats formed by mangrove communities in tidal rivers and creeks are amongst the most important nursery areas for a range of animals.

Bird life is attracted to these areas to feed on the multitudes of insects, nectar, fruits, animals, fish and crustaceans that make these habitats so special.

Very few species actually live in these habitats full-time; of those that do, the majority are specialists. Gerygones, chestnut-breasted rails, mangrove herons and kingfishers are all seen in these habitats.

Spinifex

Spinifex habitats are diverse. They include beach zones, sandstone escarpments and desert. There is always bird life amongst the spiny clusters – some of it knows no other habitat.

Frequently these areas border particularly scenic places whose vegetation allows birds to rest and nest … and make feeding forays into the grasses.

The white-quilled rock pigeon loves the protection and seed store provided in escarpment country, and its smaller cousin, the red-plumed pigeon, flits and runs through the more traditional spinifex habitats.

Wetlands

These habitats can be salt influenced, brackish or fresh. Whichever they are, there is a whole suite of bird life that is attracted to them: birds that dive, birds that hover, birds that swoop in large aggregations taking massed insects, birds that wade. They are all hunters and gatherers exploiting the wetlands.

Wetlands provide many benefits – food, protection, nesting sites and, for a birdwatcher, a chance to observe new and specialised species at work and play.

Pied cormorants

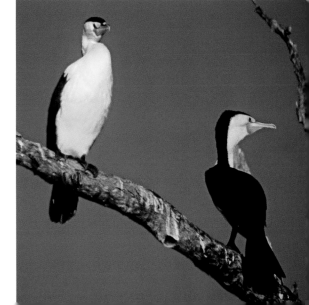

Comb-crested jacanas use lilypads as stepping stones, with their extra long toes spreading their weight, grebes and darters chase small fish and crustaceans into the depths, and the osprey glides above, occasionally crashing down on an unsuspecting sooty grunter fish.

Rivers

The extent of river habitats in Australia is immense. There are thousands of kilometres of defined river habitats in all states, and all are dominated by vegetation that is attractive to bird life.

Water means life, and the birds that use these habitats find much on offer. They can fish, catch insects from the vegetation or the water surface, or feed on nectar from the flowers.

Cormorants and egrets dive and stalk their fishy prey, white-breasted woodswallows swoop to take insects on the wing, and honeyeaters take nectar and lerps from the fringing vegetation.

Islands and coastal areas

Australia has thousands of near-coastal islands and thousands of kilometres of beaches and associated environments. These areas are home to seabird species that use the islands for nesting and as a base for foraging across the oceans. Mariners are familiar with Wilson's storm petrel (also known as the Jesus bird), for one, as it dances across the open ocean searching for morsels and small fish.

Island habitats have a particularly important function as areas where species can retreat – from mainland-based predators (introduced or otherwise), from wildfires, and from other hazards.

And between the sea and mainland are the sandy beaches, which are home to bird life that relies on their particular features. Pelicans nest and breed, terns in their thousands wheel and form breeding colonies and the beach stone curlews patrol the tide line searching for easy pickings washed ashore – their mournful night calls evoke memories of lost spirits amongst Aboriginal Australians.

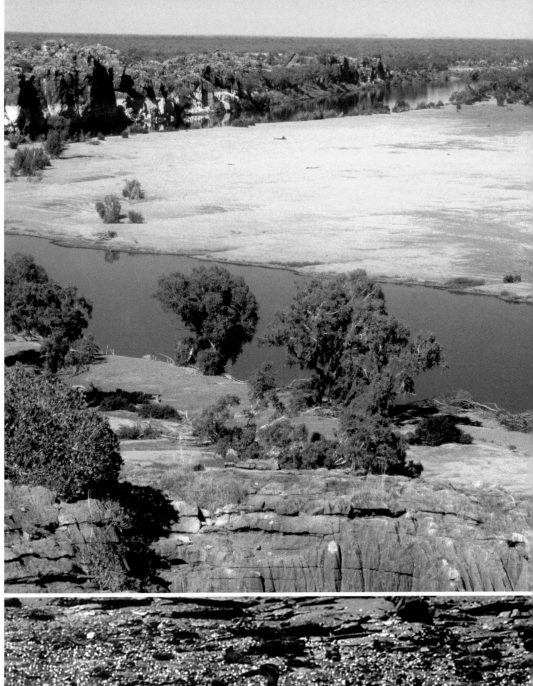

Top: Fitzroy River habitat
Bottom: Beach stone curlew

Winter (June–August)

North of Kununurra, at the spectacular Needles, is the largest flatback turtle nesting beach in Western Australia.

The turtles respond to ancient instincts and return every year during the winter months to their hatching beaches across northern Australia. Dragging themselves up the sandy beach the turtles will often excavate two nests – one is a false nest constructed in an attempt to defeat potential land-based predators, and in the other the female turtle will lay up to 50 leathery white globe-shaped eggs.

She then backfills the chamber with sand, patting it firmly into place with her hind flippers, before flinging a layer of soft sand over the chamber area.

Many turtles time their approach to the nesting beach to coincide with the incoming tide – it is easier to get onto the beach then, and on completion they may have less distance to travel to reach the safety of the water before the tide begins to ebb. Crocodiles are ever present, and will target the nesting flatback turtles from now through to September.

Humpback whales begin arriving in Collier Bay as early as June and their migration north will continue for several months. Some females will calve during their time in northern waters. Food there is minimal, but they still have huge energy reserves to draw upon.

In the north and east in early June, large aggregations of the magnificent rainbow bee-eaters are concentrating near the wetlands. These birds have returned to the north to avoid the southern winter, and their trilling calls are constant near dusk as they return to flock in their favoured trees.

Humpback whale at Collier Bay

However, nights are cold, easterly winds are drying the cane grass, so fires start to occur, and insect numbers are decreasing.

One of the dominant plant genera that is well represented across the region is the acacia group. Also known as wattles, the 100-plus species that can be found include the large showy pindan wattles that surround Broome in the west and the aptly named elephant ear wattle in the northeast. The acacias are renowned for their beautiful flowers, which can range from ball shapes to cylindrical forms and have a colour range from intense golden yellow to creamy butter.

On the peninsula north of Broome, Aboriginal peoples seek out bush honey at this time of year, as the native bees feast on the masses of pollen and nectar produced and store it in hollow logs and trunks of trees.

By August the flowers will be starting to fade, but if the cold easterly winds from the desert have arrived the air can still be thick with pollen dust – masses of genetic material being transported at the whim of the winds.

Though the Kimberley is not renowned for its wildflower displays, following a good rainy season there can be a burst of activity to rival the everlasting displays of the Murchison/goldfields region.

There are the wonderful pinks and mauves of the gomphrenas and mulla mulla and the creamy white of the erythrostachys (similar in form to the better-known verticordias [feather-flowers] of the south).

Between May and July, a small slender tree that grows to about eight metres and has feather-like silvery green leaves begins to flower. This is the magnificent silky grevillea or Kimberley Christmas Tree, and it produces large golden flowers that are stunning amongst the dried yellows of the surrounding bush.

These flowers produce masses of nectar, and are very attractive to native bees and children of all ages. Some great examples can be found south of the Dunham River and near Lake Argyle in the east Kimberley, north of Drysdale River station near the

Kimberley Christmas tree (Grevillea pteridifolia)

Mitchell Plateau, and on well-drained sandy soils around Mt Jowlenga and the Logue River in the west.

In the wetlands, tidal rivers and coastal beaches crocodiles are easy to see, as they spend long periods basking during the day to gather energy and digest the previous night's meal.

Flying foxes begin to concentrate around waterholes as the country dries and food and water resources concentrate into wetter areas.

With the drying country comes fire – usually caused by human activity (management, camping) – and associated with every fire are the black kites, masters of the swoop and glide feeding strategy. These birds form large scavenging aggregations that spiral hundreds of metres into the Kimberley sky on the thermals (rising hot air currents) at fire fronts. They are constantly alert for burnt offerings and creatures struggling to escape the flames.

As July progresses, freshwater crocodiles (freshies) begin overtures prior to nesting; these can include vocal and physical displays. The early breeding activity (from May and June) continues, and nesting (females') tracks and excavations can be seen on sandy banks along the Ord River, on the shores of Lake Kununurra and on the extensive shores of Lake Argyle.

In the west, the Fitzroy River and its many tributaries provide ample habitat for these ancient reptiles to breed and hunt.

The quiet of the night is shattered as large male freshwater crocodiles begin their territorial displays along the banks of Kimberley rivers and billabongs – there is a loud slapping as they slam their jaws together. This is part of seeking the best position to display their wares to passing females.

In between the slapping of jaws there are also hissing and throaty rumbles, and the remarkable bubbling and roiling of water along the animals' flanks caused by their vibrating the intercostal muscles between their ribs.

This activity will continue for a month or two, depending on conditions. The displays can eventually become aggressive; injuries to large adult male animals, including loss of limbs and jaws, are not uncommon.

Woe betide any adolescent crocodile that gets close to a large aggressive male – many juvenile animals will not survive the aggression of the males.

In coastal areas, threadfin salmon come close inshore through the turquoise waters of Roebuck Bay, often hunting in water less than 30cm deep. Spanish mackerel concentrate off Cable Beach, hunting across isolated reef systems for schools of bait fish.

The Indo-Pacific sailfish follows the Timor and Leeuwin currents and the nutrient-rich waters that flow north and south in response to the daily tidal movements.

Along watercourses and over rocky soils and sandstone ranges the spectacular

Overleaf: Pink mulla mulla (Ptilotus exaltatus)

117

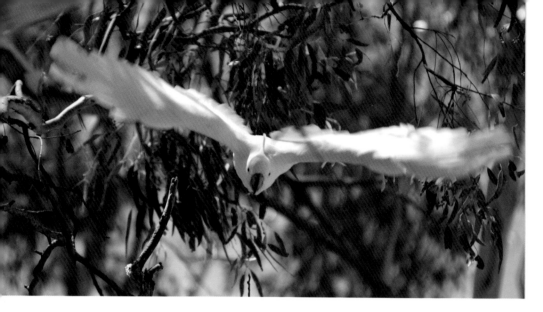

Kimberley heather is producing masses of white and mauve-pink flowers. A member of the same family as the eucalypts, it also has a highly aromatic scent when the leaves are crushed.

The kapok tree, which grows on the slopes of small sandstone hills near Warmun, Kununurra and Fitzroy Crossing, has a deciduous habit, dropping its leaves during the winter months but at the same time producing masses of showy yellow flowers and large fruits in bunches.

This species is a bush tucker and ceremonial plant for Aboriginal people – the flowers can be eaten and the downy seeds have been used to highlight headwear and ceremonial equipment. It is also a water supply tree.

Along the Gibb River Road the whitewoods are bursting into flower. Their large creamy clusters of flowers are most distinctive.

Visitors and locals alike have travelled the Gibb extensively by this time of year and the road has become heavily corrugated. Now dust hangs in the air for long periods following a vehicle's passing. The dust settles on the roadside vegetation and develops a streaked pattern across the foliage following the overnight dew set.

By mid-August freshwater crocodile nesting is in full swing.

Waterholes are contracting and consequently concentrating wildlife – food is in short supply for most creatures. On the Dampier Peninsula the cockatoos and parrots begin to congregate near the remaining fresh water.

Soaks at Carnot Bay and north near Lombadina provide refuge areas for large numbers of birds.

The mound spring wetlands north of Broome on the Dampier Peninsula and north of Kununurra between Westwood Creek and the Keep River in the Northern Territory play pivotal roles in providing water in what is now stressed and drying country.

Offshore the seabird rookeries are very active, as brown boobies, lesser crested terns

Sulphur-crested cockatoo

and frigate birds take advantage of the huge schools of baitfish that congregate through the Buccaneer and Bonaparte Archipelagos.

Breeding is rapid, and the boobies, frigate birds and several species of terns all reproduce as quickly as possible (six to seven weeks) to allow their offspring every opportunity to fledge and grow strong before the first devastating cyclone forms off the coast.

Though times are tough inland, the ocean remains bountiful for pelagic predatory fish.

Thousands of seabirds wheel and glide above schools of hunting northern blue-fin tuna and queenfish, diving into the feeding frenzy occurring below the surface.

Around island rookeries young birds are beginning their flying lessons – many are lost to the predators that gather to take advantage of this juvenile bounty. These include sharks, barracuda and crocodiles, which surge from beneath the water to catch unwary first-time fliers.

Hatchling freshies begin to appear. They can most often been seen at night in Lake Kununurra and Lake Argyle and along the upper reaches of suitable freshwater rivers and other accessible waterholes, such as at Windjana and Geikie Gorge.

Throughout the wetlands of Lake Kununurra and Lake Argyle the aquatic plant *Hydrilla verticilliata* begins to increase its growth. Large floating mats develop as the daytime and water temperatures begin to rise.

Top: Juvenile freshwater crocodiles feed on insects Bottom: Freshwater crocodiles Image by V Hayden

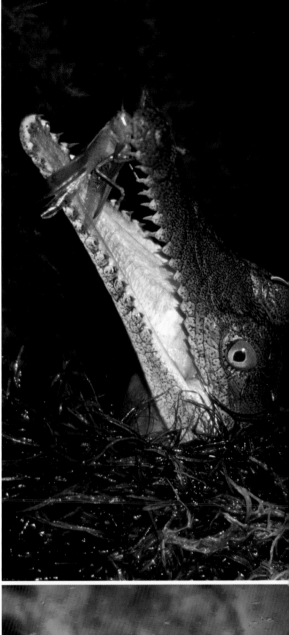

Young freshies can often be found resting and waiting on these for insects to fly, swim or crawl within range of their waiting jaws. Like all crocodiles, they have a series of sensory pits on either side of their jaws. These pits can detect pressure changes caused by motion, so when a suitable prey item comes within range the crocodile will snap sideways to take it.

On the seaward edge of the mangrove systems that are a feature of the Kimberley coast the spectacular flowers of the pornupan tree (*Sonneratia alba*) are in full bloom.

The showy white flowers hold a store of nectar that is targeted by both animals and man. The flying foxes feed extensively on it at night and man collects the flowers to drain the sweet nectar.

The wild pear has begun to produce flowers in the northwest Kimberley – in the

south, around Broome; the new buds are only just beginning to form.

The stark deciduous kurrajong trees have been producing their unique red flowers for many weeks and will continue to do so on the rocky hillsides of the region through to November. As the moisture content of the air rises with the approaching Wet, new leaves will grow and the tree will blend back into the masses of vegetation.

Across the region the parasitic mistletoes are bursting into flower. A specialist, called the mistletoe bird, feeds on the sticky fruit produced by these plants and transports the seed throughout its range.

Most birds adopt a perching habit with feet side by side, but the mistletoe bird perches with one foot in front of the other when it excretes the sticky seed of the mistletoe plant onto an unsuspecting host tree.

In areas of permanent fresh water with peaty-type soils, such as around the northwest end of Lake Kununurra, above Kings Cascade on the Prince Regent River and near the mound springs at Mandora,

Sticky kurrajong
(Sterculia
viscidula)

the flowers of the white dragon tree, a member of the pea family, are on display in all their glory.

The flowers attract a wide range of pollinators, including birds, bats and insects, and they can also be used as a food resource by people.

In years when the east wind is not strong and many cold fronts cross the southern parts of Australia, there can be heavy dews and regular sea mist or fog during this period, particularly in near-coastal areas or where there is significant water in dams or wetlands.

These years are characterised by warm daytime temperatures and mild nights, and this allows for a burst of insect-breeding activity that attracts many birds and small reptiles – for them, these years are good ones.

The black field crickets (*Teleogryllus* sp.) respond to warmer conditions at this time of year and begin to breed and hatch. They can become a social issue as they concentrate in huge numbers and are attracted to the bright lights often found in towns.

Humpback Whales

The Collier Bay area on the West Kimberley coast is renowned as one of the premier humpback whale locations on the Western Australian coast, and some unforgettable whale-watching experiences can occur here.

The Bay has one of the largest tidal ranges in the southern hemisphere, with 11-metre (plus) tidal variations not uncommon. With generally calm seas experienced during the whale season it is an extraordinary habitat.

Mistletoe
(Amyema *sp.*)

The first arrivals can be viewed usually around mid-June as they make their way from the Antarctic winter to the tropical winter of the Kimberley, staying for up to 5 months before returning down south; the last of the whales begin their southern journey during late October.

Neap tides produce a minimal amount of variation in tidal movement (ensuring the bays and inlets of the region have good levels of water within them) and are the best time to view the whales.

Frolicking and socialising in the shallow bays for days on end, pods of up to fifteen or more whales can be seen.

It is at these times that observation of typical Humpback behaviour can be seen in close vicinity to the shoreline. Tail slapping, breaching, head raising and, if you're lucky enough, seeing the adult males suspended vertical, tail aloft above the water and singing mysterious messages to others of their kind.

The smaller Deception Bay is midway along the coast of Collier Bay and has often proven to be an attractive location for this type of activity.

The spring tides can bring tidal speeds approaching 12 knots in places and the Humpbacks are forced into deeper, more open water. Here they use the tides to move north and south, travelling between the bays and inlets.

It is on these days of cruising wide that the whales are seen regularly breaching with their bodies completely out of the water.

Collier Bay is recognised as a 'lactating area', where the mothers fatten up their newborn calves in the shallow warm bays and inlets; it is one of whale watching's great pleasures to view newborn calves learning the skills of survival in very safe waters.

Occasionally Killer whales (*Orca* sp.) have also been seen in the Collier Bay area before heading west to the Rowley Shoals to follow the southern migration of the Humpbacks as summer progresses.

Humpback numbers appear to be on the increase, with larger pods encountered every year. Although a far cry from their former numbers, the whales of Collier Bay appear to be back from the brink of extinction.

Pete Tucker

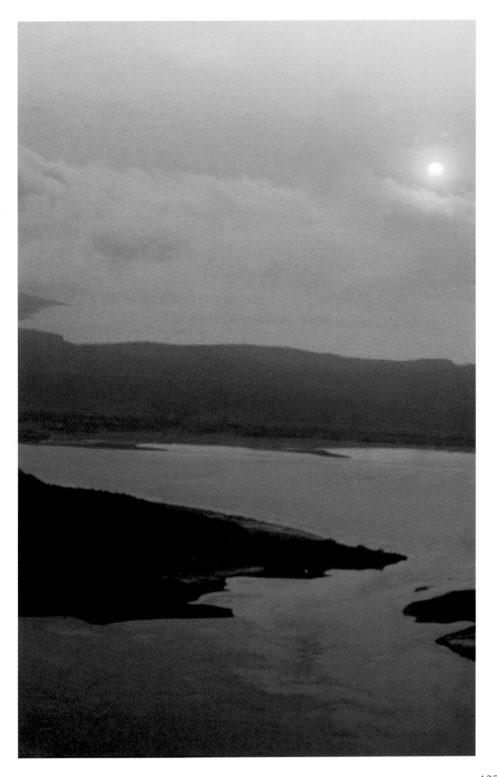

Sea fog,
Kimberley coast

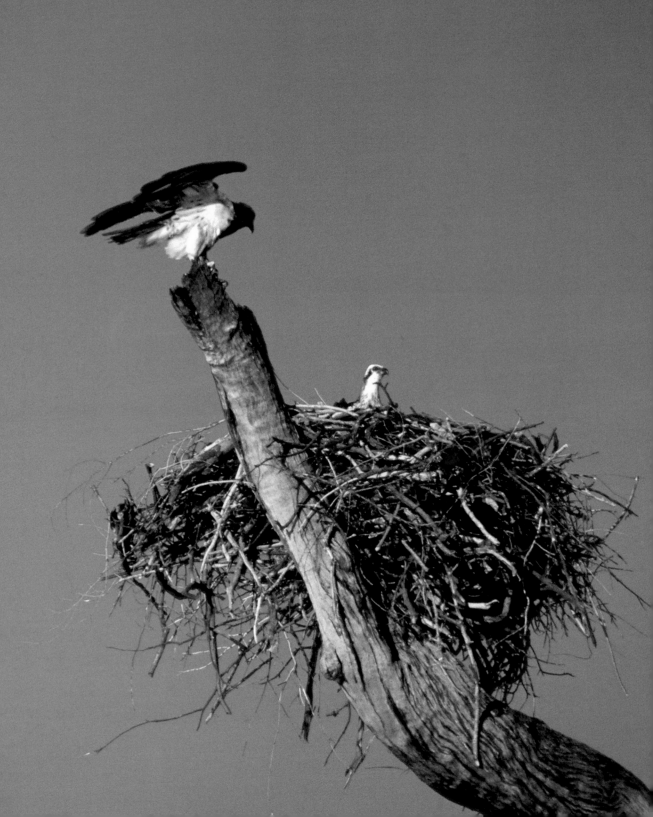

Raptors of the Kimberley

Raptors (from Latin *raptor*, a plunderer) are birds of prey that are usually most active during the day. In Australia two major families of the Order *Falconiformes* represent them.

One family group is the *Accipitridae*: representatives of this group are the hawks, the kites and the eagles. The other family group is called *Falconidae*, and is made up of the falcons.

All raptors are strong-bodied, short-necked carnivorous birds with sharply hooked bills that are designed for ripping and tearing.

Prey items, such as other birds, small mammals and reptiles, have their skin or feathers removed and then are torn into small morsels and eaten. Birds of prey have highly acidic juices in their stomach and digestive tract that enable all parts of their food to be rapidly digested.

There are a number of characteristics that separate the two family groups.

All kites, hawks and eagles hunt while flying. They cover large areas searching for prey, gliding, soaring and stooping (diving or swooping) onto stationary prey or carrion. Some species will also glide down to prey from a perch. They are able to pick out potential prey items from great distances due to their well-developed eyesight.

When the young hatch, they do so successively, with the older chick demanding and receiving a much greater proportion of the available food. This hatching strategy is

Osprey at nest

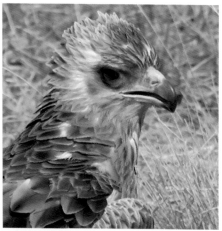

designed to ensure that every opportunity is given for the successful raising of at least one offspring.

Most members of this family are solitary and territorial, but the kites will often flock onto food. In the Kimberley it is most frequently the black kite and the whistling kite that do this.

I've seen these abilities first hand on a number of occasions and it never ceases to amaze me that these birds have an inbuilt ability to locate food and pass this information on. There is no doubt eyesight is one of their most impressive weapons.

I was driving between Derby and Fitzroy Crossing in August of 1996 when a large ginger cat ran across the highway into the grass on the north side. As I slowed the vehicle down I was extracting a .308 calibre rifle from its case. When I stopped the vehicle I noticed that a black kite had joined the unfolding events as it swooped down to perch on a eucalypt tree close to where the cat was hiding in some grass.

I kept an eye on the kite as it intently watched the grass refuge of the cat, and as the cat slunk out and began to cross an open grassless area it took off and began to circle. I was able to load the rifle, take deliberate aim at the cat and end its life painlessly.

The kite swooped down from its circle work and began to feed on the carcass, and within the space of perhaps five minutes was joined by half a dozen other kites, who proceeded to demolish the remains of the cat to some wind-blown fur and wet soil.

These other kites were nowhere to be seen as this drama unfolded, yet, presumably with their superb eyesight, they had noticed something different in the way the first bird had swooped to begin feeding and had zeroed in on the action.

A further adaptation of the hawks and eagles is an automatic and spasmodic clutching mechanism associated with their talons, which allows them to grasp and hold prey items firmly and securely.

*Top: Whistling kite
Bottom: Australian (nankeen) kestrel
Image by Russ Greig*

Adaptations such as this are best appreciated when watching the white-bellied sea eagle and the osprey at the hunt. To observe these magnificent birds of prey stooping to wetlands or estuarine habitats and taking unaware fish from below the surface is a truly impressive sight.

Hunting across mirrored waters, the osprey can see bony bream and catfish that rise to insects feeding on the water surface, and with well-timed stoops they crash, talons first, frequently almost completely submerging, onto the prey item. Their clutching mechanism comes into play and they rise with powerful wing beats to a perch and begin feeding.

The wetlands of Lake Kununurra have provided me with many opportunities over the years to observe both these species at the hunt. Ospreys frequently nest and raise young in the flooded forests and under the water – the incredible variety of flora and fauna all contributes to allowing these birds to live successfully in the area.

The falcons are small to medium-sized raptors; their talons lack the clutching mechanism described above. True falcons chase, strike and capture their prey on the wing. They have longer, thinner, more pointed wings than the other raptors. Also, several bones in their spine are fused. This gives them greater rigidity, allowing them to develop and use very strong wing muscles – they can stoop or dive at tremendous speed and kill by severing the neck of their target with a single slashing bite.

I have been fortunate to observe the power of grey falcons smashing through flocks of zebra finches beating towards acacia tree refuges. The sound generated by the speed of the falcon through the air is reminiscent of a freight train, and watching the small, almost imperceptible adjustments to wing tip and angle prior to the strike shows what masters of the air these birds truly are.

Other related species, such as the Australian kestrel, hover and drop onto their prey; yet others take carrion from other birds of prey. The young of this group hatch simultaneously. It is possible that this breeding strategy is designed to take advantage of the seasonal increases of potential prey items.

In Australia there are 18 species (in total) of kites, hawks and eagles, and six of falcons. There are only six species from the two groups together that are recognised as endemic to Australia.

All the Australian representatives of this order can be found in the Kimberley. Some are more common than others and some arrive in the Kimberley in response to seasonal events such as eruptions of native and introduced rodents and following events where insects (such as grasshoppers) swarm in massive numbers.

In the wild there are several Australian raptors that are under threat as a direct result of human activities. The peregrine falcon, in particular, has suffered as a result of the intake of agricultural and pesticide residues (especially DDT).

Raptors are at the top of the food chain, so any insecticide/pesticide residue in their prey concentrates in their bodies – these been implicated in reducing the reproductive capacity of peregrines.

The major impact on the raptors is the increased fragility of their eggshells. Under normal conditions the eggs are able to sustain the day-to-day movements and turning associated with incubation and with relatively heavy birds landing in the nest. Reduced shell thickness can result in damage to or even breakage of the eggs, with the end result that clutches are not raised and the population begins to diminish.

An endemic and rare species, the red goshawk, is found in woodland and forest areas and several birds have often been seen on the Ord River floodplain. The greatest threat to this species is probably habitat changes as a result of human activities associated with the clearing of vegetation for agriculture and the inappropriate use of fire (a persistent problem in this area). These activities directly impact on the availability of prey and habitat, and as a consequence the red goshawk suffers.

Another endemic species, the letter-winged kite, usually hunts at night, targeting rodents such as the long-haired rat (*Rattus villosissimus*). This raptor's population seems to respond dramatically to eruptions in rodent and insect populations. There can be excessive reproduction when resources are abundant, followed by a population crash as food diminishes – a boom and bust survival strategy.

Of the species more frequently seen in the Kimberley, the black kite is probably the best known. An adaptable species, it seems to respond well to the conditions created by humans. A visit to a town or community rubbish tip will let you see flocks of hundreds of this species – its hover and swoop habit is familiar to anyone who has observed a fire event in Kimberley grasslands.

There have been numerous stories about the abilities of this bird to assist in the spread of fire, and indeed the Aboriginal people of the east Kimberley frequently refer to this kite as the firebird. Black kites are often seen swooping at the fire front to capture insects and other prey that are forced from cover as a fire races forward. Occasionally, either by accident or design, they will pick up a burning or smouldering twig and carry it in their talons for some time, eventually dropping it. Sometimes they are seen to drop the firestick forward of the fire front and it has been speculated that they are increasing the burning area for their own benefit.

Around the large manmade impoundments of Lake Argyle and Lake Kununurra, and in coastal areas and on offshore islands, it is possible to see the osprey at work.

This species is renowned for its ability to catch the fish that are a major component of its diet. In many parts of the world the osprey population declined dramatically during the 19th and 20th centuries entirely because of the impacts of human disturbance.

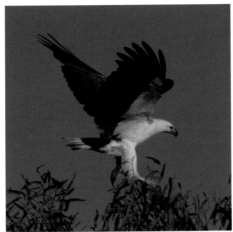

The major threat now seems to be pollution of feeding and breeding grounds. There were major impacts associated with excessive pesticide use in the Ord River Valley during the 1960s, when up to several tonnes of DDT were applied to cotton crops per week in an ill-fated attempt to control insects.

The black-breasted buzzard is unusual amongst the raptors, as it has been recorded using tools to obtain food. A recent television program showed footage of this species using a rock held in its beak to break open an emu egg to access the yolk. Generally, however, this species feeds on a variety of live animals, ranging from insects to reptiles, birds and small mammals.

In flight it is unmistakable: large and dark, with long, round-tipped wings that are held up at an angle to the body to reveal a pair of large, round white 'windows' at the base of the flight feathers.

The wedge-tailed eagle is the largest bird of prey in Australia, with a wingspan of up to 2.5 metres. It hunts by soaring to great heights on thermals to search for potential prey on the ground. It is probably one of the best known of the raptors in Australia, and is also found in southern New Guinea.

Early last century this species was believed to threaten the sheep industry and up until as recently as 2000 there were still some WA wheat-belt shires that allowed these magnificent birds to be shot.

Birds of prey are an integral part of the Australian continent and they fulfil a variety of roles, from responding to plague events involving insects or rodents, to controlling sea bird and flying fox populations, to generally just looking spectacular as they soar over the ancient landscapes of Australia.

Left: White-bellied sea eagle
Right: Black kite

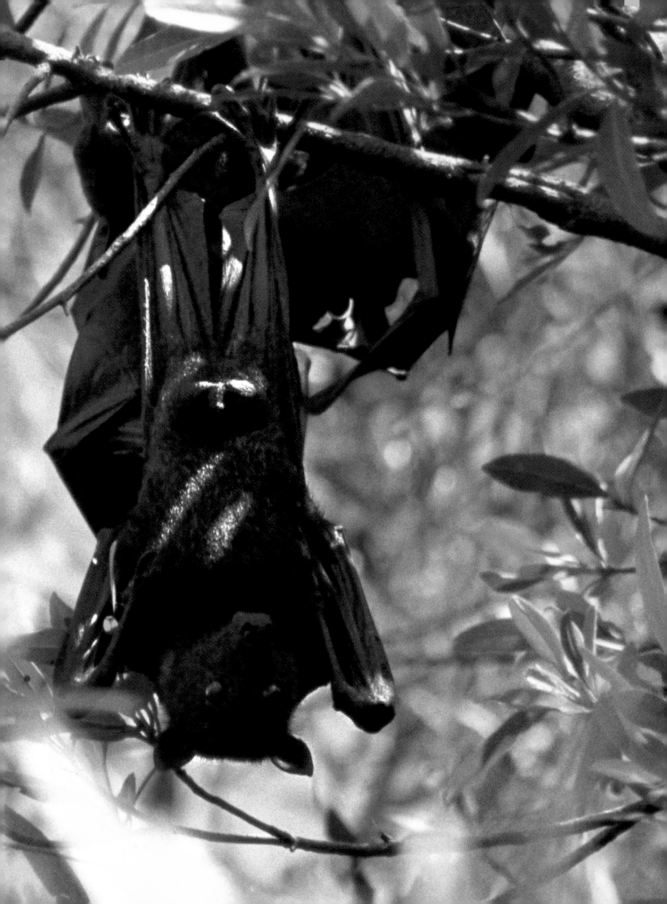

Flying foxes

They require to be carefully prepared, as the skin and fur has a rank and powerful odour; but they are generally cooked with an abundance of spices and condiments and are really good eating, something like a hare.

Alfred Wallace, 1869

A feature of the Kimberley bush is the evening exodus of thousands of flying foxes from their camps searching for new sources of food. Two species, the black flying fox (*Pteropus alecto*) and the little red flying fox (*P. scapulatus*), are found through the Kimberley.

The flying foxes and their relatives are distinguished from other bats by a number of characteristics: their diet consists of nectar, pollen and juice from the fruits and flowers of plants, they are usually large (the black flying fox can have a wingspan up to 1 metre from tip to tip), and they rely on their eyesight and sense of smell to locate food rather than on echo-location (the use of sub-sonic sound to find prey).

The mega bats, as they are called, spend the daylight hours in camps, which are usually close to fresh water. In these camps there may be several thousand individuals – I have seen some roosts near Kununurra and on the Berkeley River that almost defy belief, with bats numbering in the hundreds of thousands.

These communities have a complex social structure that results in constant vocal exchanges and 'bickering' – these generally appear to concern occupancy of areas within the camp.

Male black flying fox Image by R Grieg

133

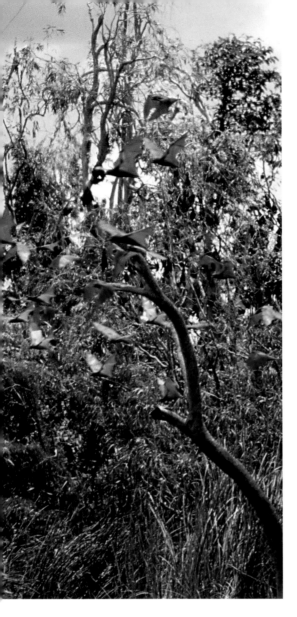

Flying foxes have developed a number of methods to locate feeding areas and then pass the information they have gathered on to the multitude. Initially camps will send out scouts – usually males – to scour the countryside within flight range of the horde. Upon returning to the camp an unusual information-sharing strategy apparently occurs, with many bats scrambling to taste or smell other camp members' urine, presumably with the aim of determining who was eating what last night. It seems others will follow the bat with the sweetest tasting/smelling urine to the food source!

The masses of bats within a camp may appear to be totally disorganised, but there is actually a well-defined set of social prompts that maintain harmony. On the top of the roost site are the older males – they are there to provide a defensive barrier and warning alarms to the female and juvenile bats, who are usually found in the middle to the lower reaches of the colony.

The trade-off for placing themselves in harm's way, so to speak, is that they remain relatively clean – you can imagine the quantities of urine and other excrement that will be falling from the males onto the females and juveniles!

The distinctive aroma that flying foxes are renowned for obviously comes from this – but the other interesting point is that adult males appear to use this aroma to help them identify females during the breeding season – unfortunately for some of the male juveniles, they are sometimes mistaken for sweet-smelling females!

Flying foxes are a conundrum of sorts, especially in today's conflicting climate of conservation and production.

If you are a commercial fruit grower around Broome, Kununurra and Derby (to a lesser extent), you may dread the warmer months of the year when the mangoes,

Little red flying foxes at camp

134

pawpaw and other tropical fruits are beginning to ripen – it is possible to watch your livelihood disappear over several nights.

On the other hand, without flying foxes, most of the diversity of plant and animal life that occurs in the Kimberley may disappear.

There have been some success stories concerning flying foxes and fruit growers. In Kununurra in the mid-1990s, cashew production was being trialled, and there were occasional forays by black flying foxes targetting the sweetly astringent fruit of the cashew trees – unfortunately the cashew nut is attached to the fruit and the bats would fly off with the profits.

Following similar incidents in the Northern Territory, sacrificial cashew crops were planted (to draw the bats away from the main crop) and a series of suitable roost trees were planted adjacent to those crops. The bats would take the cashew fruit up to the roost trees, process it and drop the remainder onto tarpaulins laid under the trees – the cashew grower would then harvest cashew nuts that had been picked, cleaned and processed for him by the bats.

Top: Flying foxes prefer native fruits and flowers Bottom: Flying foxes are important pollinators of mangroves also (Brugeria sp.)

The conflict between fruit growers and flying foxes arises because many of the commercial fruit crops found in Australia have been developed from wild species that were probably originally fed upon and pollinated by the bats (and of course much of their original habitat has been removed to grow these crops).

Flying foxes have been described as ecological linchpin animals: linchpins keep the wheels on a cart – if they are removed, the wheels fall off! They are immensely important to many natural ecosystems. The methods they employ to feed and the distances they travel make them potentially more important than birds and insects as the major pollinators of a host of native trees: they stuff flowers and fruits into their

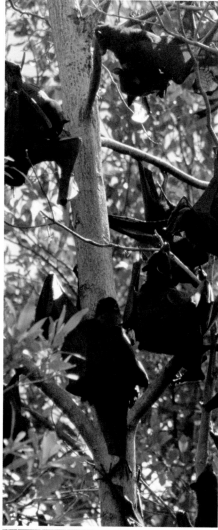

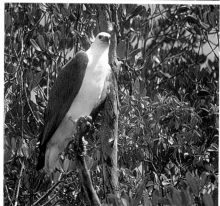

mouths while clambering about in the canopy, getting covered with pollen and other genetic material which they then carry to the next feeding area.

A huge number of important timber species and the wild progenitors of many of the tropical fruits, plus literally thousands of other plant species, depend on flying foxes to help maintain this diversity. Without them whole ecosystems would collapse.

Scenes of these animals in conflict with people must be balanced against a number of factors, of which land clearing and habitat destruction are by far the most important. Of course there will be conflict if a food resource is removed – the animals will move on to the next best thing, which in most cases will be our own resources.

Replanting unproductive areas and degraded lands with suitable native shrubs and trees will provide all the necessities for these animals, and many others. It may also reduce the chances of seeing thousands of tonnes of valuable topsoil rolling across our cities on the east coast, reduce greenhouse gases and reduce the impact of other wildlife on our crops.

On the other hand, flying foxes are a source of human food in many other countries, and indeed were used by Aboriginal people for this purpose as they became seasonally abundant. Flying foxes have strongly flavoured red meat that tastes quite good when combined with condiments.

Pre-European and firearm days these animals were harvested in a sustainable

*Top: Black flying foxes at camp
Bottom: White-bellied sea eagles prey on flying foxes*

fashion and were just another seasonal resource of much-needed protein; the harvesting had a minimal impact on populations.

The potential impacts of indiscriminate hunting, both for food and control, are likely to be devastating. Take, for example, the two species of flying fox that lived on Guam in the Pacific Ocean. Due to excessive hunting, one species has not been recorded for almost 30 years and the other has been pushed to the edge of extinction, largely because of over-hunting.

Humans are not the only animals that prey on flying foxes. During the build-up to the monsoon in northern Western Australia, large aggregations of black flying foxes and little reds gather in the paperbark forests around the impoundments of Lake Kununurra.

From these bases they fly out in massive numbers searching for food each evening, in the afterglow of the setting sun. As the animals fly from the camp they take the opportunity to get a drink of water – gliding down over the glassy lake they lap water as they fly just centimetres above the surface.

Suddenly the water erupts and a crocodile lying in ambush just below the surface thrusts upwards, jaws agape and snapping … and knocks the mega bat into the water.

Immediately several other crocodiles surface and charge for the injured animal. It is all over in a matter of seconds. Yet the bats keep coming; the need for water overcomes their fear of what lies in wait in the lake.

White-bellied sea eagles work the colonies in pairs. One waits high up on a vantage point, ready to snatch an unwary bat as his partner flies around, over and eventually straight into the canopy camp, terrifying and panicking the masses of animals into flight – young, old and infirm bats become easy prey for hunters who work in teams like this. Goannas, owls and snakes, and large fish, such as barramundi, all prey on flying foxes.

Both species of Kimberley flying fox are early to late wet season breeders. Up to two young are produced. Being mammals, they bear live young that are suckled from nipples located towards the junction of the wing and the body of the female bat.

Flying foxes and other bats are often seen flapping and vibrating their wings in the camp or roost. The fine skin membrane that is their wing is rich in blood cells close to the surface, and moving their wings helps cool them down. These blood-rich areas also attract a variety of bloodsucking insects, particularly ticks, mosquitoes and members of the family of biting midges known as the sandflies.

The invisible itch

One midge is an entomological curiosity, a thousand can be hell!

Doug Kettle

The Kimberley region of Western Australia is home to some 17 species of mangrove plant communities that provide habitat for a huge variety of animals and fish.

Along with a spectacular wilderness, one can encounter glorious fishing, magnificent bird watching, a wonderfully diverse flora … and, of course, the biting midges, *Culicoides* genus, collectively known by their common name, the sandflies.

Australia is home to 174 different species of *Culicoides*, all identified by the unique mottled patterns on their wings, but incredibly, at least in the Kimberley, perhaps only two of these actively feed on humans: *Culicoides ornatus* and a sub-genus known as *Leptoconops*. The latter is a nasty piece of work, producing persistent reactions which may blister and weep serum from the site of the bite in people who are sensitive to them.

I know instantly what's going through your mind, because at some unfortunate period in your life you got to know these little critters intimately. There are horror stories and then there are sandfly stories. Everybody has one – it's just the level of pain, suffering and extreme itching that varies.

Even after many years of living and being fortunate enough to travel extensively in the Kimberley, it is hard to get excited about memories of sandflies.

Mangroves are home to Culicoides *sp.*

How could something so small, something that's barely discernible, cause such grief? What the hell good are they? Does anything benefit from their existence? How in the blazes do you stop them? You've got to be joking – they urinate on you!

The Kimberley is by definition situated well within the tropics, and it is sandfly habitat. The difference between the seasons is dramatic and the landscape goes through a remarkable transformation, but throughout it all the sandfly waits patiently, for a mammal or bird or reptile or amphibian – in fact, any species that breathes and has blood.

Australia is home to a multitude of biting insects. Everyone is familiar with mosquitoes and the dramas they can bring, and there are the March flies that always seem to come in November, but nothing really competes with sandflies.

But they're not really sandflies, they're biting midges. True sandflies are relatively innocuous and pretty harmless to us. Not like these guys. An encounter with them can make you feel you've had a bucket of itch tipped over you!

So what is their technique? Generally, most biting insects are attracted to us because we excrete carbon dioxide – this is mainly done through air exchange as we breathe, but it also comes through our skin, and the aroma is like a beacon to some of the biting midges. Why carbon dioxide? Well it's actually indicative that a warm-blooded animal is in the vicinity, and if you're a blood-feeding insect,

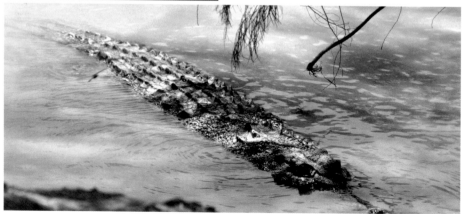

Top: A 'sandfly' (Culicoides ornatus) Image by A Lowrie
Bottom: Crocodiles are also food for biting midges

the greater your ability to detect your food source, the better your chance of continuing your species' existence.

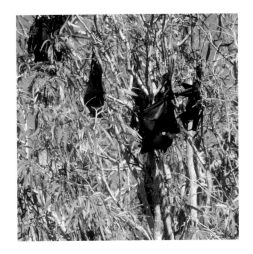

A factor that helps *Culicoides* is their size. They really are almost too small, with a size range from less than 0.5 mm to about 2.5 mm. This size causes big problems for those unfortunates amongst us who present as more obvious food.

When the midges feed they bring a set of specialised mouth parts (mandibles) into play. These mandibles act like a miniature brace of saws lying parallel to each other and able to be moved alternately – these cut through the tougher outer skin into the capillary layer below.

While the incisions are being made, the midge salivates, not only to lubricate the 'saws', but in some species to also introduce an agent which helps stop the blood clotting, thus making it easier to feed on the flowing blood.

The reaction that affects many of us is probably due to antigens in their saliva. If we were able to introduce our saliva into their blood the reaction would be just as devastating. Pity they're so small!

But the best is yet to come: usually only the females feed on blood. It's the same with most other biting insects. This is probably due to the fact that it's females who have to develop eggs after mating with a male they can barely see (generally the male is smaller than the female), so it's more important for them to eat high-protein food. The males generally just feed on nectar.

While they are a significant annoyance to humans, there is considerable evidence that biting midges can also be a vector for a range of viruses that can affect other creatures as well as man.

In Australia, some species are responsible for such nasties as Blue Tongue Virus and Akabane Virus in sheep and cattle; these viruses were possibly introduced to this country, and are very horrible.

So what is their habitat? Where do they live and breed and bite? Predominantly mangroves and the wet, sandy (ecotone) areas associated with these. However, they have been found on any vegetation associated with their preferred breeding habitats. This includes moist grassy areas such as the lawn at the hotel, and vegetation around swimming pools. So even though they came from the mangroves, what we are able to offer is pretty suitable too.

Blood is taken from the wings of bats

Most adult species only disperse a short distance from their breeding areas, unless

it's a windy day. And bright lights and barbecues really do act like beacons. Their bites are not confined to any hour of the day or night, but they can be particularly aggressive during the evening, especially if the tide is in and it's a humid, still night.

The *Culicoides* do have an ecological niche, though. One species, *C. anopheles*, actually feeds on the lymph (a blood constituent) of the *Anopheles* mosquito – that other biting insect known for its propensity for spreading malaria. Also, the females of the biting midge family (*Ceratopogonidae*) are mostly predatory on a range of other insects, and this aspect of their behaviour can be quite helpful. And both males and females also feed on nectar, and several are pollinators of economically important plants. The larvae of several species feed on a range of nematodes or segmented worms that may feed on us. They are also a food source for a range of other helpful insects (such as dragonflies) and their larvae.

In most cases, when we come across these biting midges we quickly develop a desire to be elsewhere. Can we do anything to reduce their impact upon us?

Biting midges occur all over the world, from the tundra to tropical rainforests and people of all races have experimented with a range of repellents. The sandflies' smallness and mottled camouflaged wings give them protection when they land on exposed parts of our bodies, and they will readily enter a net designed to keep mosquitoes at bay.

Throughout parts of Asia, especially in southeast Asia, smoldering fires provide

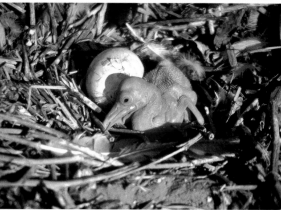

Top: 'Sandflies' (biting midges) are tiny Image by A Lowrie
Bottom: Hatchling pelicans are an easy target for midges

142

some relief for stock and humans; people have been known to tie burning cow-dung sticks to their waist to protect themselves with smoke. In fact this smoke-style repellent seems universal. Aboriginal people in the Kimberley and the Top End also use smouldering white mangrove (*Avicennia mariner*) for the same purpose.

There are, of course, any number of commercially available repellents, none of which is really effective. And then there are the homegrown repellents. I was particularly intrigued by the dark rum, vitamin B and garlic concoction I first heard about in Kununurra. I did try it for several weeks, but no one would talk to me and the 'sandies' thought it was a marinade.

But the best approach is to create a barrier, if you can. There are now dome-type nets available which appear to stop these little biters in their tracks. Made from nylon, they have a mesh so small that sandies can't get in. The down side is that they don't let much breeze in either, and they are susceptible to sparks and embers from campfires.

Dress sense is probably most important. Cover up when in sandfly territory – in particular, make sure a hat is part of your protection, as midges burrow into the hair on the scalp to bite and a lumpy, itchy scalp is not something to look forward to in the tropics.

Protecting exposed skin with a lotion-type repellent and regularly replacing it as it sweats off or is washed off can provide one degree of protection. Personally I use an oil-based lotion I have developed myself – it seems the most effective one. It has only a minor repellent factor, but it does create a barrier which midges and several other biting insects cannot get through.

All in all, an encounter with the biting midges is one to avoid. The results are usually devastating, and almost always in the midges' favour.

Some people appear to develop immunity through extended exposure, and some lucky individuals are just plain revolting to the biting midges' delicate palate. But if you're intent on viewing some of the most remote and pristine habitats in the world, you'd better also prepare for the sandfly encounter of a lifetime.

Spring (September–November)

During September, daytime temperatures begin to rise (especially in the northern parts of the region), but are still comfortable. On the west coast sea fogs are often encountered in the morning; they have a unique salty dampness that can blanket the near-coastal areas and affect marine-based communities such as Broome and Derby.

These fogs can often be of such concentration that the Sun may not burn them off until late in the morning. In the pindan woodlands spiderwebs are coated with a glistening wetness of dew, reducing the webs' efficiency until late into the day.

Around the waterholes and along the freshwater sections of the tidal rivers the silver paperbark is heavy with flower and the air is heavy with sweet, cloying aromas as the plants vie to attract pollinators. The nectar literally drips from these bottlebrush-like flowers – and it can be gathered to make a sweet and refreshing drink.

The leaves of the silver paperbark shimmer and shine in a rippling cascade as the winds begin to shift to the north and west and the season begins another change. The shining effect is caused by the tiny hairs on the underside of the leaves, which catch and reflect sunlight.

There are many species of melaleuca (paperbark) found in the region. Some of the largest are the cadjeput trees, which can reach heights in excess of 15 metres. The masses of flowers these trees produce attract insects, birds and the predators of each.

Inland the hot fires of the Dry have wreaked their havoc across the parched grassland and woodlands. Many trees have been killed and exotic pasture grasses take the opportunity to move in and dominate the landscape.

Pink anemone and pink anemone fish (Rowley Shoals)

Some areas are taken over by the spear and soap wattles. The monocultures that result from these fire events cause many long-term problems for biodiversity of the region.

The constant burning that is a feature of this time of the Kimberley year results in blackened areas that can cover many square kilometres.

As the ambient temperatures begin to rise with the coming of summer the burnt areas begin to act as a heat sink, absorbing and storing the sun's radiant heat. On hot windless days the thermals created above these areas often result in the creation of a willy-willy – a localised and tightly spiralling vortex of wind carrying masses of ash and other burnt material high into the sky. These black spirals can often contribute to

Webs are easy to see covered in dew

the continuing fire cycle, as they pick up smouldering embers and transport them over long distances in a very short period of time.

There are many floral shows at this time of the year. Travelling through the region visitors will see masses of the glorious mulla-mulla that occurs in a range of colours, from silver-green through to lilac-pink.

The flatback turtles are still nesting in the north and the black jew or mulloway, a type of fish, comes close to the shore hoping to catch unwary hatchling turtles.

The ocean temperature is beginning to rise – which contributes to the fogs. This rise is a signal to the humpback whales to begin their southern migration with their new calves. The massive stores of insulation they have collected could become life-threatening if they remain in the north much longer.

Along the coast the red-tailed black cockatoos are feeding on red flowering gums and the large family groups are reacquainting themselves with their lifelong partners. Soon the first rains will bring new growth of seeds and terminal branchlets that they can use for food and to line their hidden nesting hollows.

The fires of the past years have decimated many of their traditional nesting areas, and suitable nest hollows are becoming few and far between. Many birds may not even breed.

West winds prevail along the Dampier Peninsula while in the north the days become hot and calm.

Around Lake Kununurra freshwater

Top: Hibiscus *sp. begin to flower in spring*
Bottom: Bottlebrush (Melaleuca *sp.*)

147

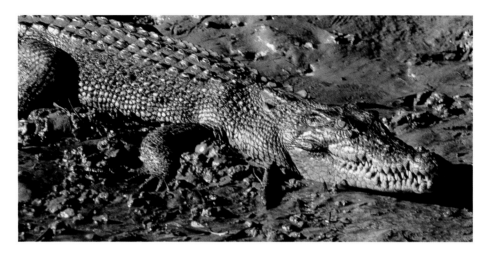

crocodiles lie in ambush near the large flying fox colonies, waiting for these large bats to glide over the open waters and drink on the wing – it is possible to see crocodiles launch themselves from the water to catch bats mid-flight.

October is the start of the build-up – daytime temperatures begin to increase and there is plenty of thunderstorm activity and rising humidity.

The rising ambient temperatures, the rumble of thunder and the presence of lightning are all catalysts that encourage the saltwater crocodiles (salties) to begin breeding. It will be three months before the eggs from their union are ready to be laid in the large mounds of vegetation that the female constructs. With the desire to breed comes increasingly aggressive activity, particularly from the males.

Salties are essentially solitary animals (unlike many of their cousins) and rarely act in a cooperative manner. At this time of the year the young mature males (those longer than three metres) begin actively seeking new territory – so there are big crocodiles making regular sorties into the established territories of other males. Territory is selected on the basis of (among other things) availability of food, availability of nesting resources that the female can use and availability of fresh water – if a male can hold a territory he has a better chance of being selected by a female.

Feeding activity increases for these animals as the rising temperatures impact on their metabolism – they are hungry all the time and keen to replace fat reserves lost during the colder months. This activity can occur from now through to at least May. Most crocodile attacks on humans occur during this eight-month period.

With the rising humidity that Kimberley floral icon, the boab tree, begins to produce new leaves, and this new growth is a startling colour contrast against the brilliant blue of the sky.

Across the Kimberley Plateau and south to Broome the sweet aroma of gardenias perfumes the bush. On the pindan plains they take the form of low, sprawling shrubs;

Young male salties are aggressive

on the plateau a related species can become a tree. Their unusual flower whorls are a thick cream white with petals arranged in overlapping sequences.

On the alluvial plains or on poorly drained areas the deciduous large-leaf cabbage gum becomes noticeable as it produces masses of new purple foliage and stunning white bark in anticipation of rain.

In the wetland areas the swamp paperbark begins to flower – its sweet aroma inundates the air and acts as a beacon for many different species of insects and birds.

The red-collared lorikeets arrive in large numbers to drink the sweet nectar, coating their bodies in masses of pollen, which they then carry to the next trees. Bar-breasted, red-throated and singing honeyeaters flit from flower cluster to branch, taking nectar and insects in equal quantity.

In towns, particularly in the east Kimberley, the raintrees are producing masses of pale green flower clusters. The sweetly cloying aroma attracts many honeyeaters and insect pollinators. These trees are rainforest specialists; introduced into Kimberley townsites as ornamental trees from the Northern Territory, they carpet the ground with the cast-off remains of their flowering activities.

This is an active time for birds – it is important that they exploit as much of the available food resources as possible before the difficult times come around again.

Migrating south from Asia as the southern summer weather patterns develop come the orioles, and their metallic 'tonking' calls begin to be heard in the north and east.

Around and on the freshwater wetlands, the large floating mats of cumbungi (*Typha domingensis*) begin to set seed. Moving with the whim of winds and currents, these mats can travel over 40 kilometres in a day, spreading genetic material as they go and causing minor territorial disputes for their resident bird life – the crakes, crimson finches, jacanas, reed warblers and cisticolas.

The days are becoming hot by the end of the month and the wind has begun to back to the north and northwest, bringing moisture to increase the humidity.

In the north and east thunderstorm activity increases daily as the region moves into November. Massive build-up storms made up of cumulo-nimbus clouds herald the coming rainy season. Insect activity increases and multitudes of locusts hatch in the grasslands – whether they plague or not will be determined by a number of factors, including continuing rainfall, food availability and temperature.

When there has been significant localised rainfall near a bitumen road, drivers should be vigilant to avoid killing basking frilled lizards – they are attracted to the warm steaming conditions of fresh rain on hot tar.

Seasonal visitors continue to arrive in increasing numbers – in the north and east there are the dollarbirds, with their spectacular swooping flight and chuckling calls, and the channel-billed cuckoos, showing their direct and loping flight.

Resident jacanas on the wetlands near Kununurra run for cover, with their chicks

149

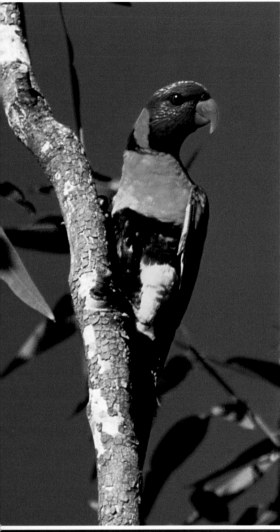

clasped under their wings, from the willy-willys that roar across Lake Kununurra from the northeast.

Along the coast, and particularly around the shores of Roebuck Bay near Broome, the migrating wader birds begin to concentrate in their thousands. These birds are truly incredible wanderers. Many have flown from the northern hemisphere, from breeding areas on the steppes of northern China and Russia. They come to northern Australia to avoid the decimating cold of a northern winter, and to feed on the biomass of benthic creatures across the exposed tidal flats of Roebuck Bay.

All are specialists: each species has evolved a bill length that allows it to target creatures at a particular depth in the chloropal muds of the tidal areas. This way they avoid direct competition for feeding areas.

During daylight hours they track the movement of the tide, following as it ebbs and moving in front of it as it floods. At high tide it is common to observe thousands of birds of many different species congregated together at select sites around the bay. At nighttime many of them will roost in the mangrove communities in the area and on the wide expanses of Cable Beach.

This is the time to visit a spectacular diving destination: the Rowley Shoals. Located some 170 nautical miles (340km) west of Broome, the Shoals are home to huge varieties of marine life – all well-known reef species can be seen there, as well as large pods (sometimes more

Top: Red-collared lorikeet
Bottom: Spinner dolphins (Rowley Shoals)

than 60 animals) of spinner dolphins. These incredible marine mammals use their powerful tail to propel themselves metres into the air, executing spectacular spinning acrobatics. They come to the Shoals when the coral spawns. This attracts a smorgasbord of creatures that create a food chain that culminates with the dolphins, orcas, humpback whales, sharks, Indo-Pacific sailfish, manta rays and other top line marine predators.

Washed by the southerly flowing Timor Current, the Rowley Shoals includes a unique set of habitats. Larval stages of fish, crustaceans and corals are all recruited to the Shoals along the pathway provided by the current. The turquoise-blue waters, the low sandy cays at Clerke and Imperieuse atolls, the reef systems that are washed by a 4.5 metre tidal range, the deep oceanic waters and the reef breaks found at the northern reefs provide wilderness seascapes that are truly impressive.

The high humidity and heat begins to stimulate the activities of reptiles too, and although the daytime temperatures can become quite extreme – they can range upwards of 40°C – the nighttime temperatures are quite suitable for the movement of snakes.

All across the Kimberley snakes emerge to hunt at night. Many of their prey species are nocturnal; the pythons, elapids and colubrid snakes have evolved to target prey at this time and avoid the daytime temperature extremes. An evening vehicle excursion can result in many species being observed crossing roads.

The lightning displays in the build-up clouds prove the dominance of nature and the air crackles and hisses with the streaking bolts of energy.

*Top: Build-up storm and squall
Bottom: Giant clam on Acropora coral*

153

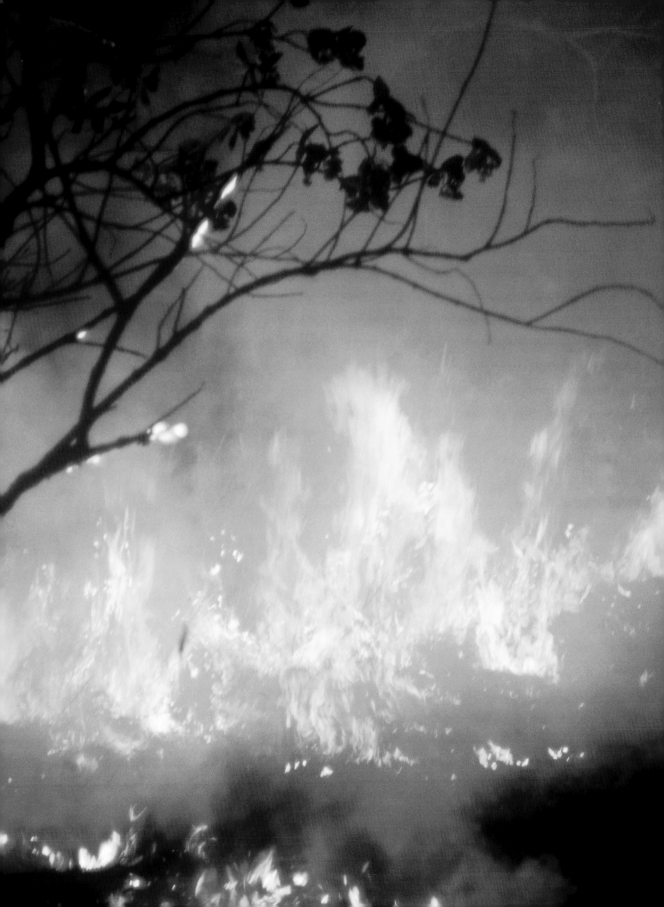

Fire – a burning issue

Fire dependent communities burn more readily than non-fire dependent communities because natural selection has favoured development of characteristics that make them more flammable.

RW Mutch

Any traveller to the Kimberley region will see evidence of fire's effect on the environment. Disturbance of this kind can, on the one hand, be important – it may even be necessary for the continued functioning of ecosystems in the region. However, fire can also be viewed as one of the area's major threats.

Fire and its effects have contributed significantly to evolution and the development of organisms in many natural systems. In Australia, many ecosystems are in fact dominated by fire.

When Australia separated from Gondwana it began a slow northward drift towards the equator. At this time the dominant vegetation was cool temperate rainforest; as the continent became hotter and drier, these rainforests were gradually replaced by hard-leafed vegetation.

With this drying there came an increasing incidence of fire through lighting strikes. The disturbance caused by the fires played an important role in the evolution of the enormous diversity of eucalyptus species that dominate Australian forests today.

The Kimberley has semi-arid to sub-humid tropical climatic zones with vegetation types ranging from spinifex grasslands and savannah woodlands to very small vine-

Fire in kangaroo grass

thicket rainforest patches. All of these habitat types are susceptible to the potentially devastating effects of fire; however, quite often these habitats can benefit from the appropriate use of fire.

The arrival of Aboriginal man at least 50,000 years ago added a new dimension. These people introduced a regime of fire use that is often referred to as the 'fire stick culture'. Carrying fire with them, they moved across the country. They used burning to promote growth, remove barriers to travel and maintain access to fire. These actions contributed to changes in vegetation structure and quite probably resulted in extinctions of some species of vegetation and animals.

Fires became more frequent again following the arrival of Europeans during the past 200 or so years. The conundrum within the Australian environment is that its fire proneness and its fire dependence go hand-in-hand.

The effect of fire is directly proportional to the level of volatility of the fuel. Spinifex, for instance, has leaves that are rich in resins, waxy materials and flammable oils. The natural form of these plants varies from habitat to habitat, from extensive low-growing aggregations of plants in a desert scene to the massed concentrations frequently found on offshore islands and in sandstone environments around the coast.

Given the right conditions – drier than normal rainy seasons, hot days and strong westerly or east bearing winds – bushfires can develop an intensity that renders all fire-fighting capabilities irrelevant. In the Kimberley, the critical component relates to access – most fires could be managed if they could be accessed, but due to remoteness and topography quite often they must be left to burn.

Major fires have burned through the Kimberley, generally as a result of lightning strike, but the fire stick culture is still present today, represented by small sulphur compound-tipped pine sticks.

In rainforest patches, fire can cause considerable damage by opening the canopy and allowing increased sunlight penetration. Invader species such as the sorghum grasses

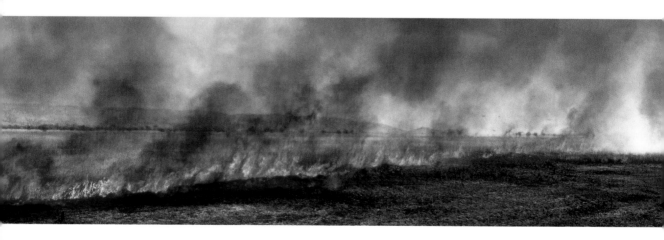

move rapidly to exploit this breach, and when they are established they provide a volatile ignition point for future fires. On the other hand, controlled fire use can help remnant rainforest increase in size by removing competitor species from its edges.

The use of fire by man is a topic that is just as controversial in the Kimberley as it is in Australia's southern states. The issues are the same, revolving around whether or not we can accommodate fire as part of the management of national parks and conservation areas, what the aims of fire use are, what its social, environmental, economic and cultural impacts are. The other major issue, according to fire managers, is that a high proportion of the population do not fully understand all the implications associated with using fire or not using fire.

The arguments are either poorly reported or sensationalised by some media when in actual fact the only real issue is determining what the correct fire regime for the area being burnt should be.

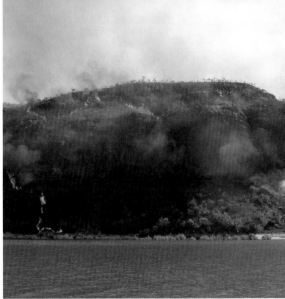

Fire in southern Australia is just as predictable and necessary as it is in other parts of the continent. The vegetation has evolved to deal with summer fire patterns caused by thunderstorm events – only recently has it been affected by the influences of man. Many early European writings make much of Aboriginal fire use patterns.

Evidence points to significant Aboriginal fire use immediately following the wet or rainy season in the Kimberley. Natural fires would have occurred during the build-up to the monsoon because of the unstable electrical storm conditions associated with that time of year and the incredible number of lightning strikes that can occur during those storms.

Conditions are hot and winds are quite often strong and squally, so if there is

Left: Grass fires can be devastating
This page, top: Spinifex grasses are volatile
Bottom: Island fires can have long term impacts Image by R Randell

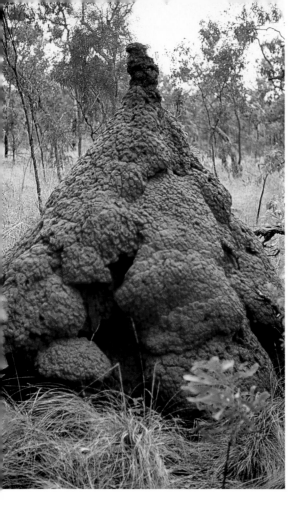

no rain and no previous burning has occurred, wildfires can travel huge distances. But perhaps the most important factor, the one controllable factor associated with any fire – the fuel – is diminished at this time.

For a range of reasons, burning during the Wet and immediately following allowed Aboriginal people to control and manage their environment. These fires helped remove some of the obstacles associated with living a hunter-gatherer life – the tall grasses were removed to allow access to hunting lands and so that people could see potential threats.

This type of burning can yield an appreciable amount of animal food. The most important were wallabies, but there was also smaller game such as monitor lizards and snakes. But there are always trade-offs: it can also destroy the tops of food plants, so that they could no longer be detected by the collectors of these resources. Burning of this kind was carried out locally, and probably under close control, to ensure that the full food potential was accessible for many months.

In the Kimberley, and in other parts of northern Australia, burning regimes were interrupted by European settlement and the subsequent development of the pastoral industry.

What was once under control was allowed to get out of hand as it became widespread practice on pastoral leases to burn annually. The intention was to remove old-growth vegetation, particularly woodlands. The practice encouraged growth of suitable feed grasses and to a certain extent it contributed to the reduction of fuel loads – the trade-off here has been the loss of woodlands and understorey, and, no doubt, several species of small mammal and birds, as well as a massive contribution to the atmospheric carbon load.

The dramatic decline of the gouldian finch across a range of habitats can be partly attributed to pastoral burning regimes – a grassland monoculture will always result in reduced species diversity and localised extinctions.

Fire use in the Kimberley needs to be based on achieving several objectives. First,

Termite mounds can be refuge areas during fire events

fire should be used to protect human and environmental values – in other words property and habitats. Second, it should be used to ensure that there are no undesirable environmental or ecological consequences across a range of habitats; in other words its use should not be indiscriminate; it should be planned and applied with these values in mind.

We also need to educate people about fire; we all need to understand not all fire use or impact is bad. Fire plays an important role in our environment, and it is a natural part of the bush. With our increased knowledge about greenhouse gases, global warming and their predicted impacts upon communities worldwide, it is time for some serious education and cultural change to begin across northern Australia. Continual wildfires should no longer be tolerated.

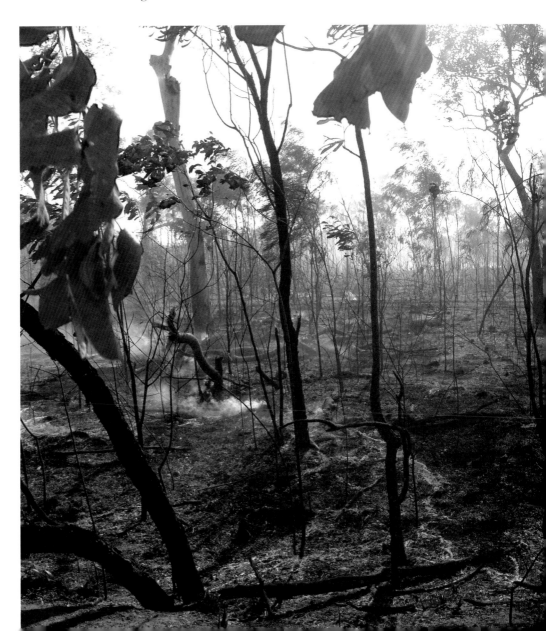

Hot fire has little value

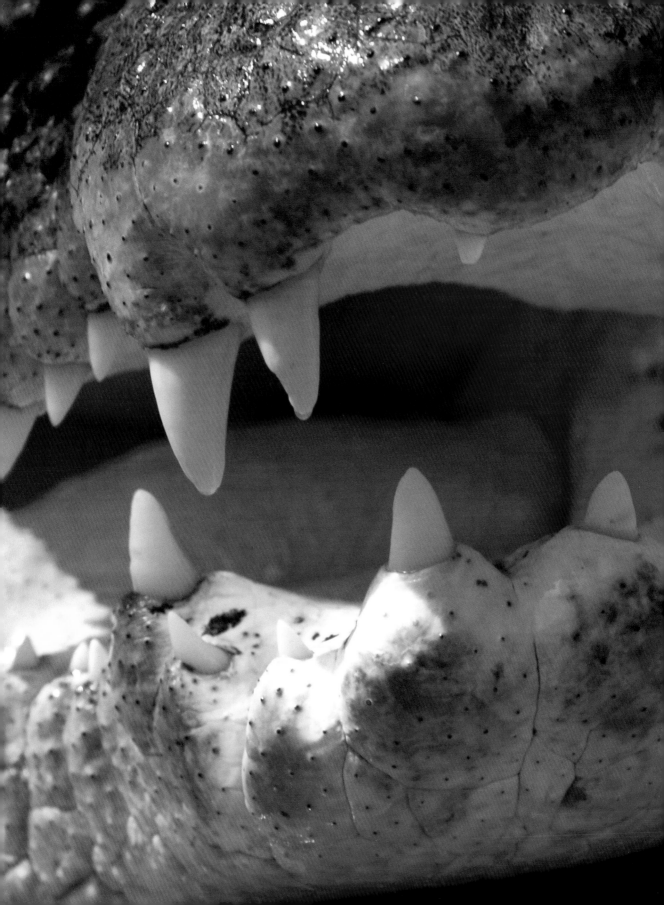

Crocodile attacks and why they occur

The ancient Greeks called them kroko – drilos, 'pebble – worms' – scaly things that shuffle and lurk around low places. For the most part man gets on with crocodiles about as well as he did with dragons; and just as he did with dragons, he will banish them from all but the remotest parts of the world.

Alistair Graham, *Eyelids of Morning*, 1973

Perhaps they didn't read the signs, maybe they got there late and it was dark, could they have listened to someone who did not know? In any event, two more creatures are dead on this planet, one through being in the wrong place at the wrong time and the other, well it probably thought it was in the right place and time really wasn't a factor.

Considering the extent of the media coverage every time a large predatory animal has killed a human, we can see that as a species we are easily shocked that one of our kind has met with a gruesome death that was not of our doing. Frequently it seems that, in contrast, we are inured to the constant images of death and destruction that our own species practises on itself.

We get used to hearing about road death statistics and, more recently, loss of loved ones due to extremist and economic madness, but events like crocodile attacks occur very infrequently.

Given the fact that crocodiles have been on this planet since well before man, it is

Too close! Image by Dave Grosse

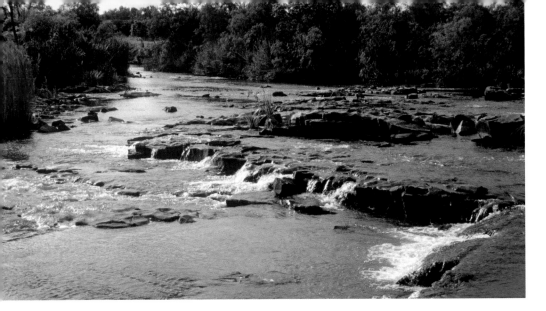

most likely that they have been preying on human-like animals since they first appeared and sought water and food from rivers and the ocean.

In Australia, attitudes have changed dramatically towards crocodiles over the past 30 years or so – these animals have been protected in Western Australia since 1970. Prior to this crocodiles were killed on sight, and in some areas they were officially considered vermin.

Today crocodiles are given two sets of values: one is aesthetic and demands the total preservation of the species and the other is economic and pursues the notion of sustainable use of a valuable wildlife product. Should proponents of the two points of view ever agree on an acceptable option then it is likely that species as a whole will benefit no end. G Webb

Whenever there is a crocodile attack, community attitudes become quite polarised. On the one hand there are individuals expressing opinions that, if they were acted upon, would result in the extermination of the species, and on the other there are individuals who believe that these attacks are natural events that should simply be lived with.

Obviously, when we get back to the real world it is best to respond to an attack with the best interests of all parties (including the crocodiles) in mind.

Most wildlife management authorities believe that it makes no sense to wipe out an important contributor to the food chain, and an economically important resource, and that it also makes no sense to allow an aggressive man-eating animal to remain in areas frequented by humans.

But even with increased awareness, attacks still occur, and in many cases attacks on humans have been invited.

A layman's explanation of crocodile biology is pertinent here, as it dispels several of

Crocodile habitat

162

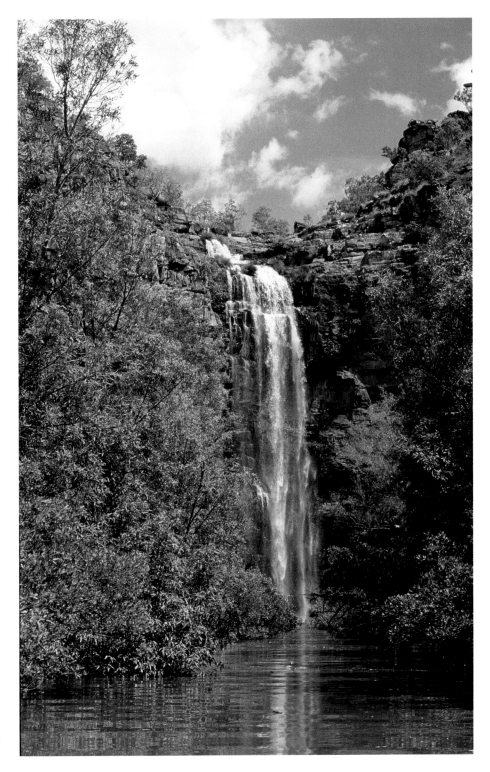

*The brackish mix of
fresh and saltwater is
perfect for crocodiles*

163

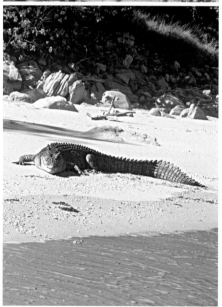

the myths that exist concerning crocodiles and their abilities. Large reptiles like crocodiles have a physiological 'restraint' built into their metabolism that makes it difficult for them to put sustained effort into attacking humans or other large prey.

They are not designed to deal quickly with lactic acid build-up. Lactic acid is a by-product of strenuous activity and we know one of its effects as cramp. We are able to deal with lactic acid build-up because our metabolism has ways to remove it rapidly – when we suffer from lactic acid overdose we can take steps to recover immediately.

When the same problem affects crocodiles, it can be more life-threatening. Due to their slower metabolic rate, large reptiles need extended periods of time to recover before they can actually begin feeding on large prey and the larger the crocodile the longer the recovery period. They run an enormous risk of 'cramping up' and actually killing themselves. Hence the story that crocodiles 'stash their prey in a larder and wait for it to get tender'.

Big crocodiles do take big prey. They've been doing it since they evolved; their problem is that they have to rest after exerting themselves.

As you can imagine, this physiological restraint casts some doubt on a crocodile's abilities on dry land also. You can still 'run in a zigzag' fashion to escape a crocodile on land if you want to, but really, how fast do you really think those stumpy legs can carry a saltwater crocodile big enough to eat a human being? No, these animals do it their way.

Crocodiles have superb eyesight, excellent hearing and sense of smell, plus, through the sensory pits along their jaws, the ability to detect pressure change and motion. But they still make errors of judgment. Unfortunately, sometimes humans become the target, particularly when we continue to push our luck.

Top: Rope traps are used to catch large wary crocodiles
Bottom: Crocodiles lift their metabolic rate by basking

Across northern Australia there are two species of crocodile. One is the freshwater crocodile, which is endemic to Australia and is generally considered harmless to man although some individuals can attain lengths exceeding three metres. The other is the Indo-Pacific crocodile, affectionately known as the 'saltie', and if the truth be known, the saltie actually prefers places where there is plenty of fresh water.

Both species have been implicated in 'attacks' on man. Some of these are undoubtedly animals behaving aggressively – which they can do for a number of reasons apart from the desire for food. Territorial displays, breeding activity, opportunism are all factors that can contribute to an 'attack'.

Since 1972 there have been around 32 recorded fatal or near fatal attacks on humans in northern Australia in which salties can be implicated: two of these occurred between 1972 and 1979, and the other 30 have occurred since 1980. (In this same period thousands of people have died as a result of car accidents, murders, family disputes and so on.) So is the frequency of attacks is increasing?

The increased number of crocodiles following protection and of course the increased numbers of people now living in and visiting northern Australia are certainly factors that could affect these statistics. People now have relatively easy access into remote areas, and let's face it, swimming in areas known to be saltwater crocodile habitat is dangerous. Statistics on past attacks indicate that there is a much greater danger when swimming at night and when alcohol is involved. When people become complacent in crocodile habitats there is a good chance of being eaten.

When a swimmer is splashing around, the crocodile only sees a small target above the water. First the crocodile hears the commotion and orientates towards the noise. This is what first attracts the animal – *is this a food item in distress?* His senses of smell and sight come into play and he submerges to investigate. He brushes past one, he brushes past another – *what's making all the noise?* Other serious attacks have occurred on people who were not swimming but were presenting a low profile, by either

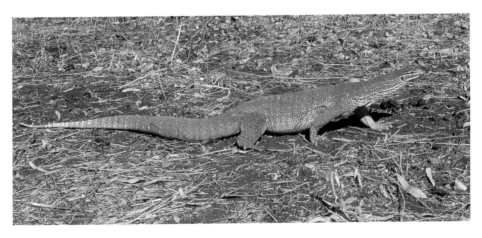

Large goannas (Varanus panoptes) *eat crocodile eggs*

bending down in the water, washing at the edge or canoeing.

Several years ago a Kununurra family were canoeing through a freshwater billabong when a four-metre saltwater crocodile attacked. The animal stalked them from behind and tipped the canoe and its obviously screaming contents into the water. The attack ceased when the animal took an interest in their camera equipment … this allowed them to safely swim to the nearest bank. Was this animal really interested in the human cargo, or could the canoe have been interpreted as a large interloper into an established territory?

A year before this a Victorian fisherman was cleaning a freshly caught barramundi at the Daly River Crossing in the Territory. Hunkered down, engrossed in cleaning his catch, he was oblivious to the frantic calls of warning from his companions several hundred metres away, who had seen a crocodile lining him up.

To this day he still does not know what possessed him to stand up, but he did so just as the crocodile surfaced and began its attack. This action probably saved his life. The crocodile stopped its attack and with mouth agape backed away. Why? Because the fisherman had changed his aspect – he had gone from looking like a small target to looking like a large disaster.

There has been little evidence of serious attacks on people fishing from the bank or even standing in shallow water fishing.

The coldest time of year in the north is the Dry, which coincides with the southern hemisphere winter. During this period only four attacks have occurred. In contrast, there have been 25 attacks between September and April, the time when the weather warms up and the monsoon affects Australia's tropics.

This is the time when the saltwater crocodiles feed more and grow more. They breed and construct nests and generally become more active. The conditions are right for attacks: there's warm weather, the stimulus to establish territory and breed is strong, and they need to eat.

The animals that have been implicated in attacks have all been longer than three metres, and where inspection has been made they have been male animals. Crocodiles in this size range are generally very aggressive. They move frequently, searching for suitable habitat to establish territory, and can be relatively young. They have a chip on their shoulder: life is a battle, and with their hormones active there can be lots of rushing about.

Small boats are generally safe from attack, but where attacks on them have occurred, larger, possibly older, males have been involved. There can be little doubt that these crocodiles interpreted the dinghies as other animals, although it is unclear whether they were attacked because of a desire to kill and feed or simply to assert dominance.

As in humans (and other species), it is possible that the sensory perceptions start to break down in old crocodiles, and they may have trouble discriminating between

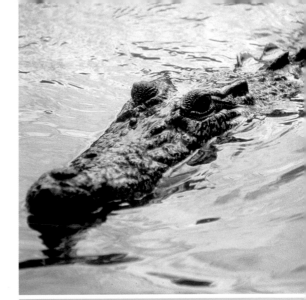

animate and inanimate objects. I have seen an old male crocodile on the Ord River continuously thumping his head into a partially submerged tree – perhaps he had an itch? And in my experience it seems that the low-frequency sound of an outboard motor does attract crocodiles.

Owners of large boats feeding crocodiles in northern Australia is a recipe for disaster; not for the boat owners so much as for the crocodiles, who come expecting a free feed and begin to identify boats with food. Soon these encounters may result in an unrecorded death of a crocodile that is just doing what it does best – or worse, another attack that will polarise public opinion yet again.

Crocodile attacks will continue to occur as more and more interaction takes place between our species. What we can do is understand what contributes to them. Complacency is the biggest killer – perhaps if we weren't exposed to so much violence among ourselves we would take more care when we visit the wilderness. If we swim with crocodiles we'll get eaten by crocodiles – if we avoid risky activities we will reduce the likelihood of serious attacks.

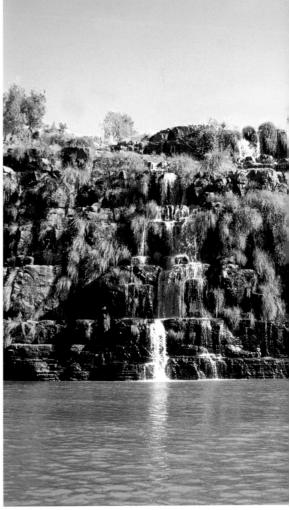

Top: Young adult crocodiles can be curious
Bottom: Kings Cascade, American Ginger Meadows was taken by a crocodile here in 1987

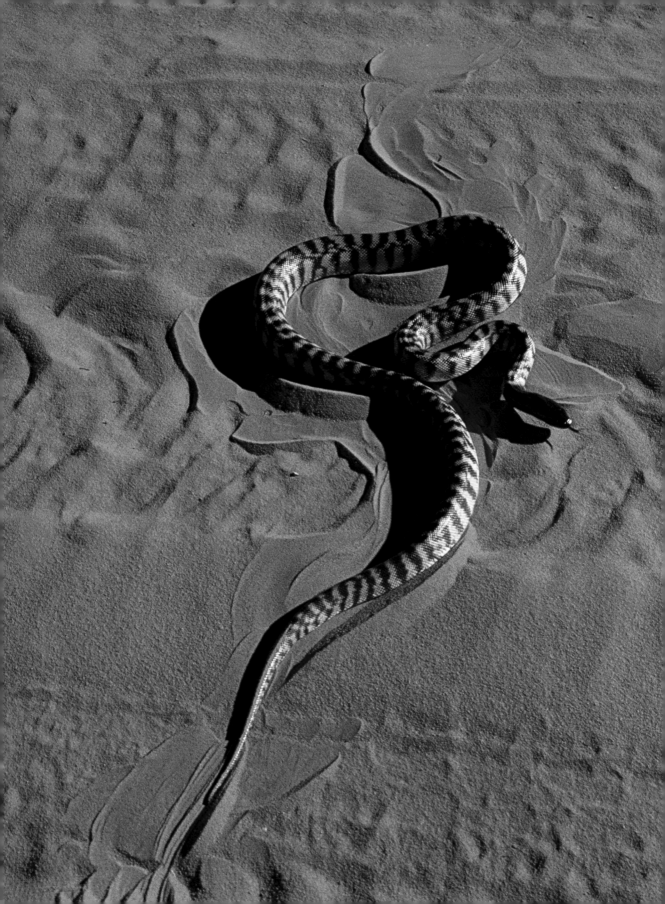

Snakes of the Kimberley

The thought of a creature that can turn the internal organs and musculature of its prey to a soup is guaranteed not to win it too many fans!

Richard Mathews, 1995

This has got to be snake country! Look at the climate for a start – it's pretty well constantly warm, there's plenty of habitat with masses of spinifex grasses, there are acacia and eucalypt woodlands, there are rainforest pockets, and to top it all off there is a variety of things that snakes like to eat. What's more, there are humans here, and we all know what sort of things they bring to an environment.

An encounter with a venomous snake can be both frightening and dangerous, so it is worth spending a little time and effort learning what types of snakes are most likely to be encountered, why they are attracted to human communities, what they eat and how to minimise the chances of anything unpleasant happening.

Snakes evolved during the Jurassic period that began about 150 million years ago, and the ancestral stock they came from also evolved into birds, lizards, turtles and the crocodilians.

Apart from the most obvious characteristics – being generally long and slender and lacking limbs – they also have immovable eyelids and no external ear opening. Snakes 'hear' by feeling vibrations transmitted through the ground into their skeletons.

This lack of an external ear opening is a characteristic that can be used to distinguish snakes from small skinks and the group known as the pygopods (legless

Black headed python

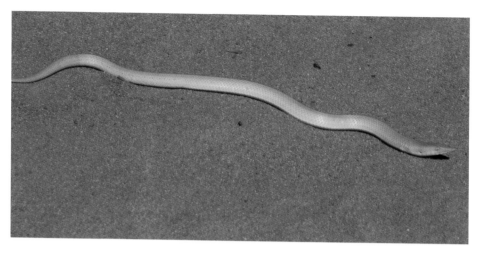

lizards). Skinks and pygopods have an external ear opening, but of course if you were staring at a sinuous reptile that has just entered your lounge room this would probably be the last thing you would think to check.

A legless lizard that is commonly found in the Kimberley and frequently mistaken for a snake is Burtons legless lizard. Frequently the end result of this unfortunate case of mistaken identity is a finely diced harmless lizard!

Our fear of snakes is closely linked to our perception of the harm they can do to us, and the myths and stories about the hypnotic effect of snakes are sustained by the fact that the animals appear to be constantly staring.

It is still possible to occasionally see the Indian snake charmer in action – swaying to a rhythm that the snake mimics – but really, who is watching who?

Subconsciously, we are probably also fascinated with an animal that injects poison to subdue its prey.

Snakes have no limbs for running, nor hands for grasping, and they have to capture prey that is capable of biting back, lacerating, scratching, kicking or running or flying away, so they need a method of subduing their prey rapidly and efficiently. This is where venom comes into play. Most snake venoms are just modified saliva – if we had a method of getting copious amounts of our saliva into a snake, the effect on them would be just as devastating as the effect of their venom can be on us.

Evolution has turned snake saliva into a mix of various enzymes that can digest or impair the function of a different part of their victim's body. Venoms can be blood poisons (*haemotoxins*), muscle poisons (*myotoxins*), nerve poisons (*neurotoxins*), anticoagulants and coagulants. Each component carries out a specialised task: immobilisation, breakdown of tissue and muscle fibre, heart failure and nerve destruction, disintegration of blood corpuscles, prevention of blood-clotting (the prey bleeds to death) or coagulation (causing thrombosis and blocking of arteries).

Burtons legless lizard

The majority of the 2800 species of snakes in the world are non-venomous. Australia has the distinction of having the highest ratio of venomous snakes to non-venomus snakes of any continent, but even so the venomous snakes are still in the minority.

Identifying snakes is a skill that can be relatively easily acquired, and if people are able to distinguish between venomous and non-venomous types, two things can be achieved. First, many harmless (and sometimes particularly helpful) species, such as pythons and legless lizards, will avoid being killed and second, should someone be bitten, prompt administration of the correct antivenom will be more likely.

These days there is antivenom for all poisonous snakes; there is even a general antivenom that can be given if identification proves difficult.

All the snakes in the world are divided into seven family groups that recognise particular features.

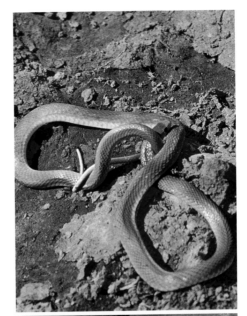

There are the blind snakes – these are tiny little worm-like snakes that are totally harmless to us but deadly to other critters, such as termites, cockroaches and other invertebrates that live in the leaf litter.

The wart snakes (also called file snakes) are another relatively harmless species. They tend to prefer aquatic habitats, as they feed on small freshwater shrimps and insects such as the giant water beetle. One species is found near Kalumburu and they are common in the Arafura wetlands of the Northern Territory.

These snakes are still popular as a food source for Aboriginal people. File snakes share habitat with large crocodiles, so discussions to identify who has collection duties can be a boisterous affair.

Pythons are another non-venomous group. They kill by wrapping their body around prey and suffocating it. Most snakes in this group use heat sensor

Top: The Western brown snake (Gwardar) is venomous
Bottom: Water python

171

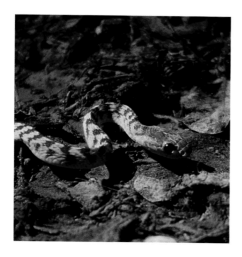

pits along their bottom jaw to help them locate prey. Some of the larger pythons in the world, including the olive python and the water python, both of which can grow to longer than two metres, are found in the Kimberley.

Water snakes are found in estuaries and freshwater systems. The three species in Western Australia are mainly found in the Kimberley, but their range does extend into the Pilbara region. These snakes are venomous, but they are generally not considered dangerous because our contact with them is very limited.

The colubrid snakes (colubrid means serpent) are rear-fanged snakes – in other parts of the world more than two-thirds of all snake species are colubrid snakes. In Australia this group is poorly represented, probably because they were not able to establish themselves in big species numbers before land bridges between Asia and Australia were flooded. The Kimberley colubrid snakes are the keelback snakes and the bronzebacks. More species are found in the south.

Then there are the 'hollow-toothed' elapid snakes. These are the 'bities' that use strong venom to subdue their prey. They may well be derived from sea snakes that returned to the land in the not too distant geological past.

Australian elapid snakes target very different types of food from elapid snakes elsewhere – they feed entirely on vertebrates. The *Elapidae* here have filled many niches occupied elsewhere by colubrid snakes, and are the dominant land snakes.

There are some spectacular examples found in the Kimberley, including the western brown snake (gwardar) and the mulga snake or king brown. (It is a curious fact of life that most snakes that are brown are called king browns and dispatched without thought.).

Finally there are the sea snakes. Fortunately, they are fairly placid creatures and rarely encountered. These snakes are likely to have serious venom, so handling them is not a good idea.

I've heard people claim that sea snakes can't bite humans because their mouths are small and the fangs are at the rear of the snake's mouth. It's not true; sea snakes do bite humans. They are in fact one of the greatest killers of third world fishermen. These snakes are medium-sized to large (two metres), and have a pair of venom fangs at the front of the upper jaw. They also have valve-like nostrils on the top of the snout and an oar or paddle-like tail to help them swim. They are found in tropical and

Brown tree snake

subtropical seas and their major food is fish.

Pearl and scuba divers can have unnerving experiences with them as the snakes attempt to mate or dispute territory with air lines on diving equipment. Nothing quite like an amorous sea snake to increase your air consumption!

There are many more species of reptile living on the Earth than there are mammals. How and why has this occurred? Reptiles don't seem to be more suitable than mammals.

As humans we place ourselves and other warm-blooded creatures higher on the evolutionary scale than reptiles, but when we begin to exmine the massive amounts of energy warm-blooded creatures need to survive, it is possible to see them as inefficient, and indeed wasteful.

How many meals do you have per day? We need high-energy food to drive our lives – it keeps us ready for action all day and all night. If it was suddenly difficult to obtain, the consequences could become brutal (remember the events following hurricane Katrina in the US in 2005).

On the other hand, reptiles have fitted nicely into a niche that, although it has some restrictions, at least means they are particularly efficient at converting their food to energy.

Reptiles are often referred to as 'cold-blooded'. They are not. They have body temperatures that reflect the ambient temperature around them; as the day warms up, reptiles too warm up. And they don't have to continually search for high-energy food to maintain a high body temperature. This means they can occupy habitats where this type of food is unavailable.

Should a global catastrophe overtake us, high energy dependent animals, such as humans, will be the first to suffer – the low maintenance reptiles will probably do just fine!

There are at least 23 species of terrestrial snake known in the Kimberley, but only about seven can truly be considered dangerous to humans, and the main reason for that is that they are attracted to the areas in which we live.

Identification is an important part of living with snakes – apart from the obvious differences amongst the groups in size, behaviour, habitat and food resources, most of the venomous species have an angular shape to the head and can behave aggressively if they feel threatened.

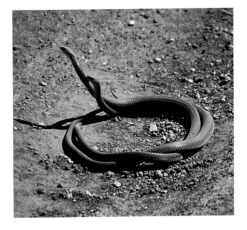

Lesser black whipsnakes in a territorial dispute

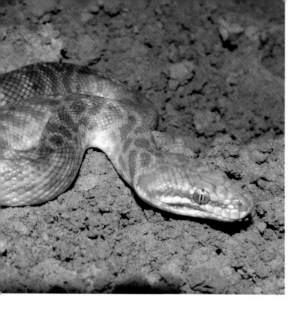

The most effective identification method is scale counts around the midbody, plus the arrangement of scales around the cloaca (anal opening) and around the head. To achieve this often requires immobilising the snake, either by cooling the animal down so its movement is sluggish or by obtaining a dead specimen.

There is no reason for anyone to come to harm from snakes, provided that care and common sense prevail.

Snakes are not attracted to people, but they find the clutter that seems to accumulate around us irresistible. Like most animals, snakes will seek out places that give them shelter from extremes of climate, or that attract the creatures they feed upon. So garden refuse, building materials, piles of stone, sleepers, fibro and tin sheeting are ideal snake homes. Providing lush vegetation growth around our homes attracts insects and the frogs and small lizards that feed on them – and these in turn attract snakes. And snakes will search out areas that are cool during hot weather, including houses, when they can find a way into them.

Believe it or not, snakes are not naturally aggressive, but like every other creature on this planet, they will defend themselves against anything that attacks or harasses them.

When I was based in Kununurra as a Wildlife Officer I frequently received phone calls during the warmer months reporting snakes in homes and gardens. In most cases, by the time I arrived the animal had departed. I would advise people to keep a watch over the snake and if it was in the home to barricade it into whichever room it happened to be visiting. This would obviously allow me to be sure that the snake was contained and give me every opportunity to capture and remove it. I visited a home one afternoon, kitted out in my snake-catching clobber – overalls, heavy boots and safety glasses – in response to a call of distress, and was informed that the snake (apparently a king brown) was contained in the master bedroom.

Entering the room I realised what a task I had ahead of me. It was a typical bachelor's room – piles of clothes (washed and unwashed) were scattered around the floor, a king-size waterbed held pride of place with liberal piles of clothes and bed linen adorning it. There were walk-in robes with 'Imelda' amounts of boots and sneakers spilling outwards and maybe 50 shirts and suits hanging in the cupboard.

There was so much snake habitat in that one room that I asked if I needed a permit to enter.

Childrens python

I had been catching and relocating snakes for several years, and during this time I had heard that elapid snakes were very poor if not incapable climbers, so I set about relocating every piece of clothing and footwear that was on the floor of the room onto the bed in the middle of the room (I think I prayed that the animal had decided to avoid the base of the waterbed).

After half an hour of gingerly sorting through clean and not so clean garments I turned my attention to the walk-in robe – slowly each shoe and boot was lifted and inspected and tossed onto the bed. The pile was assuming Kosciuszko proportion, and I was beginning to swelter – a combination of the room's heat and an ever-increasing nervousness about something feeling not quite right.

I'm not sure what made me stop and freeze. Maybe a shirt sleeve moved and I couldn't work out why – no wind, I hadn't touched it, whatever. But I did stop moving immediately, and it may have saved my life.

The snake was not a king brown – I knew that immediately. It had the distinctive russet bars of the gwardar, but what really caught my eye was its size – well over a metre – and the fact that it had flattened its neck in the typical 'cobra like' aggressive posture prior to attack.

It was watching me from its perch on the coat rail, probably hoping that I wouldn't invade its personal space and force it into a response.

You must understand, this reptile had already had a bad day. Traveling through all those clothes would have peeved anyone off, and then being forced to climb up onto a head-high coat rail must have really been irritating.

It struck as I began to move my upper body backwards, and the momentum caused it to lose balance to the point that it actually struck the double-lined pocket of my overalls rather than my face, which was its original target.

The snake's fangs got stuck in the heavy cotton material and its body was hanging down the right side of my chest like an off-centre school tie which suddenly began writhing. I was able to consider my options for at least several interminable seconds while leaning back as far as possible and trying to look down at my chest at the same time.

I finally decided to hand catch the snake straight off my overalls, and as I whipped it into a catch bag I was straight out the door – 'Clean that mess up, mate' was my only comment – into the car and away down the road. About 30 seconds later the terror and shakes caught up – oh, what might have been – six inches higher and fanged in the neck.

I let the snake go at a nice little waterhole in Hidden Valley National Park and began cursing particularly untidy men.

Plants that eat flesh

It's easy for most people to grasp the idea of an animal being a carnivore, but the concept of a plant, not of flesh and blood but constructed of vegetable matter, being capable of the same or at least a similar action is somewhat bizarre.

Allen Lowrie, 1996

Plants that eat flesh, now that's an interesting aspect of botanical life. In 1956 John Wyndham gave the Triffids due consideration when he penned a novel about their 'Day', and the *Little Shop of Horrors* introduced a flesh-eating angiosperm to Hollywood's entertainment world.

But the concept is not so strange when you look at how evolution has allowed the development of weird and wonderful adaptations to survival in all types of living organisms. One just has to consider the animal adaptations for consuming flesh to realise that it hardly seems strange that some plants should be capable of something similar.

Who knows, perhaps generations of gardeners are encouraging roses to adapt by constantly feeding them 'blood and bone'!

Worldwide there are approximately 500 species of plants that are considered to be eaters of living animals – carnivorous plants. Of this number, some 35 per cent, or 175 species, are found scattered across Australia. The majority are found in the southwest of Western Australia.

There is a growing interest in the members of this group of plants, and as a

A bladderwort (Utricularia kimberleyensis)
Image by A Lowrie

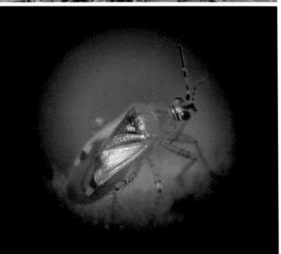

consequence, new species and subspecies are now being found. One of Australia's foremost experts in the study and description of carnivorous plant taxa is Allen Lowrie, from Perth in Western Australia. Allen has been travelling this country searching suitable habitats, including wading through wetlands across northern Australia, for many years. He is a certified carnivorous plant aficionado. He loves them and he has the ability to create similar feelings of fondness amongst his many human contacts. The Kimberley provides suitable habitat for at least 35 species of carnivorous plants.

To achieve this notoriety, these plants must have the ability to attract or lure prey, to then capture and consume it, and finally use the nutrients to their benefit.

The most common prey trapped or captured by carnivorous plants are insects. This means it may be more appropriate to refer to these plants as insectivorous plants. However, there have been some instances where small animals and reptiles have been recorded in some of the larger tropical carnivorous plants.

In Australia the carnivorous plants come in numerous shapes and forms. It is the trapping or capture mechanism, or the location of this on the plant, that is the main characteristic used to identify and distinguish one group from another.

There are five main adaptations that are used to lure and capture prey. First there is the pitfall trap method, which most people with even a passing interest in botany would recognise. This method is applied by the pitcher plants. In Australia

Top: A sundew (Drosera broomensis)
Bottom: A sundew bug (Setocoris sp.) Image by A Lowrie

there are only two species that have evolved this method – the Albany pitcher plant found in the southwest of Western Australia and the tropical pitcher plant, which is found from Cairns in north Queensland to southeast Asia.

Basically the pitfall method is where the plant produces a lure in the form of nectar that becomes sweeter and more enticing on the inside of the walls of the pitcher. In the bottom of the pitcher is a pool of fluid. It is here that the trapped insect drowns, and is eventually dissolved and absorbed by the plant. There is an umbrella-like lid that protects the digestive mixture from diluting when rain falls on the top of the pitcher.

The passive flypaper trap is found in the five species of *Byblis* that occur in Australia. The leaves of these plants are covered with glands that are capable of producing a large droplet of sticky fluid. These glands are found on stalks of different lengths on the leaves' surface. Insects that land on the sticky leaves struggle to escape, thus bringing more and more of the glands into play, until eventually they drown in a large sticky glob of viscous liquid. Over a period of time they are then dissolved and absorbed through tiny glands on the leaf.

The largest group of carnivorous plants in Australia is the *Drosera*. These plants use an active flypaper-type trap. The leaves on these carnivores are capable of folding over a prey item when pressure-sensitive areas on them are triggered by contact. The sticky trapping fluids are enhanced again by digestive glands on the leaves.

The bladderworts are carnivores of wetlands and moist soils. Usually quite delicate plants, they often have beautiful yellow flowers that hide their critter-eating abilities below the soil surface or below water. The bladderworts use anchors (called stolons and rhizoids) in the soil; in flooded areas they float at the whim of currents and wind.

Among the leaves and below the surface of soil or water they have small insect-trapping bladders. These bladders frequently have trip hairs at their entrance. As a tiny creature brushes past the hairs the trap opens and the change of pressure sucks the prey into the bladder. Then water is expelled, the trap resets and the digestive process begins.

The waterwheel plant of the genus *Aldrovandra* uses the snap trap method – it is closely related to the famous Venus fly trap from the US. Aldrovandras are free-floating aquatic plants that are moved about their habitat by wind and currents. As the name waterwheel plant implies, there appear to be whorls of leaves spiralling off

Drosera indica

179

the main stem or axis. Some of these leaf groupings have two-lobed bladders that resemble a bi-valve attached.

The saying 'like a hair trigger' is apt, as the openings to these bladders are lined with sensitive hairs. When a prey item enters the structure the hairs are stimulated to start the closing process, and eventually the two sides of the structure are pressed firmly shut. There are digestive glands in the trap that dissolve the prey into a rich soup.

Many new species of carnivorous plants have been recorded in the past ten or so years and the Kimberley region is an area that is now recognised as being rich in plants of this group. There is always the possibility of new species being discovered here, given the remoteness of the area and the difficulty of access.

From 1837–43, Lt. Ben Bynoe was naturalist cum botanist on a famous ship, The Beagle, *that was undertaking survey work and supporting land-based exploration of the Kimberley by the John Lort Stokes group.*

Somewhere during this voyage into the northwest Bynoe collected a sample of Byblis filifolia *from a location known only as 'north-west Australia'. This specimen was unlike anything that has been collected before. It was runty, small to the point of concern and didn't match anything held in more recent collections.*

At Port Warrender (near the Mitchell Plateau) there is a location known as One Tree Beach that is not on any official map. The country here is remote and rarely visited by anyone; however, the beach itself is today home to a sportfishing camp.

Adjacent to the camp is a seasonal freshwater creek that still held some water from recent tropical downpours that had been cooling the country for several days. I walked along this creek taking in the immense variety of vegetation that had responded to the recent rains. The topography is also incredible: vast areas of sandstone interspersed with impassable spinifex clumps, and stepped sandstone escarpments with hidden records of Aboriginal life and mythology. It is tough country to work on, even tougher to live off.

A new species (Byblis guehoii) from Dampier Peninsula

It made me appreciate what early European visitors must have felt – the remoteness of their situation, six, eight, twelve months or more away from familiar lives, the anxious nervousness of who or what they would next encounter and, for the naturalists among them, the absolute sense of discovery that tempered their homesickness.

There in front of me was a Byblis, growing on a sandstone escarpment near One Tree Beach in the skeletal soil remnants gathered at the base of a small sandstone overhang and protected by the sharp leaves of spinifex. The soft mauve flowers and glistening sticky leaves were immediately noticeable.

Carnivorous plants are fascinating vegetative forms, although generally small in size. The methods they employ to lure, trap and consume living creatures are guaranteed to ensure future botanical interest. And of course those creatures that contribute to cross-pollination of these flesh-consuming flowering plants and survive the experience are a whole new story.

The specimen collected from One Tree Beach has since been confirmed as matching for size the type specimen originally collected by Ben Bynoe during his Kimberley adventures. I would like to think that I had visited the location of the original collection and seen the variety of life that he had seen.

Byblis filifolia *from Carnivore Creek*

181

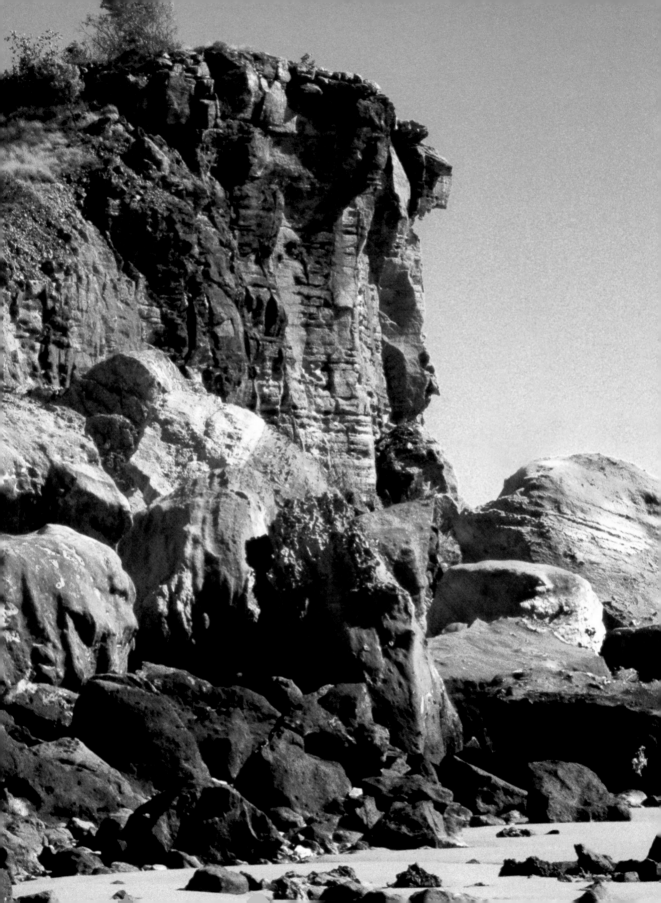

Geology

The Kimberley is an ancient land, but every year it is possible to observe first-hand the geological processes that have shaped, and continue to shape, the topography of this part of Australia.

Many long-term residents have seen the scouring of a big Wet, with the reshaping of river channels and beds and the associated dumping and removal of massive amounts of sediment. It is a land that does change visibly from year to year. The extremes of climate that can be experienced contribute to these changes – the cyclones with their attendant flooding rains and high winds, the stultifying heat of the build-up, the oppressive humidity of the Wet, the cold snaps of the Dry and the desiccating winds of the winter all allow the observer to see nature at her rawest.

And you can add to these physical elements the effects of vegetation growth, with roots forcing through any weakness, and of course man-influenced events (including fire and cattle impacts on fragile soils).

The Kimberley region can be described as a low dome capped by sandstones of the Nullagine series, interbedded with basalts, and fringed in areas, particularly around Fitzroy Crossing (Mimbi Caves, Tunnel Creek and Geikie Gorge), Wyndham (Bastion Range, Cockburn Range) and Kununurra (Ninghbin, Carr Boyd Ranges), with Devonian Period (360 million years ago) limestones, basalts and mudstones.

In the south, desert areas are dominant, and to the north there is a central plateau area (the Hann Plateau) featuring high escarpments and deep gorges cut through the sandstones. On the northern extremities a rugged coastline developed as the Nullagine

Sandstone and balsaltic rubble near Madarr, King Sound

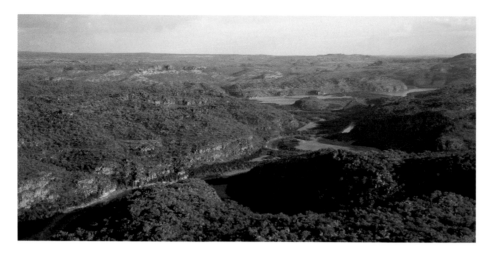

sandstones were eroded. The highest peaks can be found on the dome: Mt Ord at 930 metres and Mt Hann at 854 metres.

Many rivers radiate from the central highlands of this plateau in predominantly west and northwest directions, and these have excised steep-sided gorges through the sandstones to the coast.

The spectacular Mitchell, Hunter, Prince Regent and Sale rivers help us appreciate these events. Further to the south and east the dominant rivers – the Fitzroy, Ord and Lennard – have developed broad floodplains on their routes to the sea.

It is convenient for descriptive purposes to divide the Kimberley into four regions that are not only geologically different but to a lesser extent also physiologically and ecologically different.

First there is the Hann Plateau, which dominates the central Kimberley – it is a highland area bounded by the King Leopold Range and the Durack Range; second, there is an easterly lowland area comprising the area around the Ord Region and Wyndham; third, there are southerly lowlands in the Fitzroy River area; and fourth, there is gently undulating country comprising extensive – and almost featureless – sandy areas of eroded sandstones in the east and west Kimberley.

The stratigraphy of the islands is the same as the adjacent mainland, but because of their size, even the largest of these are still made up of only two or three rock types. In general, the offshore islands are dominated by sandstones and Precambrian (>500 mya). Volcanics that are overlaid with Cenozoic (60 mya) deposits.

On these islands King Leopold sandstones, Carson volcanics, and members of the Warton and Pentecost sandstone groups can be found. In broad terms, these sandstones are resistant, cliff-forming quartz compounds that appear as rugged, dissected terrain with gorges formed along fault and drainage lines.

The beach sands and the grey sticky chloropal saline muds, silts and fine sands

Landforms near Prince Frederick Harbour (Kimberley coast)

of the tidal zones are comparatively young Quaternary soils (0.1 mya). During this geological period rises in sea level resulted in the drowning of valleys and the formation of the indented coastline with many offshore islands that we see today.

Geological study carried out in Australia, Asia and Scandinavia on sea level changes in the past 20,000 years, along with bathymetric data from the Kimberley coast associated with oil and gas exploration, indicates that the Kimberley islands were part of the mainland as recently as 8000 to 10,000 years ago. Some islands, such as Boongaree Island, have possibly only recently (at least in geological terms) separated from the mainland.

The island shorelines are typically rocky, with numerous small sandy beaches between headlands and in areas where tidal backwater deposition (back eddies) is

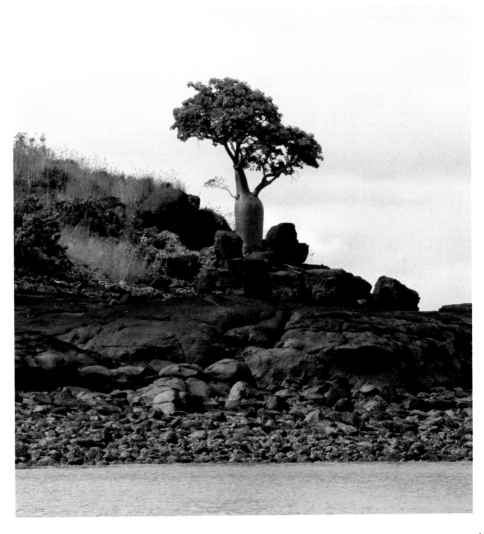

Basaltic underlay at Sheep Island Overleaf: Ragged Range (south of Kununurra)

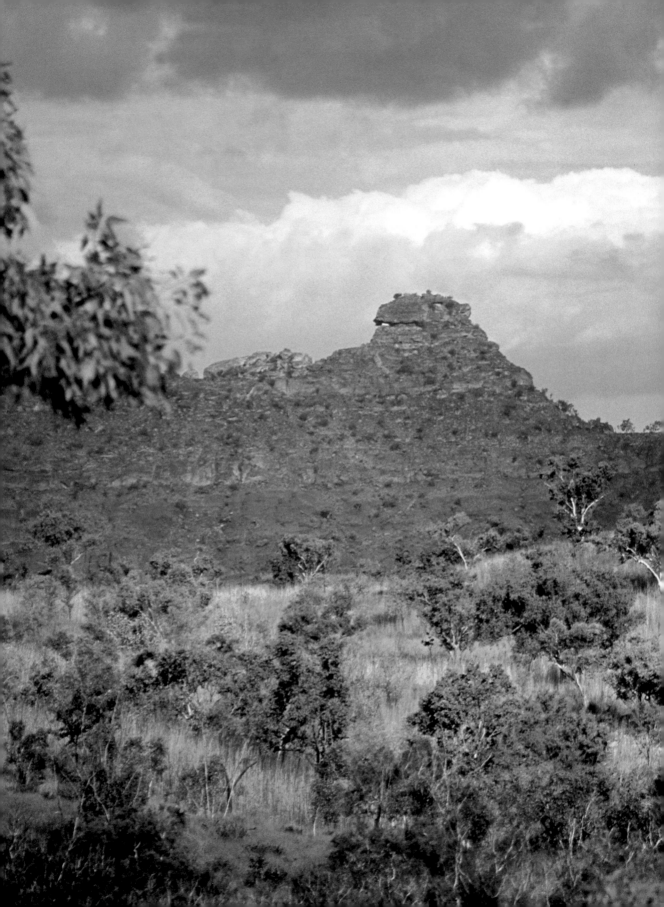

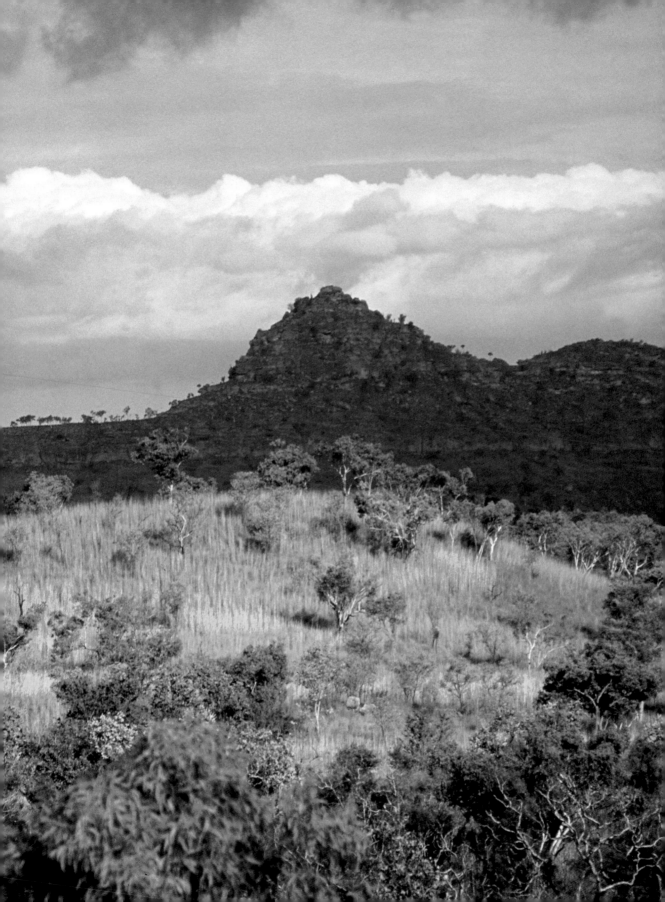

occurring. Where there are more sheltered areas, a narrow strip of littoral mud occurs, frequently underlain by sandstone and volcanic boulders; in the more sheltered bays, such as at Broome, Walcott Inlet, Talbot Bay and in Prince Frederick Harbour, there are extensive littoral mudflats with tidal creeks incised across them to the mainland.

Around many of the islands – and indeed in bays and channels subject to forces associated with tidal movement – there are rocky shoals and coral reefs. Some classic examples can be found around the Montgomery and High Cliffy islands in Collier Bay and into Yule entrance to the south of Freshwater Cove.

These are quartz arenite (a sandstone composed primarily of quartz).

Cross-bedding is nicely seen on the walk to the Camp Creek swimming hole from the Prince Regent River; it is also possible to see soft sand sediment deformation here and to the north at Bigge Island.

It also appears that the rocks that can be seen on the Camp Creek walk are weakly metamorphosed (changed in their structure either by pressure, heat or water to the extent that they have crystallised, condensed or laminated), because there are quartz-filled fractures and the rock seems to be less friable than that on Bigge Island.

The same description is relevant for the quartz veins that can be seen in Prince Frederick Harbour. It is also harder to see quartz grains in (hand) specimens taken at Bigge Island.

Top: Erosion in action
Bottom: Camp Creek

The cross-bedding on the Mitchell Plateau is harder to 'read' because beds are cut off on both the top and the bottom. Perhaps deposition was very fast and subsequently 'blurred'.

At Bigge Island rounded quartz granules can be seen at the bottom of cross-beds; and there is granule and pebble-size quartz in this unit in Prince Frederick Harbour.

Carson volcanics

This unit includes tholeiitic basalt, spilite (alteral basalt) felspathic sandstone and chert (microcrystalline quartz). The basalt, spilite and chert are typically ocean floor rock types and it is possible that most of the basalt is submarine. Chert and siltstone can be seen on the shore at Raft Point and there is basalt rubble on the beach.

If you climb up to the rock paintings, it is possible to see quartz anerite bedrock. The rock paintings are on a finer grained rock, possibly Warton sandstone. Here it takes the form of a siltstone (finer grained than sandstone) and there are what appear to be ripple marks on the gallery walls and 'roof', indicating deposition.

Hart dolerite

Basaltic rocks in Prince Frederick Harbour (Hunter River area) are most likely Hart dolerites. This unit is shown to be younger than, and intrusive into, the Kimberley group. Dolerite is a shallow-level intrusion that is the same composition as basalt but coarser grained. It appears to crop out near Krait Bay, where it takes the form of columnar jointed rocks.

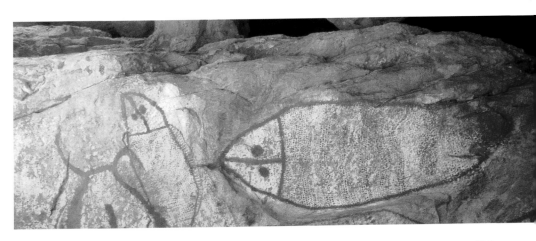

Siltstone underlies the Raft Point rock art

The 1.8 billion-year minimum age for the Kimberley group probably comes from the age data on the Hart dolerite (1.76 billion years ago), because the sub rocks must be older than that which intrudes them.

The Kimberley Craton is presumed to be underlain by Archaean rocks, so the granite and pebble-size clasts that can be seen in the King Leopold sandstone would more than likely be eroded detritus of Archaean rocks (or Protozoic, if older than the Kimberley group) that were co-mingled with the sand and silt-size sediment that makes up the Kimberley group.

It makes sense that the some of the oldest rock units are found in the Kimberley group – the King Leopold sandstone, for example, as it contains clasts from older rocks. And many geological maps do say the King Leopold Ranges contain minor conglomerates.

Observing the geology of the Kimberley is an activity best undertaken at leisure – the natural process itself has been going on for almost 1.8 billion years, and although this is a timeframe difficult to contemplate for a species that speaks in decades events that can be seen that reflect the cyclical nature of geological processes.

It is likely, in the near future, that these processes will be hastened. All it takes is a slight shift of the Earth's axis for the resulting 'wobble' to initiate geological movement and contribute to climate change.

Climate change is the greatest threat to the Kimberley – not only will it potentially result in increased eroding rainfall events such as more intense cyclones, but the impacts on biodiversity resulting from habitat change and the assaults from exotic plants and animals can only be guessed at.

Now is the time to promote reflection and plan long-term sustainable strategies that recognise Kimberley values.

Fossilised tree roots in pindan conglomerate

*Top: Cockburn
Range (near
Wyndham)
Bottom: Silica
deposits at Rowley
Shoals*

Geological time scale and significant geological events in the Kimberley region

EON	ERA	PERIOD	EPOCH	AGE mya	GEOLOGICAL EVENT
PHANEROZOIC	CAINOZOIC	Quaternary	Recent	0.01	Rising sea levels drown coastline. Dunes, deserts and sandfields formed.
			Pleistocene	1.8	Valleys and gorges formed – uplifting. 20 mya – intrusion by Ellendale lamproitas.
		Tertiary	Pliocene	5.3	
			Miocene	23.5	
			Oligocene	30.7	
			Eocene	58	
			Paleocene	68.4	Low Kimberley Surface formed
	MESOZOIC	Cretaceous		144	
		Jurassic		312	High Kimberley Surface formed.
		Triassic		248	
	PALEOZOIC	Permian		286	Ice Age
		Carboniferous		354	
		Devonian			Barrier reefs formed. The Halls Creek fault system is reactivated and allows sedimentary
				408	rocks to deposit, forming the Bungle Bungle and
				434	Ragged ranges.
				505	Start of deposition within the Canning Basin.
		Silurian			
		Ordovicia			Deposition of fossiliferous rocks in the Ord and
		Cambrian		540	Bonaparte basins. Eruption of Antrim Plateau volcanics.

EON	ERA	PERIOD	EPOCH	AGE mya	GEOLOGICAL EVENT
PROTEROZOIC	NEO-PROTEROZOIC			1000	560–550 Ma Thrusting along edge of Kimberley Basin in west Kimberley, reactivation of Halls Creek fault system. 700–800 Ma – Global Ice Age.
	MESO-PROTEROZOIC			1500	1200–1000 Ma Initiation of Halls Creek fault system. Folding and thrusting around Yampi Peninsula. Deposition of Carr Boyd group in part of the Victoria River Basin. 1200 Ma Intrusion of Argyle Diamond Pipe. 1650–1500 Ma Deposition of sedimentary rocks in the Birrindudu abasin.
	PALEO-PROTEROZOIC			2500	1790 Intrusion of Hart dolerite silts. 1900–1790 Ma Deposition of sedimentary rocks by rivers in the Kimberley Basin. 1830–1800 Ma Collision of Kimberley continent and the rest of northern Australia causes folding, faulting and metamorphism. 1840 Ma Eruption of the Koongie Park formation volcanic rocks. 1865–1850 Ma Folding, faulting and metamorphism in central and western Lamboo complex. ?Formation of a northern Australian continent.
ARCHAEAN				4500	?Formation of the Kimberley continent. Formation of the Earth.

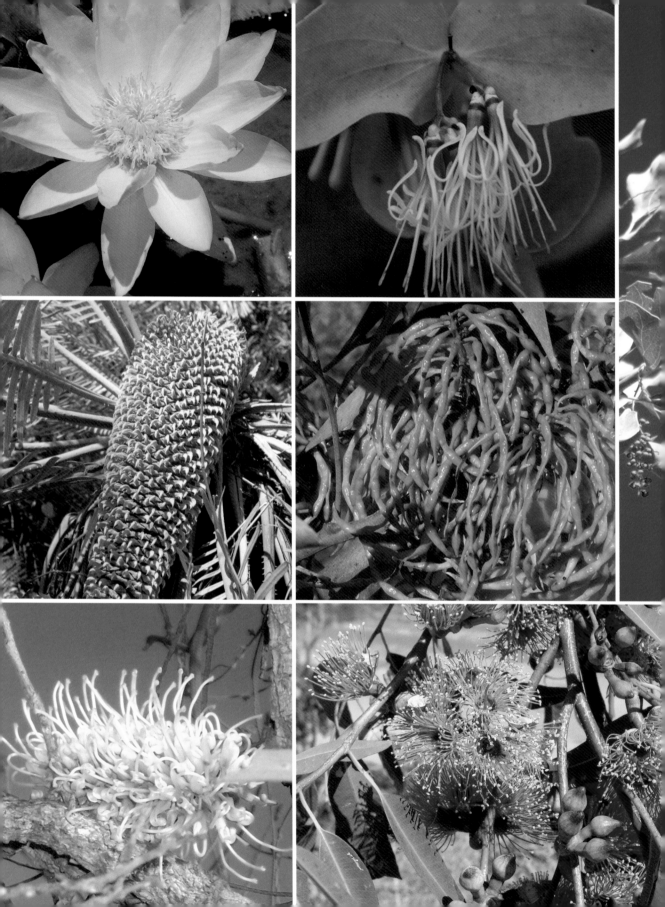

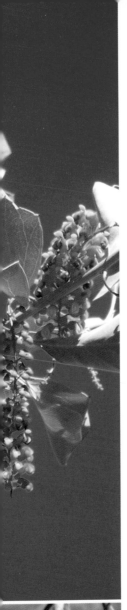

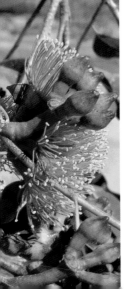

Plant names used in the text and their meaning

Adapted from *WA Plant Names and Their Meanings* FA Sharr (1996)

Banksia *(Banksia dentata)* – *Banksia*: Sir Joseph Banks (1743–1820); *dentatus*: toothed, having a toothed margin

Boab *Adansonia gregorii* – *Adansonia*: Michel Adanson (1727–1806), French naturalist; *gregorii*: Sir Augustus Gregory (1819–1905), surveyor in WA, explored northwest of WA, Qld and NT).

Bachelors button *Gomphrena canescens* – *Gomphrena*: (name altered by Linné, possibly from *Gromphraena* and *canescens*) becoming somewhat white and hoary, referring to the after-colour look of the plants as they fade from deep pink to almost white.

Broad-leaved paperbark *Melaleuca viridifolia* – *Melas* (black) and (*leucos*) white, referring to the bark of some Asian species, possibly because of the after-fire look of the trunks; *viridifolia*: *viridis* (green) and *floris* (flower).

Bladderwort *Utricularia* sp. – *Utriculus*: small skin or leather bottle.

Borreria – William Borrer (1781–1862), English botanist.

Byblis *Byblis*: a princess in mythology who was turned into a fountain, as the stems and leaves are covered in glandular hairs that glisten in the sun, 'like dripping tears'

Byblis *B. filifolia* – *filifolius*: leaf.

Byblis *B. guehoii* – *guehoii*: Russell Guého, Kimberley naturalist who discovered the species in 2004

From left to right, top to bottom: A waterlily (Nymphaea *sp), a mistletoe* (Amyema benthamii)*, holly leafed or Wickham's grevillea* (Grevillea wickhamii)*, a cyad* (Cycas basaltica)*, soap wattle* (Acacia colei)*, a hakea* (Hakea macrocarpa)*, the manowan tree* (Eucalyptus miniata)

195

Cabbage palm *Livistonia eastonii – Livistonia:* Patrick Murray, Baron of Livingston, who grew over 1000 species that formed the nucleus of the Edinburgh botanical garden; *eastonii:* William Easton, surveyor on Kimberley Exploration Expedition 1921.

Cassia *Cassia venusta – Cassia:* name of a plant; *venusta:* charming, beautiful.

Caustic bush *Grevillea pyramydalis – Grevillea:* Charles Greville (1749–1809); *pyramydalis:* pyramid shaped.

Cotton bush *Cocholospermum fraserii – Cocholospermum: Cocholos* (a shellfish with a spiral shell) and *sperma* (seed, referring to the shape of the seeds, some of which are spirally twisted); *fraserii:* Sir Malcolm Fraser (1834–1900), Surveyor General of WA.

Crabs eye vine *Abrus precatorius – Abrus:* delicate, dainty or soft, referring to leaves; *precatorius:* one who prays, as the seeds have been used as rosary beads.

Cumbungi *Typha domingensis – typhe:* reed-mace; *domingensis:* San Domingo (place name, Haiti, West Indies) and *ensis* (native of).

Cycad *Cycas basaltica – Cycas:* name used by Theophrastus, from *coicas* (the doum palm); *basaltica:* basalts, a type of marble found in Ethiopia, referring to the habitat, on basalt soil.

C. pruinosa – pruinosa: hoary, covered with hoar frost, referring to the grey-blue colour of the leaves.

C. furfuracea – furfur (scale) and *aceus* (scurfy, having little scales on the leaf).

Cypress – *Callitris intratropica – Callitris: Calli* (beautiful) and *trepis* (three, referring to the arrangement of the leaves); *intratropica: intra* (within) and *tropica* (the Tropic of Cancer or Capricorn).

Dune wattle *Acacia bivenosa – Acis:* a pointed instrument; *bivenosa: bi* (two) and *venosus* (full of veins).

Elephant ear wattle *Acacia dunnii – Acis:* a pointed instrument; *dunnii:* EJ Dunn (1844–1937), government geologist of Victoria.

Eucalyptus – *Eu* (well) and *calyptos* (covered, referring to the operculum or cap that covers the stamens in bud).

Floating pondweed *Potomogeton tricarinatus – Potomogeton: Potamos* (river) and *geiton* (neighbour, that is, found close to or in water); *tricarinatus: tre* (three) and *carina* (boat keel, as there are three ribs on the fruit).

Freshwater mangrove *Barringtonia acutangula – Barringtonia:* Daines Barrington (1727–1829), English botanist; *acutangula:* sharp-pointed angle, referring to the shape of the fruit.

Gardenia – Alexander Garden (1730–91), physician and botanist, originally from South Carolina, correspondent of Carl Linné.

Grevillea *G. dryandra – Grevillea:* Charles Greville [1749–1809], founder of the Horticultural Society; *dryandra:* like a Dryandra, referring to prostrate growth habit.

Green plum *Buchanania obovata – Buchanania:* Francis Hamilton né Buchanan (1762–

1829), superintendent of the Calcutta botanical gardens; *obovata: ob* (inverted) and *ovatus* (egg-shaped, the broadest part being the middle, referring to the leaves).

Gubinge *Terminalia ferdinandiana* – *Terminalia: terminalis*, which refers to the leaves, bunched at the ends of the branches; *ferdinandiana:* Sir Ferdinand Mueller (Baron Von Mueller).

Hakea – Christian Ludwig, Baron von Hake (1745–1818), German patron of botany.

Hibiscus sp. – *hibiscus:* marsh-mallow.

Hydrilla *H. verticilliata* – *Hydrilla:* water loving; *verticilliata:* leaves that radiate like the spokes of a wheel.

Kimberley Christmas tree *Grevillea pteridifolia* – *Grevillea:* Charles Greville (1749–1809); *pteridifolia: pteron* feather wing (leaves).

Kimberley walnut *Owenia vernicosa* – *Owenia:* Sir Richard Owen (1804-1892); *vernicosa: vernix* (varnish) and *osus* (abounding in refers to the appearance of the leaves).

Leichardt tree *Nauclea orientalis* – *Nauclea: Nauc* (ship) and *cleio* (to confine, that is, boat-shaped capsule; *orientalis* – pertaining to the east, oriental).

Marshwort *Nymphoides indica* – *Nymphoides:* like a water nymph; *indica:* India.

Mistletoe *Amyema thalassium: Amyema: A* (negative prefix) and *myeo* (to instruct, because a full description of the genus had not been published); *thalassios:* near the sea, as the species grows on the white mangrove.

Mother-in-law tree *Bauhinia cunninghamii* – *cunninghamii:* A Cunningham (1791–1839), botanist who made many collections on the Australian coast, and spent time in the Kimberley with Phillip Parker King; often called Jigal in the west Kimberley.

Native walnut *Owenia vernicosa* – *Owenia:* Sir Richard Owen (1804–92), biologist, among other things; *vernicosa: vernix* (varnish) and *osus* (abounding in, referring to the varnished appearance of the leaves).

Northern woolybutt *Eucalyptus miniata* – *miniatus:* coloured red (flowers).

Pandanus *Pandanus spiralis* – *Pandon:* name of the plant in Malay; *spiralis:* spirally coiled, referring to the leaf being coiled around the axis.

P. aquaticus – *aquaticus:* water loving.

Paratephrosia lanata – *Paratephrosia: Para* (like) and *Tephrosia* (ashes – most species are covered with grey hairs) and *lanatus* (woolly, covered in hair [leaves]).

Phragmites *Phragmites karka* – *Phragmites:* growing in hedges, as the plants grow in clumps like bamboo; *karka:* probably a vernacular name used in India.

Pindan wattle *Acacia tumida* – *tumidus:* swollen, protuberant, probably referring to the valves of the seed pods.

Poverty bush *Acacia transluscens* – *transluscens:* shining through, glistening, probably referring to the leaves.

Prop-rooted mangrove *Rhizophora stylosa* – *Rhizophora: Rhiza* (root) and *phoreo* (to bear, as the roots act as stays); *stylosus:* abounding in styles, as the flower has a large style.

Randia – Issac Rand (d. 1743), curator of the Chelsea Physic Garden, apothecary.

Rattlepod *Crotalaria* – *Crotolon*: rattle, castanet (shake the seed pod!).

River paperbark *Melaleuca argentea* – *argentea*: silver, as the leaves are silvery.

Rock fig *Ficus platypoda* – *Ficus*: fig tree; *platypoda*: *platys* (broad, flat) and *podos* (foot, probably referring to the habit of the roots when attaching themselves to sandstone walls).

Rock spinifex *Triodia racemigra* – *Triodia*: *Treis* (three) and *odous* (tooth); *racemigra*:*racemus* (bunch of grapes) and *ger* (to bear, probably referring to the flower heads).

Rubiaceae – possibly similar form to the blackberry bush.

Sundew *Drosera* sp. – *Droseros*: dewy, referring to the prominent glandular hairs that give the plant the appearance of being covered in dew); *broomensis*: from Broome, Western Australia; and *indica*: Indian; also applied to anywhere in the far east.

Snakevine *Tinospora smilacena* – *Tinospora*: *Tinus* (the laurustine, a European shrub known for its fragrant pink or white flowers) and *spora* (small seeds); *smilacena*: convoluted, with a twining habit.

Sorghum (cane grasses) – *Sorgho*: name of the plant.

Spinifex longifolius – *Spinifex*: *spina* (spine, thorn) and *fex* (maker); *longifolius*: *longus* (long) and *folius* (leaf).

Sticky kurrajong *Sterculia viscidula* – *stercus*: dung (some species smell bad); and *viscidulus*: sticky.

Stinkwood (helicopter tree) *Gyrocarpus americanus*: *Gyrocarpus*: *Gyros* (ring) and *carpos* (fruit, as the fruit gyrates and spins as it fall to the ground); *americanus*: American.

Tall mulla mulla – *Ptilotus exaltatus* (*Ptilotos* – soft-winged; *exaltatus* – raised up, tall).

Triumfetta plumigera – *Triumfetta*: Giovanni Battista Trionfetti (1658–1708) or his brother Lelio (1647–1722), both professors of botany in Italy; *plumigera*: *pluma* (small soft feather) and *gero* (to bear, as the fruit is covered in long, soft hairs).

Turkey bush *Calytrix exstipulata* – *Calytrix*: *Calyx* (cup) and *thrix, trichos* (hair, referring to the awn or stiff hairs that form the end of the calyx lobes); *exstipulata*: *ex* (without) and *stipulate* (stipules).

Turpentine wattle *Acacia lysiphloia* – *lysiophloia*: *lysis* (loosing, setting free) and *phloios* (bark, as the bark curls away from the trunk and branches; sometimes referred to as Miniritchie).

Waterlily *Nymphaea* spp. – *Nymphae*: nymphs, goddesses who inhabited fountains and rivers.

Waterwheel plant *Aldrovandra* spp. – *Aldrovandra*: Ulysses Aldrovandri (1522–1605), Italian botanist who founded the natural history museum at Bologna.

Wild pear *Persoonia falcata* – *Persoonia*: Christian Hendrik Persoon (1755–1837), specialist fungi botantist; *falcatus*: shaped like a scythe or sickle, referring to the leaves.

Wild plum *Terminalia platyphylla* – *Terminalis*: referring to the leaves being bunched at the end of the branches; *platyphylla*: *platys* (broad, flat) and *phyllus* (leaf).

White cedar *Melia composita* – *Melia*: ash tree, as the leaves are similar to those of ash trees; *compositus*: laid together, compound, possibly referring to the branches.

White dragon tree *Sesbania formosa* – *Sesbania*: from Arabic *saisaban*; *formosa*: beautiful, on account of its form.

White mangrove *Avicennia mariner* – *Avicennia*: Avicennia (980–1037), Persian physician who contributed a major text of medical study; *mariner*: growing by the sea.

Wooly Glycine *Glycine tomentella* – *Glycine*: *glycios* (sweet to taste, refers to the leaves) amd *tomentella* (dense, short, matted hairs on the leaves).

Xanthostemon *X. paradoxus* – *Xanthostemon*: *Xanthos* (yellow) and *stemon* (thread, stamens); *paradoxus*: unexpected, strange, marvellous.

Introduced species

Cabbage bush *Calatropis intratropica* – *Calatropis*: *Cala/calos* (beautiful) and *tropis* (ship's keel, referring to the keeled 'corona leaflets').

Coffee bush *Leucaena leucocephala* – *Leucaena*: *leucos* (white, grey) and *cephala* (head, probably referring to the white stamens clustered together to form the ball-like flowers).

Gallons curse *Cenchrus biflorus* – *Ceghros*: a type of millet; *biflorus*: two flowers.

Jerusalem thorn *Parkinsonia aculeata* – *aculeatus*: furnished with prickles.

Mossman river grass *Cenchrus echinatus* – *echinatus*: with prickles, like a hedgehog or echidna.

Noogoora burr *Xanthium occidentale* – *occidentalis*: western.

Stinking passionfruit *Passiflora foetida* – *Passiflora*: *Passio* (the suffering of Christ) and *floris* (flower, referring to the fancied resemblance in parts of the flower to the instruments of Christ's suffering); *foetida*: evil-smelling, foetid.

Glossary

Ambient: that which encompasses or surrounds on all sides

Benthic: the bottom of the sea – in tidal areas the bottom of the sea is exposed at low tide

Billabong: freshwater lagoon or waterhole

Black soil: type of cracking clay. In Kimberley, refers to Kununurra clay

Bolide: a bright, shooting meteor that frequently explodes into a cascade of smaller burning fragments (occasionally even with an audible explosion)

Cellulose: a carbohydrate that is the chief component of the cell walls or woody parts of plants

Cnidarians: jellyfish, and the stinging cells or nematocysts they carry as defence

Convection: to come together, as in heated particles of air

Convergence: to tend to come together at one point

Crepuscular: pertaining to twilight; glimmering; becoming active at twilight, as in crepuscular insects

Cro-Magnon: after the Cro-Magnon cave near Dordogne in France where the remains of a prehistoric race of mankind were discovered

DDT: acronym for Dichlorodiphenyltrichloroethane – a manmade insecticide

Deciduous: shedding their leaves at the end of the growing period

Dioecious: being separately male and female

Dreamtime: Australian Aboriginal myths that deal with the creation of the universe and that establish the rules of human and social behaviour that are the foundation of social, secular and ceremonial activities

Echo-location: the use of sound to determine surrounding surfaces

Eucalyptus: a genus of trees in the myrtle family, native to Australia

Galls: a tumour on plant tissue caused by irritation due to insect damage, fungal invasion etc.

Inflorescence: the flower(s) of plants and their arrangement on a stem or axis

Kino: the sap from a number of species of trees that has medicinal or cultural uses

Mangroves: a group of tropical trees and shrubs that grow along riverbanks and estuaries and are tolerant of high salinity levels

Monsoon: a wind that reverses its direction seasonally; in northern Australia, it blows from the southeast in winter and from the northwest in summer

Nebulae: misty, cloudlike patches seen in the night sky, consisting of groups of stars too far away to be clearly seen

Neophyte: in biology a newly 'hatched' member of the species, particularly referring to termites

Nomadic: given to wandering, with no permanent home

Nymphal: in zoology, relates to a chrysalis or pupa; a stage of development

Pathogen: any microorganism or virus that causes disease

Pelagic: of the open water or open sea, referring to species that live in this environment

Perennial: lasting through the whole year or for a long time; in botany, having a lifecycle of more than two years

Phyllodes: enlarged, flattened leaf stalks that resemble and perform the functions of a leaf

Pindan: a type of iron rich soil dominant in the coastal west Kimberley, especially between Broome and Derby

Photosynthesis: the formation of carbohydrates from water and carbon dioxide by the action of sunlight on the chlorophyll of plants

Pneumatophore: a porous structure, used as a breathing organ, on the roots of certain tropical plants, particularly mangroves

Progenitor: an ancestor in the direct line

Protandrous: having male sexual organs while young, but later developing female sexual organs

Racemes: a flower cluster in which the flowers grow singly on small stems arranged along a longer stem

Raptorial: like a raptor; having the behaviour or the characteristics of any bird of prey

Savannah: grassland characterised by scattered trees

Sedentary: remaining in one locality; not migratory

Stimuli: any action, activity or agent that causes reaction or changes in plants and animals

Terrestrial: pertaining to or existing on the Earth (as distinguished from aquatic, marine, parasitic or epiphytic)

Tide: the alternate rise and fall or the surface of the oceans, seas, and the bays, rivers etc. connected to them, caused by the gravitational attraction of the Sun and the Moon

Tymbal: a ribbed membrane located on either side of the abdomen, particularly in cicadas, grasshoppers and crickets

Vector: in biology, any organism that is the carrier of a disease-producing virus

Willy-willy: localised wind storm that forms a tightly spiralling vortex of wind

References and suggested reading

Barr, A, et al. *Traditional Bush Medicines – An Aboriginal Pharmacopoeia*, Aboriginal communities of the Northern Territory and Greenhouse Publications, 1990

Bennetts, HW, Gardener, CA, *The Toxic Plants of Western Australia*, 1956

Bindon, P, *Useful Bush Plants*, Western Australian Museum, Perth, 1996

Brunet, Burt, *The Silken Web, A natural history of Australian spiders*, New Holland, Syndey, 1998

Burnham, R, Dyer, A, Garfinkle, R, George, M, Kanipe, J, Levy, DH (Consultant editor Dr J O'Byrne), *Advanced Skywatching*, Reader's Digest (Australia), 1997

Cribb, AB & JW, *Useful Wild Plants in Australia*, William Collins, Sydney, 1981

Department of Agriculture, Western Australia (AGWA), *APB Infonotes*: #37, 1978; #38,1978; #6/90,

Erickson, R, George, AS, Marchant, NG & Morcombe, MK, *Flowers and Plants of Western Australia*, Reed Books, Sydney, 1982

Farb, Peter & the Editors of LIFE, *The Insects*, Time-Life International (Nederland) NV, 1964

Guého, Russell, *Icons of the Kimberley*, Northern Habitat, Broome, 2003

Graham, Alistair and Beard, Peter, *Eyelids of Morning (the mingled destinies of crocodiles and men)*, Chronicle Books, San Francisco, 1990

Healey, J & Marks, J, *The Reader's Digest Encyclopedia of Australian Wildlife*, Reader's Digest(Australia), 1997

Horden, Marsden, *King of the Australian Coast*, Melbourne University Press, Melbourne, 2002

Johnson, D, *Night Skies of Aboriginal Australia: A noctuary*, Oceania Publications, University of Sydney, 1998

Kenneally, K, Edinger, DC and Willing, T, *Broome and Beyond*, WA Department of Conservation and Land Management (CALM), 1996

Kerrod, Robin, *The Star Guide*, , RD Press, 1993

Kowari2 ANCA, *Plant Invasions*, 1991

Low, Tim, Feral Future, Penguin Australia, 2001

Lowrie, Allen, *Carnivorous Plants of Australia* (Vols, 1, 2 and 3), UWA Press, Nedlands, 1998

McComb, AJ & Lake, PS, *Australian Wetlands*, Angus & Robertson, Sydney, 1990

Mathews, Richard, *Nightmares of Nature*, HarperCollins, Sydney, 1995

Mountford, CP, *The Dreamtime Book*, Rigby, Sydney, 1974

Petheram, RJ & Kok, B, *Plants of the Kimberley Region of Western Australia*, UWA Press, Nedlands, 1986

Pietropaolo, J&P, *Carnivorous Plants of the World*, Timer Press, Oregon, 1986

Shine, Richard, *Australian Snakes – A Natural History*, New Holland, Sydney, 1999

Van Oosterzee, Penny, *Where Worlds Collide: The Wallace Line*, Reed Books, 1997

Webb, G, & Manolis, C, *Crocodiles of Australia*, Reed Books, 1989

Wheeler, JR, (editor), *Flora of the Kimberley Region*; WA Herbarium CALM, 1992.

Wightman, GM, 'Mangroves of the Northern Territory', in *NT Botanical Bulletin* No. 7, Conservation Commission of the Northern Territory

Zborowski, Paul, Storey, Ross, *Insects in Australia (a field guide)* ; New Holland, Sydney, 1998

Chapter specific referencing

Rhythm

McFarland, D (Ed.) *The Oxford Companion to Animal Behaviour*, Oxford University Press, Oxford, 1981

The Start

Farb, P, *The Insects*, Time – Life International (Time Inc.)(Nederland) NV, 1964

Storey, R, & Zborowski, P, *A Field Guide to Insects in Australia*, Reed New Holland, Sydney, 1998

Aboriginal Food Calendars

Aboriginal Communities of the Northern Territory of Australia, *Traditional Bush Medicines (An Aboriginal Pharmacopoeia)*, Northern Territory of Australia, 1990

Kenneally, K. Choulles Edinger, D. Willing, T. Broome and Beyond. Department of Conservation and Land Management, Perth, 1996

Summer

Bureau of Meteorology, 2004

Tropical Revolving Storms

Bureau of Meteorology, 2000 and 2005

Queensland Department of Transport, *Small Ships Manual,* 13th Edition, Brisbane, 1998

Kimberley Flora

Erickson, R, George, AS, Marchant, NG, Morcombe, MK, *Flowers and Plants of Western Australia*, Reed, Frenchs Forrest, 1982

Kenneally, K, Choulles Edinger, D, Willing, T, *Broome and Beyond*, Department of Conservation and Land Management, Perth, 1996

Wheeler, JR (Ed.), *Flora of the Kimberley Region*, Department of Conservation and Land Management, Perth, 1992

Stargazing

Burnham, R, Dyer, A, Garfinkle, RA, George, M, Kanipe, J, Levy, DH, *Advanced Skywatching*, Readers Digest (Australia), Sydney, 1997

Kerrod, R, *The Star Guide*, Readers Digest, Surrey Hills, 1998

Kimberley Birdwatching (Ornithology)

Hill, R, *Australian Birds*, Thomas Nelson, Melbourne, 1968

Schodde, R, Tidemann, S, *Complete Book of Australian Birds*, Readers Digest, Surrey Hills, 1986

Fire – A Burning Issue

Mutch, RW, 'Wildland fires and ecosystems – a hypothesis', *Ecology*, 51, 1046-51, 1970

Crocodile Attacks and Why they Occur

Webb, G, Manolis, C, *Crocodiles of Australia*, Reed Australia, Frenchs Forrest, 1989

Snakes of the Kimberley

Mathews, R, *Nightmares of Nature*, Harper Collins, London. 1995

Plants that Eat Flesh

Lowrie, A, *Carnivorous Plants of Australia Vol 3*, University of Western Australia Press, Nedlands, 1998

Plant Names

Sharr, FA, *Western Australian Plant Names and Their Meanings*, University of Western Australia Press, Nedlands, 1996

Acknowledgements

Many people have contributed to the information contained within these pages, either through general discussion on events that have been witnessed, a desire to share a special moment, or professional knowledge of the specific area of discussion. I truly appreciate your years of experience and friendship. You all make the Kimberley priceless- I trust I do you justice in these pages. I would particularly like to thank Captain Bruce Palmer for his contribution of tidal information and Peter Tucker from Levêque Wilderness Fishing for his observations on humpback whales at Collier Bay. Kerry Slingsby, Robert Vaughan, Mick Smith, Hugh Brown and Al Castle read early drafts and provided encouragement and critical comment. Greg Quicke from Kimberley Astrotours reviewed the section on Stargazing, and the amazing Tim Willing the section on Kimberley flora. Their professional knowledge is immense. Steve Nicholls and Debbie Sibasado reminded me of cultural protocols and their lifestyle is in effect what this book encapsulates. My sister Claudine provided the map, and my family, friends and peers were always pushing for a completion date. Vanessa Hayden is a dynamo in the Kimberley, and her support, cajoling and threats have helped me produce the book. Thank you all.

Index

Bold numbers indicate images